Keeping Time
in Sag Harbor

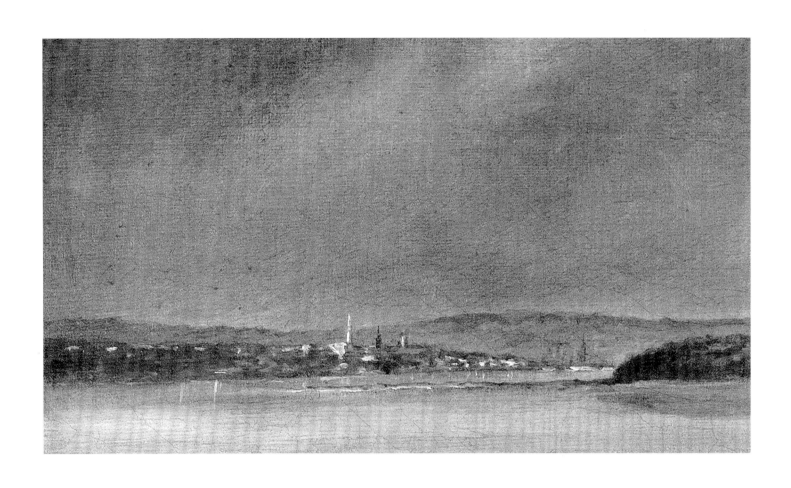

Center Books on American Places
George F. Thompson, series founder and director

Keeping Time in Sag Harbor

PHOTOGRAPHS AND TEXT
BY STEPHEN LONGMIRE

with interviews
by Joyce Egginton

The Center for American Places
Santa Fe and Staunton

in association with
The Sag Harbor Whaling
and Historical Museum
and Columbia College Chicago

PUBLISHER'S NOTES: *Keeping Time in Sag Harbor* is the ninth volume in the *Center Books on American Places* series, George F. Thompson, series founder and director. The book was brought to publication with the generous support of Furthermore: A program of the J. M. Kaplan Fund; the Sag Harbor Whaling and Historical Museum; Columbia College Chicago; Friends of the Center for American Places; and the many others who appear in the author's acknowledgments, for which the publisher is most grateful. At Columbia College Chicago, thanks also to Dr. Warrick Carter, President; Steven Kapelke, Provost; Leonard Lehrer, Dean of the School of Fine and Performing Arts; Michael DeSalle, Chief Financial Officer; and Bob Thall, Chairman, Photography Department. For more information about the Center for American Places and the publication of *Keeping Time in Sag Harbor*, please see page 298.

The Center for American Places, Inc.
P.O. Box 23225
Santa Fe, New Mexico 87502, U.S.A.
www.americanplaces.org

Distributed by the University of Chicago Press
www.press.uchicago.edu

15 14 13 12 11 10 09 08 07 1 2 3 4 5

Library of Congress Cataloging-in-Publication Data is available from the publisher upon request.

ISBN 1-930066-68-6 (clothbound)
ISBN 1-930066-69-4 (paperback)

Frontispiece: Sag Harbor, from Cedar Island Lighthouse, painted by Hubbard Latham Fordham, 1866 (detail). Original in color.

Remove not the ancient land-mark
which thy fathers have set.

—*Annie Cooper Boyd,*
 over the front door of her "Long Island Herald House"

"Did you see what they've done to the
old Bagbalm house?" "I hear the lady who just
moved in was the mistress of Calvin Coolidge."
The houses are like characters in a long-running play
that the whole town is invited to watch,
and tell stories about forever—a hard offer for
a writer to refuse.

—*Wilfred Sheed,*
 "Sag Harbor: An American Beauty,"
 Architectural Digest, *May 1990*

"Sag Harbor's a little off the beaten trail,
but there's a tremendous spiritual challenge here.
When a whole town lives in the past . . .
I mean there are some extraordinary problems."

—*Donald Crawford, Minister,*
 Old Whalers' Church, quoted by Berton Roueche,
 "The Steeple," The New Yorker, *March 5, 1949*

For Joyce, Joan, and Joy,
who made it home

Contents

Preface

T HE INSPIRATION FOR *Keeping Time in Sag Harbor* is the 300th anniversary of the village, whose existence was first noted in the Southampton Town records of 1707. What drew the early inhabitants to this place remains its principal resource: a deep-water harbor with easy access to neighboring bays, Long Island Sound, and the Atlantic Ocean. While the community that sprung up around the commerce of the harbor has changed, each passing economic era has left a lasting mark on the fabric of the village. Today, as in former times, the water continues to play a central role in Sag Harbor's evolution. So do the buildings that have become an integral part of its identity. *Keeping Time in Sag Harbor* celebrates the enduring character of this unique American village through contemporary and historic photographs and insightful commentary.

The Sag Harbor Whaling and Historical Museum, founded in 1936 to collect and exhibit objects that are significant to this community, is privileged to sponsor *Keeping Time in Sag Harbor* in honor of the village's 300th anniversary. The museum's collections reflect the prosperous whaling era of the nineteenth century, the lifestyle of Sag Harbor's seafaring families, and the objects of everyday life that contributed to the character of the port. The collections are exhibited in a magnificent Greek Revival house, once home to the whaling magnate Benjamin Huntting and his family, and now a prominent landmark. Since its founding, the museum has expanded its mission to reflect its leadership role in the preservation of the village and to interpret its collections for a new generation.

Keeping Time in Sag Harbor reflects this new direction, inviting those who know the place intimately and those seeing it for the first time to appreciate its intrinsic beauty—and the unique challenges it faces—by gazing through the photographer's lens and the eyes of eloquent residents and guests. Some are writers who have called Sag Harbor home, including James Fenimore Cooper and John Steinbeck; others are people walking the streets today. Together, they assess the effects of the passage of time on this community, its architecture, its artifacts, and its citizens.

This project owes its existence to the artistry and dedication of Stephen Longmire, an accomplished photographer, writer, and historian. This book and the museum exhibition associated with it are the result of his creative vision. *Keeping Time in Sag Harbor* is a lasting memento and a fitting gift to the village in this 300th anniversary year. We hope the book inspires further exploration of Sag Harbor's past and present and an awareness of its special place in the nation's story.

—Zachary N. Studenroth
Executive Director
The Sag Harbor Whaling and Historical Museum

Introduction

THE YEAR I WAS BORN, my parents bought a second home across the bridge
from Sag Harbor. A journalist friend of my father had settled in this "waterlogged
Williamsburg," as his son would later dub it, restoring houses from the whaling era, and my parents drove the hundred miles from New York City to visit. The way the sea bled into the sky
over eastern Long Island, with its flat farmland and old villages, reminded my English mother of
East Anglia. Over the years, that summer cottage became a year-round home, first to my father
and then to me, and an anchor for my family through changing times. Little did my parents
know, they were buying me a home for life—one I may be unable to keep, but to which I
inevitably return.

"The Promised Land," Dad would announce as we crossed the Shinnecock Canal, boarding
the South Fork, the island at the end of Long Island that points out to sea. The words Promised
Land were right there on our map, where the land thinned down to a strip before its final flourish at Montauk, so naturally we believed him. After schooldays in the city, my brother and I considered this a place of endless summer, where the joys of living close to the land and water never
stopped. Perhaps because of that early bond, I felt the area's history was part of my own. Whales
surfaced frequently in my childhood drawings in the early 1970s. Like an old wicker porch chair,
Sag Harbor was full of ghosts. Many were artists and writers to whom, as the child of writers, I
also felt close.

When I brought my future wife to visit in the 1990s, I kept to the local back roads. I had
gotten into the habit of concealing even from myself the signs of a transformation more evident
every year, as a farming and fishing community that welcomed summer guests became a year-round resort. I wanted her to see the place I knew and loved; other friends, visiting on their own,
had seen only the spreading "Hamptons," a playground for the rich. Until we moved out full-

time, I managed to keep Kelley ignorant of the Montauk Highway, a wall of traffic separating us from the Atlantic Ocean in summertime, and the predicament of a place that could be loved to death. A native Midwesterner, she took comfort in the realization that she was standing on a spit of sand the Wisconsin glacier picked up during the last Ice Age, more than 10,000 years ago, as it ground its way out to sea, and it felt familiar underfoot. People can make themselves at home almost anywhere, but a place's stories must touch their own.

Sag Harbor's colorful stories have given it both a strong identity and people willing to protect it. As the South Fork's urban center, it developed first and redeveloped last. For a long time, it was spared the trends of the more popular oceanfront resorts nearby. But Sag Harbor is a community in transition as it turns 300, in danger of losing its memory despite farsighted efforts at architectural preservation and land conservation—a function of the same volatile real estate market that renewed its wealth. In the forty years I've known it, the village has gone from backwater to boom town, with roots pulled up as often as they're put down. Few communities can rival its historic integrity, so the transformation is plainly visible. Old buildings are made new, while the surrounding farmland and beaches are developed. Some residents have roots centuries deep, but, with spiking property values, longevity is getting scarce. Many newcomers love the village as much as those who came before, but it's hard for stories to survive when few people know them. I've never lived anywhere people love as much or lose as often. The relationships between land and water, between past and present, feel like family connections to me. These days, people often ask how long you've been here, after inquiring where you live. This book is my reply and a birthday present to the village, made in the hope that we can all be naturalized by looking and learning where we are.

Sag Harbor was among my first photographic subjects, a quarter-century ago, but it took many years and changes before I could photograph it for keeps. The village's houses are historians that more or less stay put, and they have helped me tell its story. Buildings are time capsules, full of the lives they have held. The same is true of photographs. Both can tell stories of people and their places, using the fabric of life. And both tend to wear in, not out, as the objects that furnish our daily lives take on the shape of the past. Familiar landmarks, built or natural, are essential aids to memory. Buildings remind us who and where we are, and sometimes they intimate why. As vessels of the past, they can be the collective unconscious of a community trying to hold on to its identity.

"The city, however, does not tell its past, but contains it like the lines of a hand," Italo Calvino observed. It is "written in the corners of the streets, the gratings of the windows, the banisters of the steps…."* Photographs can awaken these deep memories, if they are made with attention and love. An impassioned photographic memory might help a community such as Sag Harbor, which values its traditions but faces changes that often seem outside its control. Local preservation laws hold out the hope of self-determination, now that most of the village is a historic district and few changes to its appearance can be made without public review. The process takes constant vigilance and a rooted citizenry, hard things to find in a community increasingly made up of second homes.

In the pages that follow, my contemporary photographs—along with select historic photographs and other early images—summon Sag Harbor's history, as it appears on the ground. The photographs, old and new, are both artworks and artifacts. Together, I hope they show what it is to live in a place where the past is implicit in the present, yet where the future proposes dramatic changes. It is a new twist in the village's long cycle of booms and busts. Sag Harbor's houses were built by the economic speculation of whaling during the century after the American Revolution. They were preserved by neglect for a century thereafter, while the village lived off its factories. Now, these same houses are the engine of its real estate industry, helping to sell local history at a profit. My pictures, made in the three years leading up to Sag Harbor's 300th birthday in 2007, take a cue from the historic ones I found along the way, aspiring to serve as time capsules, too. Soon they may be historical documents themselves, if the village's reconstruction continues on its current path, with its modest houses growing ever larger, priced out of reach to all but seasonal residents.

Sag Harbor has changed more than any other place I've known, even as it has fought harder than most to keep itself intact. For the better part of a century, between 1881 and 1981, the community packaged timepieces for a living in its watchcase factory. Maybe these photographs will help current and future Sag Harborites keep time in a new way by catching the village's likeness at a crucial juncture. This book is an effort to record history in motion, in a place where it has been asked to stand still but will not. Photography also stops time, which nevertheless slips by, so it seems almost a parable of the camera's shifting vantage.

*Italo Calvino, *Invisible Cities*, translated from the Italian by William Weaver (San Diego, New York, and London: Harcourt, 1974), 11.

Thoughts about Sag Harbor's past, present, and future developed alongside my photographs, but pictures drove this project from the outset. The journey began as a walk down the back streets of my mind, and I walked all the village's streets in the three years I haunted them with my large-format camera. I laid a few ground rules early on to be sure my eye led my head. Each picture had to advance my sense of the relationship between the place and its people, showing how they wear their history. Many local controversies cross these pages, since buildings play leading roles in Sag Harbor's politics, but no photograph was made to prove a point or advance a cause. Some stood out like beacons, signaling my way: the former Presbyterian manse, with its proud eagle (page 97), being offered for sale, as most Sag Harbor houses are eventually; or Lynnette Pintauro, at work at her computer upstairs in the whaling museum (page 65) with another local woman, Phebe Smith, watching over her from an 1830s portrait on the wall. It was probably painted by Orlando Hand Bears, who is responsible for the earliest surviving image of Sag Harbor (page 25). Lynnette and Phebe have both moved downstairs, but this casual connection of old and new remains in place and keeps Sag Harbor alive. An unconscious continuity, it brings history up to date. This is the relationship I set out to record, hoping never to see its end.

The picture of the nineteenth-century astronomer and clockmaker Ephraim Byram's watch-tower (page 124) was a late addition, but a very welcome one. With a moonbeam tracing its orbit for the duration of the long exposure, it reminds me of his orrery, a working model of the solar system that fit inside a room. Looking over the photographs, I see that my village is haunted by the moon. Both are worlds in miniature, shining in their perpetual motion. The companion texts—"extracts," Melville would say—tell the story of a small world that has been orbiting much larger ones for some time. Today's residents chime in, bringing us up to date and preparing the road ahead.

Keeping Time
in Sag Harbor

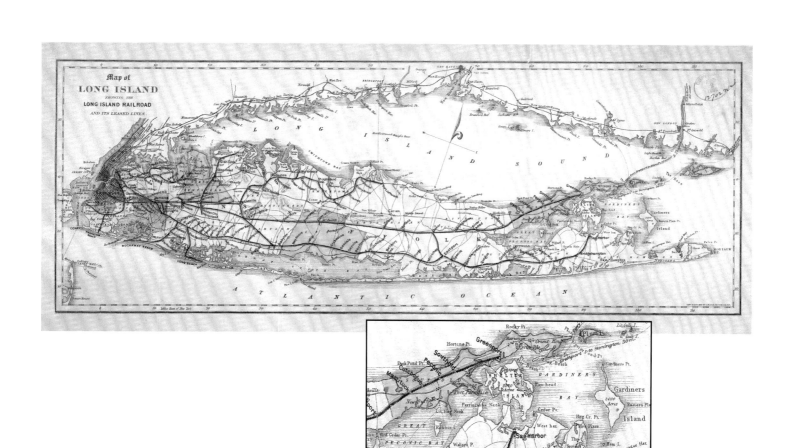

"Map of Long Island showing the Long Island Rail Road and its Leased Lines," published in New York City by G. W. & C. B. Colton & Co., 1882. *(At the time, Sag Harbor was the eastern terminus of the train's southern line. Train service to Sag Harbor continued until 1939. The South Fork begins at Canoe Place, where the Shinnecock Canal was built ten years after this map was made. Brooklyn and New York, still two separate cities at the time, are the densely built areas at the island's western edge, with the Connecticut shore to the north.)* Original in color.
Courtesy of the Library of Congress, Geography and Map Division.

Whalers, Watchmakers, and Weekenders

Sag Harbor has the character of a national historic district,
a living part of American history. Though it is a small town,
Sag Harbor is as much a part of the national scene as the French
Quarter of New Orleans, or Greenwich Village in New York.

—Suffolk County Planning Department, *Sag Harbor Study and Plan* (1971)

A colonial port first heard from in 1707, Sag Harbor has had its fortunes linked to those of the big city at the opposite end of New York's Long Island for most of its three centuries. Soon after Sag Harbor and New York City were named the state's two ports of entry for the collection of customs in 1789 (in one of the very first Acts of Congress, when revenue to run the new government was a high priority), the little port on the island's East End registered more tonnage of square-rigged vessels engaged in foreign trade, or "sailing foreign," than New York harbor.[1] Now the order is reversed, and the seaside village is a fashionable weekend satellite of the nation's commercial hub. Instead of sending its ships around the world, Sag Harbor now waits for the world to visit. Its popularity as a resort, accelerating fast since the late 1980s, has coincided with an era of low mortgage rates and high real estate investment. For much of the twentieth century the village was economically depressed, so this windfall has brought unforeseen stresses as well as benefits, and significant population turnover, as longtime residents give way to wealthier New Yorkers seeking second homes.

Similar upheavals are being felt in other historic settlements within weekend commutes of prosperous American cities—on Cape Cod and its neighboring islands (linked, geologically and

3

historically, to eastern Long Island's twin forks); in New York's Hudson River valley; along the Maine coast and Maryland's Eastern Shore; in California's Marin County; even on Michigan's Leelanau peninsula. The popularity of second homes, especially near water, has forced development in places long cherished for their seclusion and historic integrity. In Sag Harbor, architectural preservation laws designed both to secure the community's historic legacy and to protect it from unplanned change have focused attention on its many early houses, and their value has skyrocketed. This has brought a wave of renovation that amounts to a make-over for the remote village.

An architectural treasure-trove, Sag Harbor retains a chronicle of early American buildings, high style and vernacular, thanks to its long history of economic ups and downs. The buildings that are doorways to its past were preserved for most of their lives by a combination of neglect and love. Now that the village is a nationally recognized historic district—an effort of the 1970s, refined in the eighties and nineties—historic preservation is the law. It is a law homeowners love to hate, since it helps to increase their property values but limits their ability to remodel. The village government has had its own ambivalence about its preservation efforts, especially in the early years, fearing they might interfere with business. Old-timers wonder if the landmark status isn't chasing them from their homes, but it's hardly the only culprit. Times are changing as the village turns 300: its houses are bought and sold as investments and renovated as often as they change hands. Local history has become a commodity and an increasingly scarce resource.

This uniquely American place has led at least three lives during its first three centuries, all of them still visible on its streets. Once among the busiest whaling ports along the New England coast, Sag Harbor was an "oyle" boom town for roughly three-quarters of a century following the American Revolution of 1776–1783. After its whaling industry went belly up in the mid-nineteenth century, the community reinvented itself as a manufacturing center that took in summer guests, preserving the architectural record of its former affluence in the amber of neglect. Now, its old houses are the basis of a thriving resort economy that is reinventing the place again, in keeping with a new era's ideas of affluence.[2]

"The town came into money at a very good time—the first half of the nineteenth century—and ran out (and stayed out) of it at a good time too: ever since," Wilfrid Sheed wrote in 1990, on the eve of the current realty boom. "In the 1830s and 1840s, when Sag Harbor was a booming whale town, you didn't need good taste to build well—it took genius not to. And by the time ugliness had entered America, Sag Harbor couldn't afford it."[3] In its lean years, the village main-

tained its early buildings with little more than paint. Houses that might have been remodeled or replaced elsewhere were left alone, though some decayed past saving, leaving gaps like missing teeth. Victorian porches and other "improvements" were added here and there, but the Greek Revival still reigns on Sag Harbor's side streets, with all its hopes for a democratic architecture on a human scale in this brave new world.

"Because of its peculiar economic history Sag Harbor is a kind of living museum of pre-industrial Americana," another longtime resident, Jason Epstein, wrote, "a nineteenth-century manufacturing city that never advanced beyond its infancy and so has been spared the pattern of rapid industrial development and subsequent decay characteristic of more 'successful' places such as New Bedford or New London." In the 1970s, when these words were written, the local preoccupation with refurbishing old houses was little more than a hobby. "The village's loss," Epstein added, "is the antiquarian's gain. Sag Harbor survives as an invaluable historical asset."[4] The antiquarian's perspective exposes a frequent tension in preserved communities, which keep the relics of past economies alive, long after they are economically viable.[5] In the intervening decades, Sag Harbor has turned this situation to advantage, selling its historic houses at a premium. Opinions are divided on the consequences, but "adaptive re-use" is the mantra of historic preservation, and this trend is oddly in keeping with the way the village made its first fortune, in another form of speculation.

NEW BEDFORD, MASSACHUSETTS, was the biggest of the New England whaling ports, with 329 whaling vessels registered at its peak in 1857. Nantucket, New London, and Sag Harbor vied for second place, with fleets of eighty-eight, seventy, and sixty-three at their respective heights in the mid–1840s.[6] By the end of the decade, Sag Harbor had dropped out of the race, its ship owners overextended by the cost of "fitting out" vessels for longer and longer voyages, as the ships chased their quarry first from the Atlantic and then the Pacific. There was also the burden of rebuilding the waterfront after a devastating fire in 1845. A year later, Nantucket burned and began its decline, until summer tourism saved it in the last quarter of the nineteenth century. Sag Harbor's waterfront went up in smoke three times in the nineteenth century, making the village's survival all the more extraordinary. As a result, it is home to one of the state's first volunteer fire departments, an ongoing source of local pride. The incorporation of its fire department in 1803 established Sag Harbor's boundaries, though the village itself did not incorporate until 1846.[7]

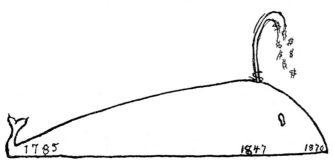

. . . Eighty-five years of deep sea whaling

Annie Cooper Boyd's timeline of Sag Harbor whaling, from her daughter Nancy Boyd Willey's booklet, The Story of Sag Harbor *(1939).*

The port had its banner year in 1847, landing whale oil and bone worth nearly a million dollars. But that same year, local ship owners lost an estimated $75,000 after covering their expenses.[8] The California Gold Rush of 1849 and the discovery of petroleum in Pennsylvania a decade later both contributed to the decline of deep-sea whaling, but it had ceased to be profitable in Sag Harbor shortly before these newer money-making schemes came along. New Bedford kept whaling into the early twentieth century (though San Francisco surpassed it as the country's busiest whaling port in 1886), but the Massachusetts port was big enough to attract distant capital. Most Sag Harbor ship owners and investors lived nearby, and their fortunes waned with the fleet. Whaling earned the village $7 million between 1837 and 1847, the decade of its biggest returns, and roughly $25 million overall, between 1785 and 1871.[9]

Sag Harbor struggled to reinvent itself after the decline of its whaling trade, trying its luck with one factory then another, starting in 1850. A textile mill built that year burned in 1879 (page 225); two years later, Joseph Fahys's watchcase factory rose from its ashes. Fahys had been an investor in the prior venture, the Montauk Steam Cotton Mills. A French immigrant, he married into North Haven's Payne family, which traced its roots back to Puritan days.[10] Fahys's wife, Maria L'Hommedieu Payne, had a ship captain for a father, named Charles Watson Payne (like his father and his son). He lost his life to a whale soon after her first birthday. A family genealogy that Mrs. Fahys kept notes the longitude and latitude of her father's burial at sea, roughly between the tips of Africa and South America.[11]

Packaging some of the nation's first mass market timepieces was Sag Harbor's leading business for the century starting in 1881—a decade after its last whaleship sailed, never to return.[12] According to one local historian, the factory melted down $6,000 worth of gold and turned out 1,200 watchcases a day in 1890.[13] A related business, the Alvin Silver Company, made such popular items as the commemorative silver spoons for the 1893 World's Columbian Exposition in Chicago—newly rebuilt after its own devastating fire in 1871. Several "watchcase houses," simple frame structures designed for factory workers, were built in this era, expressing the village's new industrial character and the welcome it held out to immigrants.

This might seem a departure from the almost feudal economy of whaling, which made a few families rich but employed most of the village. There was significant population turnover at this juncture in Sag Harbor's history, as there is today, but villagers still worked in a single industry in the factory years, and the names of prominent whaling families were well represented among the firm's managers and trustees. Joseph Fahys and Company, the overarching concern, employed nearly 1,000 people in Sag Harbor in the 1920s, nearly a third of the population. At the outset of the Depression, in 1931, it shut up shop, leaving the village again in the lurch. At the urging of the community, the Bulova Watch Company reopened the factory six years later, putting Sag Harbor back to work.

The former factory, dark since 1981, still watches over the downtown business district like a ghost (pages 127–30 and 228). Rendered redundant by quartz technologies, it sat idle for a quarter-century, but it may soon house luxury condominiums. Some of today's villagers worked in the building, others have parents who did, so the fate of this structure that held so many lives, employing the community as long as the whaling industry, has been a symbolic one for the decades its fate hung in the balance. Heavy metals found in the surrounding soil left it a toxic clean-up site and delayed development. During this time, ivy hid the sprawling brick structure, which nearly fills a large block, and trees poked through the windows. It looked as though the building might be allowed to fall to the ground, given the obstacles to its restoration. The potential of such demolition by neglect tested Sag Harbor's ability to enforce its architectural preservation laws, resulting in a stalemate until a new developer bought the building in 2006.

Now the village has wind in its sails again, with a brisk real estate trade in the houses its whalers and watchmakers left behind. Selling and rebuilding its historic houses and developing the few vacant lots is clearly its leading business today, along with tourism, despite an eclectic year-round population involved in other pursuits. By and large, Sag Harbor has absorbed the gathering tide of New Yorkers seeking second homes in this compact urban setting by the sea and benefited from the resulting redevelopment. But many residents now wonder how much they can shape their village's future. Sag Harbor's architectural preservation ordinances, evolving over the last three decades of the twentieth century, promise a measure of self-determination, since any change to the community's appearance is a subject for (often heated) public debate. Since 1985, the volunteer Board of Historic Preservation and Architectural Review has been empowered to determine the "appropriateness" of alterations to the streetscape visible from any public access

or from neighboring yards, effectively declaring the view public property. Still, the economic forces at play can seem overwhelming and the battles absurdly slight. However many roots are torn up by the community's transformation, it cannot close its doors.[14]

Sag Harbor still boasts itself the "un-Hampton," offering street and night life, an antidote to the high privet hedges and high-priced boutiques of the more fashionable oceanfront resorts nearby. Until quite recently, few stores in the village have been run by national chains. The neighboring Hamptons host outlets of many familiar luxury brands, but few stores offer essential goods or services that local people can afford. Asking no pedigree of newcomers, Sag Harbor makes little fuss over its few dignitaries, who have included many artists and writers over the years. John Steinbeck is remembered locally for helping to run the boisterous Old Whalers' Festival for several summers in the 1960s. (See his welcome to latter-day whalers on page 274.) This left a bigger impression than his novels, though one depicts the place embarrassingly well. Names are changed in *The Winter of Our Discontent*, but this tale of a proud, beleaguered New England port willing to sell its soul to regain its name hits close to home. A Sag Harbor shopkeeper once paid the Nobel prize-winner the ultimate compliment: "He should have been born here and shouldn't have been famous."[15] The village recalls what it is to be a city; and cities are places people go to disappear, not just to make their fortunes.

FOR SEASONAL RESIDENTS, it is always summer on Long Island's East End, one long vacation. Many who move out year-round continue to expect this comforting constancy. "I just don't want it to change," a Sag Harbor retiree who has taken an active interest in the fate of the village's architectural legacy tells me. There is solace in believing the objects and places in our lives are fixed, so we can measure our own changes against them. We age more gradually in a world that does not alter. This fiction of permanence helps resorts thrive, even as their seasonal popularity belies its truth. Sanctuaries to summer, they suggest that time has stopped or, at the very least, slowed down, making them safe places to bring the kids or to remember being one. At times, such fictions threaten to keep Sag Harbor in political infancy. Keeping it as it was, or as it might have been, is often cited as the justification for the local preservation ordinances. Is their goal a record of the past or a model for the future? Opinions differ widely. Many of those who own second homes in the village consider it their chosen home, even if they only spend summer weekends and vacations. Perhaps they aren't so different from the sailors who once shipped out on the local

whaling crews, returning from two- to four-year voyages hunting big game around the globe only to set off again. Sailors also looked forward to retiring back "home," if they made it back alive.

When Sag Harbor vessels met on the high seas, the square-riggers might heave to side by side, spilling wind from their sails to "speak" each other. The men called back and forth how many days out they were and what other ships they'd seen, hoping news of their progress might stretch homeward along this early telegraph. If they shared an anchorage or the same course in fair weather, the captains might row across to visit each other, taking a few lucky oarsmen along to "gam" together for an idle hour or two.[16] Once the captains had compared their luck, exchanged news and perhaps a token gift, they might send mail aboard whichever ship had the fuller hold and looked likely to return home first. In the late 1840s and early fifties, as profits from the local whale fishery dried up, many former whalers banded together to buy unused ships and try their luck in California, whose mountains promised to be made of gold. In their haste for the gold fields, some abandoned their ships in San Francisco Bay, near the Long Wharf they named for the one back home. Sag Harborites often roomed and drank together in the new boom town of San Francisco, those who returned (mostly empty-handed) recalled.

What did it mean to be from Sag Harbor, to a "floating population" that was seldom home? What does it mean today? A minor character in Herman Melville's whaling novel *Moby-Dick* is simply called Sag Harbor. His home port is his identity. Aboard ship, this may have been a comforting tie to land. In today's society, where professionals are moved about and ties to place are secondary, second homes, in places we choose for ourselves, are anchors of another sort: homes for the heart, for the lucky few.

BALANCING THE RIVAL needs and demands of Sag Harbor's year-round and seasonal residents is no easy task. The taxes that absentee homeowners pay fuel local schools and services. For years this seemed a fair trade, with seasonal residents underwriting the local economy and local politicians favoring development. But the lines are blurring, as "summer people" extend their holidays by telecommuting, or flee the city altogether, and longtime villagers are priced out. The 2001 attack on the World Trade Center fueled this exodus from the city. Some people feel safer in the country—even though a disaster affecting Long Island could force its many residents along a "coastal evacuation route" whose signs point right back to the clogged bridges and tunnels of New York City. With the advent of private schools on the East End and technologies that let

many professionals work from home, more New Yorkers are making Sag Harbor and its surroundings their primary address; others are spending longer weekends, through spring and fall.

An ongoing reassessment of property values in the town of Southampton, which contains most of Sag Harbor, is spreading the higher taxes recent homebuyers have been paying evenly across the community, a questionably democratic gesture that has left natives and other longtime residents in dismay. Many bought their homes when the village was a modest address. Now they are sitting on gold mines, but they only realize the profits if they sell and leave the area, effectively cashing out. Tempting as this may sound, it is galling to those who have put down roots. "I'm being taxed on a fantasy of what my house would bring were I to sell it," Judith Long, a Sag Harbor resident since 1966 who sued the town over the reassessment, wrote to me in 2006. "As I never will sell it, I'm being taxed on an idea." Some have proposed that owners of second (and third) homes be charged a luxury tax, instead of spreading higher taxes across the community. The neighboring town of East Hampton, which includes roughly a third of Sag Harbor, has resisted reassessment, effectively accomplishing this goal. Many of Sag Harbor's year-round residents pull up stakes each summer, staying with friends or traveling to rent their houses during the tourist season; others take second mortgages, or reverse mortgages if they're older, living off their property values.

An entrepreneurial antiques dealer I know is fond of advising me how to keep up with this treadmill. You have to own a house, he advises, then sell it every few years and keep trading up. It's a viable strategy, but the cost is never settling down. Watching "for sale" signs pop up like garden ornaments in recent years, I've wondered whether every house isn't for sale—if any of them really is. High prices go up like test balloons to see who will reach for them. If no one rises to the challenge, one realtor confided, the solution may be to raise the asking price. This attitude has turned many Sag Harbor houses into showplaces, whose owners are always expecting prospective buyers, summer tenants at the very least. I began to wonder if it wouldn't be more efficient to advertise which houses are *not* for sale. The village has begun to feel a bit like the stock market in physical form.

Many old houses that were run-down in recent memory have been restored in this boom market, some more than once. And businesses have thrived, if they own their premises and aren't at the mercy of spiking rents. "Isn't it wonderful what's happened to Sag Harbor?" a shopkeeper who gave me my first summer job asked me in the early 1990s. For him it was an easy question— for me, a genuine dilemma. It's gotten hard to find the village of my childhood, a place of weath-

ered cedar shingles soaked in time's briny mist. But it's still here, thanks to a persistent spirit and the many residents, old and new, committed to its preservation. The people are as important as the place, and, at their best, they're inseparable. It's not wealth, of which Sag Harbor has always had its share, but the frequent turnover of property that threatens the community's continuity, erasing collective memory by shortening the average stay. Many newcomers are drawn by the village's history. Most want things to remain unchanged as of their arrival. But each new transplant inherits a subtly different place. The benchmarks are forever shifting, so new arrivals don't feel old losses, which is a blessing and a curse. Can a community be preserved and lost at the same time? The story of Sag Harbor certainly raises the question.

WHALING WAS THE ECONOMIC SPECULATION of its day, a high-stakes gamble that paid off big or not at all. So today's realty-based economy is hardly out of place, but its investors are gambling with the place itself. Sag Harbor is a monument to the spirit of mercantile capitalism in its unruly early American form. Yet, the challenges of maintaining the connections to place that have kept this one visually and socially intact are real, with today's extreme housing costs. The median price of a house in the village was just under three-quarters of a million dollars in 2005—twice what it was five years before—and roughly a million in 2006.[17] Many Sag Harbor houses are now priced in the millions, and there are very few houses in the vicinity under half a million.

Needless to say, it's difficult for newcomers who aren't wealthy, or for the grown children of locals without land to subdivide or share, to join or stay in this increasingly polarized community. "We've priced out our children," one realtor poignantly admitted. This recent development shows no signs of reversal. Rents rival those in New York City, yet most of the available jobs are in service industries whose wages cannot cover the high costs of East End living. Necessities such as gas and groceries cost more because of the challenge of getting them to the tip of an island whose main roads are often blocked with traffic. Those catering to the tourist trade pass on these costs, occasionally adding a little something extra. "It's summer in the Hamptons, what do you expect?" the teenage lawnmower explained when he raised his price. Hence the irony: to relocate to the area full-time, you must bring an income from somewhere else. But New Yorkers are used to putting up with inconvenience, and many let go of basics like affordable housing and worry-free commuting long ago. To some, the East End's problems seem oddly like amenities. From a realtor's perspective, today's Sag Harbor is not expensive, but exclusive. The number of people struggling to buy into the community proves it is worth the price.

This hot market has attracted a new kind of Sag Harborite. For the half-century following World War II, New Yorkers in gradually increasing numbers bought old houses cheap and restored them as weekend homes, often as old-timers moved into more convenient modern ones at the outskirts of the village. "It felt like sleeping beauty yawning," one smitten arrival of the late 1960s recalls. But, as a longtime member of the local architectural review board observed—after years spent listening to homeowners ask permission to enlarge and update their historic structures—"people moving here now don't want old houses, they just want to live in Sag Harbor." Maybe that's all previous generations of weekenders wanted too. But, in this case, money does make a difference. The village once had a distinctive shabby charm, and people made the most of what they stumbled into. Now, developers truck in "historic" fixtures and gardens to finish off old houses they've gutted and made new. This surely wasn't anticipated when the review board was established, but it has no say over what happens indoors and little say over what happens in the yard. It does permit well-hidden swimming pools, a sore point for some, a necessity to others. Throughout today's East End, which pumps its drinking water from a finite underground aquifer—despite widespread concern over the dangers of depleting or polluting groundwater— there are swimming pools down to the beach. If yours is the only house on the block without one, you may be the last to find a summer tenant.

To New Yorkers, Sag Harbor is now part of the Hamptons. But, until recently, the Hamptons and Sag Harbor did not recognize each other as social equals. This is an old distrust. One veteran descended from a Sag Harbor whaling captain recalls that, during World War II, "whenever Southampton Town wanted twenty men, they took fifteen from Sag Harbor." In her youth, another older friend tells me, "East Hampton mothers didn't want their sons to go to Sag Harbor"—a holdover Puritan scruple against the port's many bars. There were thirteen in 1911, according to a Presbyterian Church report.[18] In my childhood, "the Sag Harbor mile" was still run from one bar to the next, closing each in turn. A dark warren on Main Street, the Black Buoy, was the late-night finishing line. Its former quarters have been home to a rotating display of more fashionable restaurants in recent years. As even the Presbyterians realized, the village's bars were its social halls—first for its sailors, later for its factory workers, many of them straight off the boat from Ellis Island, having come from Eastern Europe or Italy. Its polyglot population gave Sag Harbor the oldest Catholic and Jewish congregations in Suffolk County, dating, respectively, to 1835 and 1883.

Since whaling days, probably well before New York abolished slavery in 1827, the village's outlying Eastville district has been home to a sizable African-American comminity, with close family ties to the East End's several inter-related Indians nations.[19] Many men of color worked in the whaling industry, while their wives were employed as domestics in the village. By the early twentieth century, Eastville's boarding houses had become a summer destination for African Americans from the city. Since World War II, several waterfront developments nearby have provided summer homes to middle-class blacks, who once felt unwelcome in white resorts. Now these historically black neighborhoods are being integrated, as modest homes get harder for year-round residents to find. Eastville was geographically distinct from the rest of Sag Harbor until the edges of the village were built up in the late nineteenth century; until quite recently, the beach communities of Azurest, Ninevah, and Sag Harbor Hills were socially distinct.

Before concluding that the entire East End is a luxury retreat, a waterfront community gated by inflated property values, consider that the federal census—which gathers its information in April and tends, therefore, to poll full-time residents—consistently reports household incomes well below Long Island averages for Southampton and East Hampton, the two oceanfront towns whose dividing line Sag Harbor straddles. Together these towns make up the South Fork, where property values are among the highest on Long Island (which includes much more densely settled suburbs of New York City).[20] Because of the great discrepancy between South Fork incomes and housing costs, the local work force, if not grandfathered in, may commute 100 miles or more round-trip each day on slow roads that few residents want to see enlarged, blocking traffic with the "trade parade." Carpenters and landscapers are the parade marshals, though bureaucrats, schoolteachers, and many other professionals are also commuting long distances. Together with real estate, building is now the region's trade, as its sandy glacial soils—some of them rated among the nation's best for farming by the U.S. Department of Agriculture—are sold and resold. So far they seem a reliable substitute for gold. "There's one sure rule of East End real estate," a retired broker volunteered. "Whoever you sell your house to will be richer than you are."

Frustrated would-be homeowners may yearn for this unreal estate bubble to burst, but it could have dire consequences for an area so reliant on tourism. A generation ago the farmland around Sag Harbor grew more corn and potatoes than subdivisions, and people came for open space, not the summer society. Old hands lament how few young people are in a position to settle on today's East End, but who can part with land or houses below market value? Not the local governments. "Affordable housing" is election season's recurrent rallying cry, but real housing

subsidies are received as warmly on the East End as on Manhattan's Upper East Side. Housing subsidies, if they were affordable, could improve the lot of the East End's many Latino laborers, who often share overcrowded (and sometimes illegal) group homes, and they might let professionals doing equally essential jobs move into the community or stay.[21] But, while property values keep rising faster than the stock market, it's hard to persuade anyone to take housing off the open market, not even to make a long-term investment in this precious and precarious place. Instead, many seasonal residents stand ready to unload their property, if and when the tide should turn. Another irony: distinctive places are a commodity in this real estate economy, yet it treats places as if they were expendable. It was not so long ago that Sag Harbor was the South Fork's low-cost alternative.

But these are sleepy times, compared with the village's rowdy past. Apart from summer weekends, Sag Harbor has not exceeded its peak nineteenth-century population of 3,600, hovering around two-thirds that number, or 2,400, for decades. The peak summer population, within its limits of roughly one square mile, is harder to gauge, but the Long Island Power Authority, worrying about potential "brown outs" (and reckoning in a few adjacent areas), estimates that it triples, jumping to 7,200. The place was built to boom, and efforts to hold it at a standstill go against the grain. As the South Fork's urban center—or just "the harbor," as one retired Bridgehampton farmer still says—it has coped with recent developments more gracefully than the surrounding Hamptons, whose traditional farming and fishing economies are almost impossible to sustain in an era of astronomical land values and speculative overbuilding. Sag Harbor was made for a world not so different from this, by entrepreneurs in love with a miniature metropolis by the sea. It has been adopted by many devoted seasonal and year-round residents who love the place as if it were their own—and, of course, it is, since cities, however small, are built for newcomers as well as old hands. Despite its current growing pains, which could shrink the year-round population, the village retains much of the infrastructure and human capital for redevelopment along more sustainable lines, as it looks forward to its fourth century. But it awaits another economic transformation, perhaps a new industry, to help it imagine another future.

Notes

Epigraph: Suffolk County Planning Department, *Sag Harbor Study and Plan* (Hauppauge, NY: Suffolk County General Services, July 1971), 6.

1. Sag Harbor was a port of entry until 1913. Its early Custom House—once the home of Henry Packer Dering, Collector of the Port from 1791 to 1822—is now a museum, run by the Society for the Preservation of Long Island Antiquities. For more on early shipping into New York's ports of entry, see note 5 to "Where Houses Are Historians" (pages 242–43).

2. Although early tourism relied on the railroad and resort hotels, eastern Long Island has few hotels today, west of the sport fishing mecca of Montauk; second homes or seasonal rentals are the rule.

3. Wilfrid Sheed, "Sag Harbor—An American Beauty," *Architectural Digest*, May 1990, 36.

4. Jason Epstein, "Sag Harbor Tour" in Jason Epstein and Elizabeth Barlow, *East Hampton: A History and Guide* (East Hampton, NY: Medway Press, 1975), 98; 101. (Revised and reissued by Random House, 1985.)

5. It's no accident that Charleston, South Carolina, was home to this country's first historic district in 1931; its shipping never recovered from the Civil War. Most municipal preservation laws in America post-date the National Historic Preservation Act of 1966, which created the National Register of Historic Places.

6. Nantucket's whaling fleet peaked in 1843, New London's in 1846 and '47, Sag Harbor's in 1846. By contrast, a smaller whaling port, Mystic, Connecticut—where the only surviving American whaleship, the *Charles Morgan*, is preserved at the Mystic Seaport Museum, after an eighty-year whaling career that began in 1841—had eighteen vessels at its largest, in 1846. See Walter S. Tower, *A History of the American Whale Fishery* (Philadelphia: University of Pennsylvania Press, 1907), 123–24. I am grateful to Laura Pereira, Assistant Librarian at the New Bedford Whaling Museum Library, for calling my attention to these figures.

7. The Sag Harbor Fire Department's 1803 charter from New York State can be found on the department's Website (www.sagharborfd.com) and at the Sag Harbor Fire Department Museum, housed in the former village hall. In addition to establishing the community's boundaries, the charter created its first governing body, a board of trustees authorized to tax residents for the purpose of fire protection. State approval was needed since the fire district included portions of two towns: Sag Harbor spans the line dividing the two colonial towns of Southampton and East Hampton. Prior to the village's incorporation in 1846, town meetings in these two towns—colonial bodies dating back to the 1640s—were the prevailing local governments, each nearly ten miles away. Sadly, fire consumed many early Sag Harbor records.

8. This surprising fact is the subject of William R. Palmer's 1959 Columbia University dissertation, *The Whaling Port of Sag Harbor* (available from University Microfilms International, Ann Arbor, MI), the best history of Sag Harbor whaling to date.

9. These dates span the period from the *Lucy*'s first voyage to the *Myra*'s last. Comparatively little whaling was done from the port after 1850, though several voyages were mounted. There was a modest revival in the 1860s, when the price of whale oil went up during the Civil War—a result, in part, of Confederate shipping blockades. No complete figures exist for Sag Harbor's whaling returns before the Revolution, but a modest amount definitely occurred. See Luther Cook's 1837 letter on the origins of Sag Harbor whaling (page 257).

10. Joseph Fahys (1832–1915) came from Belfort, near Alsace, a region France and Germany traded back and forth during his lifetime. As a result, some sources call him German; in fact, Belfort separated from Alsace to remain a part of France. In 1856, he married Maria L'Hommedieu Payne (1837–1927) of North Haven. The couple lived in Brooklyn and North Haven, in a mansion on Fahys Road, just across the bridge from Sag Harbor, opposite her family home on Ferry Road. The Fahys house was taken down in the 1940s by their descendants, who considered it too large to maintain. Fahys and his wife now rest in the only mausoleum in Sag Harbor's Oakland Cemetery. Early in the twentieth century, this formidable structure, complete with its own Tiffany window, faced a formal garden.

11. I am grateful to Martha Sutphen for sharing with me this hand-written volume, passed down to descendants of the Payne family. Charles Watson Payne is among the young ship captains named on the Broken Mast Monument in Oakland Cemetery; he died at thirty, it explains, while master of the ship *Fanny*.

12. The *Myra* was condemned and broken up at Barbados in 1874, three years after leaving Sag Harbor for the last time, under Captain Henry Babcock.

13. George Finckenor, "Sag Harbor In Its Industrial Heyday: The Watchcase Factory," *The Sag Harbor Express*, May 5, 1997.

14. By contrast, the state of Vermont recently changed its law to allow communities to set different school-tax rates for full-time residents and owners of second homes.

15. Quoted in Paige Grande's essay, "John Steinbeck's New York: A Home in Sag Harbor," on the Website, www.literarytraveler.com.

16. According to Elizabeth Burns Brady, "gamming with a ship means visiting another ship, sometimes swapping boat crews for the evening, who exchange tobacco and kill all the whales in the ocean across the cabin before they part company." See her essay "Shelter Island and the Whaling Industry" in the *1968 Journal of the Old Whalers Festival and Third International Whaling Competition* (Sag Harbor: Old Whalers Festival, Inc., 1968), 18.

17. I am grateful to George Simpson of Suffolk Research Service, Inc. for compiling these figures. See the organization's Website (www.suffolkresearh.com) for more information on East End realty costs and trends, under the heading "Market Figures." East End realtors are bracing for the slow-down in the housing

market that economists are predicting across the nation, but the records of recent property transactions in the area confirm that it is a microclimate with its own rules. A decline in sales appears to be countered by higher prices. National economic indicators such as "new housing starts" are almost irrelevant here.

18. *The Sag Harbor Survey* (New York: Department of Church and Labor, Board of Home Missions of the Presbyterian Church in the U.S.A., 1911), 8. At the time, the village population was 3,408. Nearly 900 of these people worked for the Fahys Watch Case Company (but only 350 attended the Presbyterian Church).

19. Many of Eastville's Indian families came from Montauk, after the peninsula, long used by whites as communal grazing land, was summarily auctioned off in 1879. Tribal representatives are still contesting the forced relocation that followed. See John A. Strong, *The Montaukett Indians of Eastern Long Island* (Syracuse: Syracuse University Press, 2001; paperback, 2006).

20. Really, the South Fork is the southern tine of the East End's twin peninsula, which together resemble a fork—or, better yet, the southern fluke of the tail of what the Long Island poet Walt Whitman called his "fish-shaped island," nuzzling the smaller island of Manhattan. The rest of Long Island is protected from the Atlantic Ocean by a strip of barrier islands, including Fire Island, but the South Fork is left exposed to waves of all sorts.

21. The State of New York Mortgage Agency (SONYMA) offers subsidized mortgages with low down payments and below-market interest rates to first-time homebuyers, but they cannot be used to buy homes over the program's price caps. These go up annually, but they remain consistently below the cost of the least expensive East End homes. (The maximum house price for which a SONYMA mortgage could be used in 2006 was $429,610, at which time the median home purchase price in Sag Harbor was roughly a million dollars.) The towns of East Hampton and Southampton have built several subsidized housing units (often over the protests of neighbors), none of them in Sag Harbor. Sag Harbor is revising its zoning code to allow accessory apartments in homes.

Sag Harbor
at 300

*G*o back with me fifty years and stand as I then stood on Sag-Harbor's dock. Look with me as then I looked on an industrial enterprise; that out of the depths of the sea, impoverishing no human being, brought millions to our shores. Who can measure the diversified labors it employed. This ship has just arrived, worn, grimy, soiled, her masts, and spars, and sails, and rigging, and hull, battered and weather beaten, all need to be renovated. Her supplies furnished, her casks stowed. Her defective masts and spars fitted. Her bottom coppered. Her rigging and sails renewed. Mighty hands heave her down to be corked and sheathed and coppered. Carpenters replace defective timber and plank. Painters smooth and decorate and gild. Masons set up the try works. Riggers, keen of eye and strong of nerve, strip the ship, from the tip of her taper top gallant mast to her cut water, and replace, and renew, and wind, and knot, and tar, and tighten, till all is strong, and trim, and taut. All this for one ship. Multiply this by a score and a half, and you get some idea of the volume of majestic movement, of human industry, that flowed to the wharf in olden time.

—HENRY P. HEDGES, *Early Sag-Harbor, an address delivered before the Sag-Harbor Historical Society, February 4th, 1896*

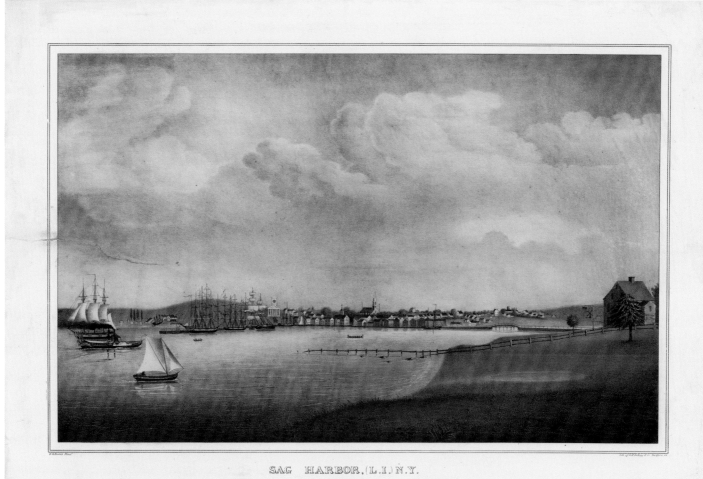

SAG HARBOR, (L.I.) N.Y.

View from the North.

Sag Harbor, Long Island, New York (view from the north). Lithograph by Daniel Wright Kellogg from a lost painting by Orlando Hand Bears, ca. 1840. Courtesy of the Connecticut Historical Society Museum, Hartford.

I believe a lot of people end up staying in my village because of its mesmerizing street pattern. A labyrinth of narrow side streets is strung cobweblike between three wider streets which, outside the village boundaries, become roads that connect respectively to another village, the ocean, and a larger town with more movies. Within the village every alley or side street eventually runs into one or the other of these three broader streets, which themselves converge at last in a single curving Main Street—where sooner or later everyone runs into everyone else—that in turn funnels onto a long wharf that leads straight out to sea. With such a map, every errand is an adventure.

—CAROL WILLIAMS, *Moving Stories* (2003, UNPUBLISHED)

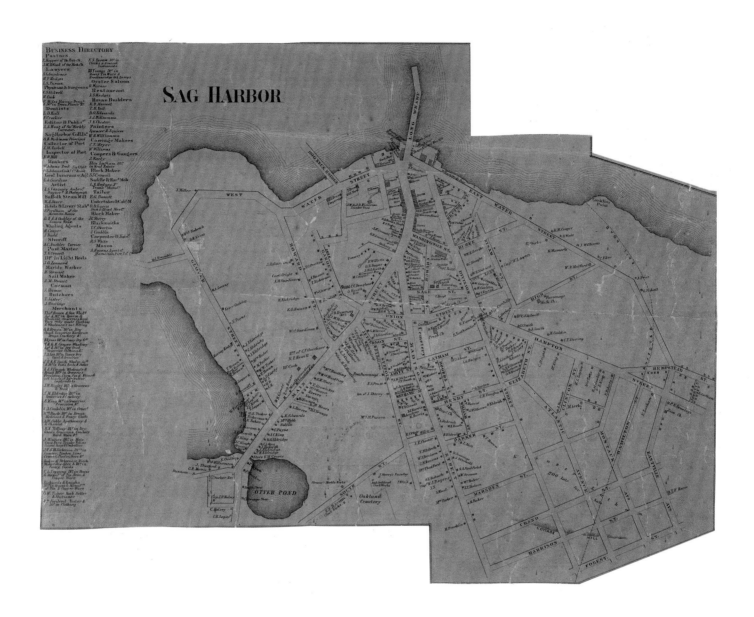

*Sag Harbor in 1858, from the map of Suffolk County published that year in Philadelphia by John Chace, Jr.
Courtesy of the East Hampton Library, Long Island Collection.*

*S*ag Harbor was back up the Bay, around past Cedar Island Light, a foreign place to us. The last whaler had sailed from there seventeen years before. People were talking about a revival, but none of them really believed it. Sag Harbor captains, most of them really from Bridgehampton or Southampton, still commanded whalers out of San Francisco or Honolulu for the Arctic fishery. You could still see Kanakas, and Indians, and Chinese too, on Sag Harbor Main Street, and you could see saloons and such social eyesores. Sag Harbor had Irish, too, working in the watchcase factory, and a Catholic church, a candle shop. Sag Harbor made me nervous.

—Everett T. Rattray,
 The Adventures of Jeremiah Dimon: A Novel of Old East Hampton (1985)

Sag Harbor, from Cedar Island Lighthouse, painted by the lighthouse keeper, Hubbard Latham Fordham, 1866.
Courtesy of Joy Lewis.

*I*t is as indispensable that a whaler should possess a certain *esprit de corps*, as that a regiment, or a ship of war, should be animated by its proper spirit. In the whaling communities, this spirit exists to an extent and in a degree that is wonderful, when one remembers the great expansion of this particular branch of trade within the last five-and-twenty years. It may be a little lessened of late, but at the time of which we are writing, or about the year 1820, there was scarcely an individual who followed this particular calling out of the port of Sag Harbor, whose general standing on board ship was not as well known to all the women and girls of the place, as it was to his shipmates. Success in taking the whale was a thing that made itself felt in every fibre of the prosperity of the town; and it was just as natural that the single-minded population of that part of Suffolk should regard the bold and skilful harpooner or lancer with favor, as it is for the belle at a watering-place to bestow her smiles on one of the young heroes of Contreras or Cherubusco. His peculiar merit, whether with the oar, lance, or harpoon, is bruited about, as well as the number of whales he may have succeeded in "making fast to," or those which he caused to "spout blood."

—JAMES FENIMORE COOPER, *The Sea Lions; or, The Lost Sealers* (1849)

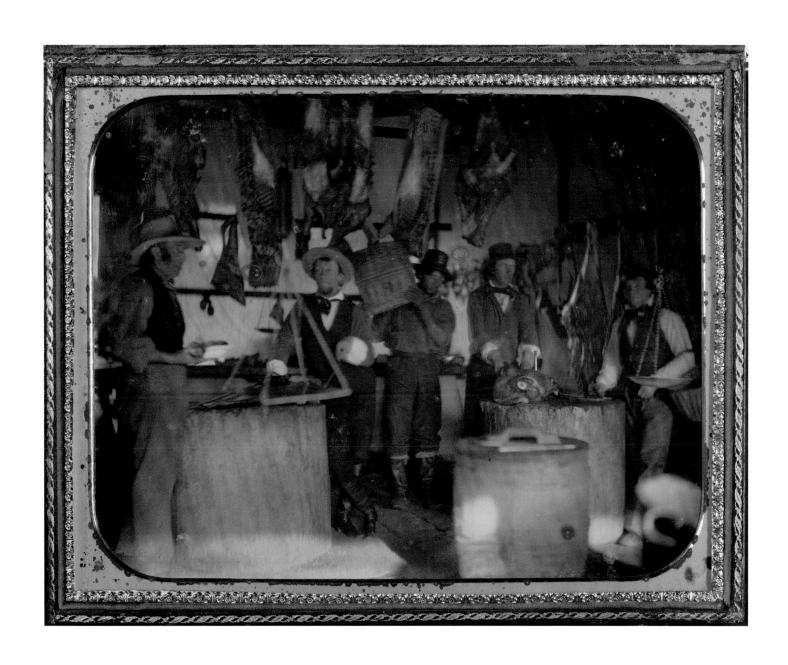

Provisioning a ship on Sag Harbor's waterfront. Hand-colored, full-plate daguerreotype, ca. 1850, photographer unknown.
Courtesy of the Nelson-Atkins Museum of Art, Kansas City, Missouri. (Gift of Hallmark Cards, Inc.)

*A*rrived at last in old Sag Harbor; and seeing what the sailors did there; and then going on to Nantucket, and seeing how they spent their wages in *that* place also, poor Queequeg gave it up for lost. Thought he, it's a wicked world in all meridians; I'll die a pagan.

—HERMAN MELVILLE, *Moby-Dick; or, The Whale* (1851)

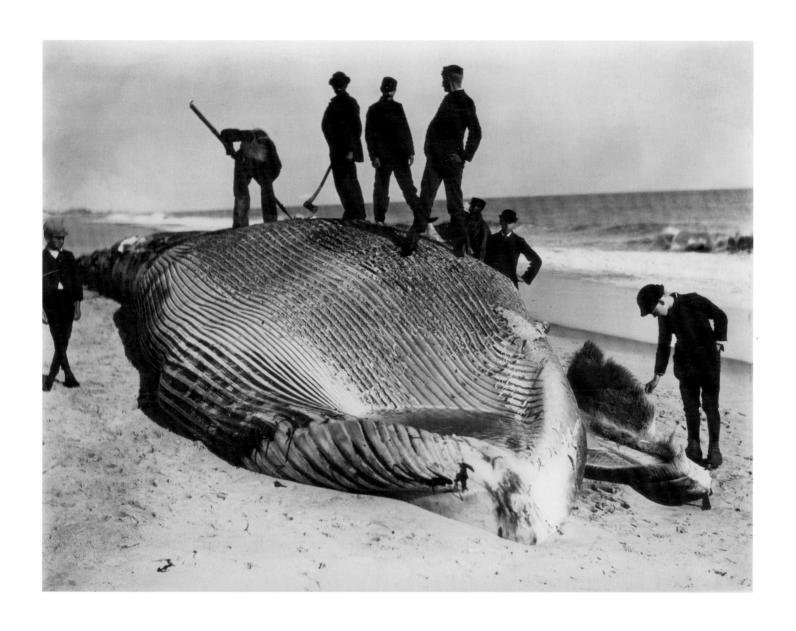

Beached whale, Atlantic Ocean shore between Sagaponack and Wainscott, photographed by William Wallace Tooker, ca. 1910. Courtesy of the East Hampton Historical Society.

\mathcal{S}omething lives inside of any deserted building, something which the past has left there, something made up of the lives, the acts, the events which in bygone days have been enacted there.

It is so with the old custom house. The walls are crumbling, the flagstaff is broken, its yard is choked with weeds. Many a year has passed and little stir or excitement has there been about the place save twice a day the joyous outburst consequent on the dismissal of an infant school kept within its walls. But the school is no longer there. It is a tomb. The old custom house stands and broods over the past, and the tombstones in the graveyard adjoining seem also to be thinking over events gone-by and every night, out of their graves arise a crowd of ghostly whaling captains. They enter that ghostly old custom house, they take out a lot of ghostly papers and a fleet of phantom ships are cleared by a ghostly collector—an old Federal collector, arrayed in last century costume, in small clothes, stockings, a queue, a cocked hat—courtly gentleman of the old school, who firmly believed in the divine right of the Federal party and would have detested a Jackson man as an English nobleman does a Radical.

But those times are all gone. The last vessel of our whale fishery is gone. We have no more oil, no more bone, no more money and we don't build any more churches and we don't fill those that are built and so the old arsenal stands brooding over the past.

—Prentice Mulford, "the arsenal's last days" (1875)

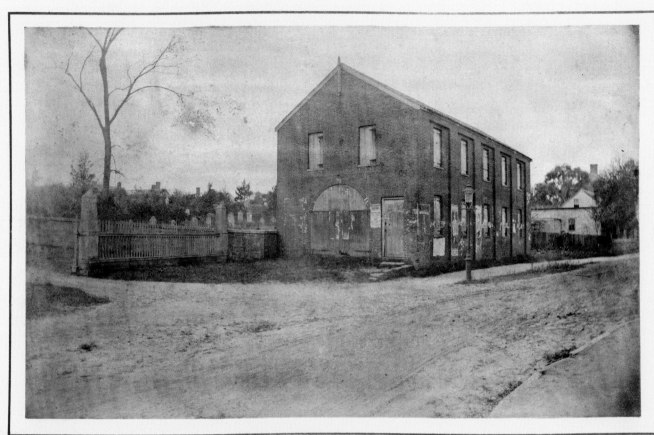

The Old Arsenal.
(Built. 1811)

The Old Arsenal, photographed by William Wallace Tooker, early 1880s.
Courtesy of the John Jermain Memorial Library, Sag Harbor.

*L*iving in Sag Harbor at the present time are a number of people who can truthfully say that they have been in the jaws of a whale and escaped unharmed to tell the tale. It occurred this way: In 1858 the schooner *S. S. Learned*, owned by H. & S. French, fitted out for a whaling cruise along the south shore of Long Island. A big whale was caught off Block Island, cut up and brought to Sag Harbor for trying out. The Captain towed in the whale's head, and it was set up on the beach near North Haven Bridge, with a chair in its extended jaws, in which many had the novel opportunity of seating themselves.

—Harry D. Sleight, *The Whale Fishery on Long Island* (1931)

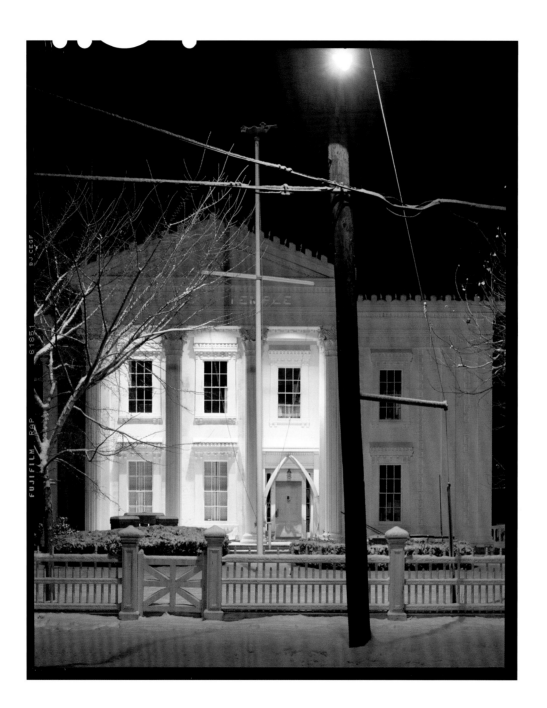

Capt. David Cory, board chairman, Sag Harbor Whaling and Historical Museum; elder, Old Whalers' Church (interviewed in 2005)

For a long time we didn't know what brought Minard Lafever here. He was a very prominent architect in New York, and we have no doubt he designed the Old Whalers' Church and the building that is now the Whaling Museum. He would have been expensive, but some people here had a lot of money. There was an old Sag Harbor family named Sleight. One of the Sleights became a printer and published one of Lafever's pattern books. Another Sleight was on the church's building committee, so that was probably the connection.

A fellow named Luther Cook was also on that committee. He was a whaleship owner who had an office on the waterfront. We suspect that the plans and documents for the church were in his keeping and were destroyed when the fire of 1845 burned most of the waterfront, including his office. So the only paper evidence we have of Minard Lafever's involvement is a letter that a carpenter who worked on the church wrote to his mother in 1843 mentioning that Lafever had been inspecting the site. This didn't surface until the early 1970s. (The letter, from Edward Merrall, is on page 263; a letter from Luther Cook is on page 257.)

The museum was built, we think in 1845, as a house for Cook's brother-in-law, the second Benjamin Huntting, a merchant who owned ships and other businesses, and it was the finest house in town. It cost $7,000, roughly a whaleship's gross income for a year. The capitals and columns, and those alcoves and niches you see all around, are close copies of those in Lafever's books. We have had a number of experts visit the museum, and all of them are certain that Lafever was the architect. But we have no documentary evidence.

The two buildings have a lot of similarity in style, down to the motif of blubber spades around the roofs. They were built when whaling was at its height and the village was expanding. The Presbyterians were certain their congregation would get bigger, and they built a church so large that, if you

pack people in six to a pew, you can seat 1,000. Comfortably it holds 800. But they were planning for a future that never happened. Five or six years after the church was built, whaling began to fail and the village got smaller. Later, when the factories were built, the immigrants who came to work in Sag Harbor were mostly Catholic and Jewish. Many of the larger houses became boarding houses for working fellows. The reason why so many of these buildings have been preserved was because they served a purpose in that industrial era.

Mrs. Russell Sage came to Sag Harbor in the 1890s, bought the John Jermain house on Main Street, her grandfather's old place, and restored it as a summer home. In 1907, a year after her husband died, she bought the Benjamin Huntting house across the street. Mrs. Sage was a very wealthy widow who did a lot for this village. The building that is now the Municipal Building was then the village school. When she was told that the state education department had condemned it for use as a school, she gave the money to build Pierson High School, which was begun the same year she bought the Huntting house. She went to its first graduation in the park and was horrified at the park's condition—it was a fair ground where they had a race track and baseball games. So she bought it and created Mashashimuet Park. She bought Otter Pond and added it to the park, and she built the John Jermain Memorial Library. And that's what the taxpayers would like now, to have another Mrs. Sage come by.

After she died in 1918, the local Freemasons bought the Huntting house from her estate and created a lodge room with a high ceiling upstairs. In 1936, they invited an early Sag Harbor Historical Society— no relation to the one down the street—to use the downstairs rooms for exhibits, and that grew into the Whaling Museum. The museum bought the property from the Masons in 1945, though the lodge still meets upstairs and it still says "Masonic Temple" on the front portico.

*M*ontauk Light could be seen from the top of the wedding-cake steeple of the Sag Harbor Presbyterian Church, they say, before the 1938 hurricane lifted Minard Lafever's ingenious concoction off the roof peak and smashed it down. The steeple, rising 187 feet above the ground, which is roughly fifty feet above sea level at that point, was built like a telescope, and each section, Greek, Roman, Chinese, Egyptian—Lafever was an architectural eclectic—was pulled up through the one below by block and falls, teams of oxen on the whip. The bell tolled as it fell.

—Everett T. Rattray, *The South Fork: The Land and the People of Eastern Long Island* (1979)

That steeple didn't fall off. It popped off. The pressure built up and it came out like a champagne cork. The big timbers were still there, and it's a shame they didn't restore it. They could've put it back up again. But then everyone started taking the pieces that fell on the street for souvenirs.

—Dominick Cilli, dairy farmer (interviewed in 1976)

"Our steeple wasn't blown down by accident. These people here had got so they were worshipping the steeple more than they did God. So He took it away."

—Donald Crawford, Minister, Old Whalers' Church, quoted in
The New Yorker (1949)

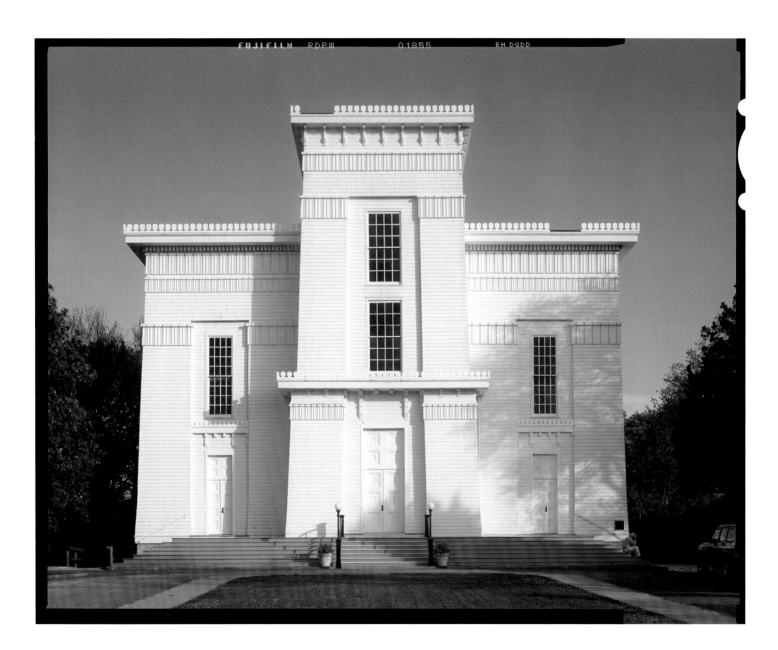

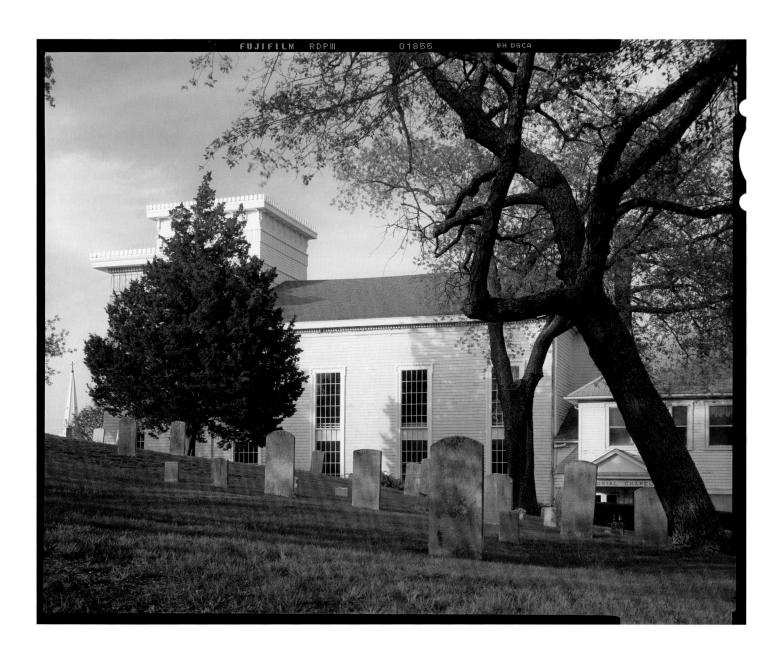

A brief pause ensued; the preacher slowly turned over the leaves of the Bible, and at last, folding his hand down upon the proper page, said: "Beloved shipmates, clinch the last verse of the first chapter of Jonah—'And God had prepared a great fish to swallow up Jonah.'"

"Shipmates, this book, containing only four chapters—four yarns—is one of the smallest strands in the mighty cable of the Scriptures. Yet what depths of the soul Jonah's deep sealine sound! What a pregnant lesson to us is this prophet! What a noble thing is that canticle in the fish's belly! How billow-like and boisterously grand! We feel the floods surging over us, we sound with him to the kelpy bottom of the waters; sea-weed and all the slime of the sea is about us! But *what* is this lesson that the book of Jonah teaches?

—HERMAN MELVILLE, *Moby-Dick; or, The Whale* (1851)

It was required by owners to lower for whales on Sunday. Captains with religious compunctions against whaling on the Sabbath have been deprived of ships after one voyage. Capt. Henry Huntting, of Bridgehampton, was such an one.

—HARRY D. SLEIGHT, *The Whale Fishery on Long Island* (1931)

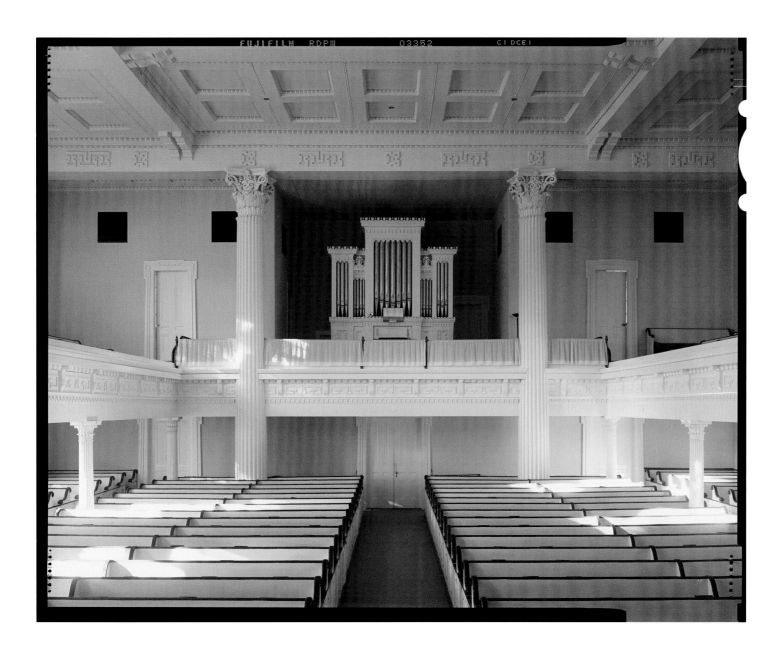

Throughout the whaling days and the factory days, there were people who came from elsewhere, and who soon became part of the village. It's very easy to belong here. That's not true in Southampton and East Hampton, where the wealthy families have more control. In Sag Harbor, there is no ruling class. That's why village meetings are so untidy. Nobody thinks anyone else is in charge.

The village hasn't changed as much as people think. In fact it has improved. When I bought a house here in 1976, Bulova was gradually shutting down and the historic district was being set up. The people of Sag Harbor deserve a lot of credit for creating the historic district. It saved the village.

—Capt. David Cory (interviewed in 2005)

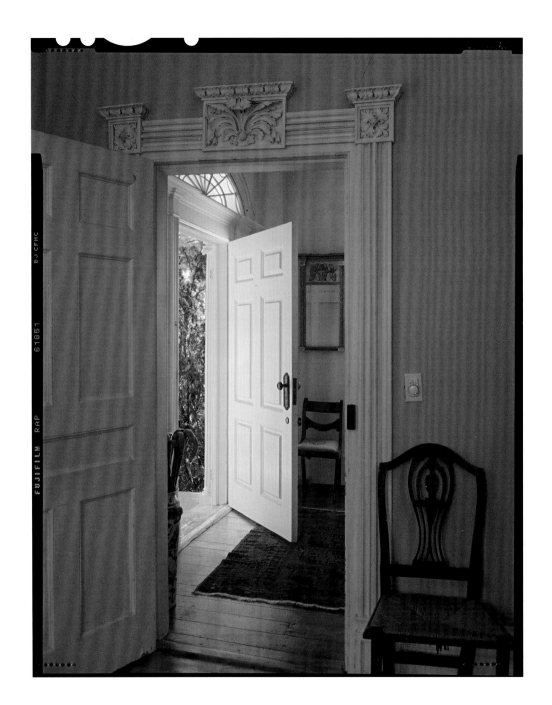

DOROTHY SHERRY, CO-CHAIR OF THE SAG HARBOR HISTORIC PRESERVATION COMMISSION IN THE EARLY 1970S (INTERVIEWED IN 2005)

I love this village. The first time I saw it, in the early sixties, it reminded me of small towns back in Iowa that time had gone by. It was almost like a Depression village. People came here in the summertime, but it didn't seem to have anything else going for it. It was a cheap place. You could rent a house for $50 a month. John read books for the Book-of-the-Month Club, and that paid $300 a month. There was also some income from his play writing. He could work from home, so we decided to try and settle here.

When we moved to Sag Harbor in 1964, several Time-Life writers had already fixed up old houses as summer homes. Fill Calhoun was the first of them to discover Sag Harbor, and others followed. (See his letter on page 272.) Back in the late forties, you could get an old house in need of work here for as little as $1,500. A lot of local people, when their parents died, sold their family homes and moved to new ones just outside the village. It was the summer people who bought these old houses and restored them.

By the time John and I bought our house, the price was $15,000. Even after we began living here full-time and sending our children to local schools, we were still considered summer people. And summer people were thought to be snobbish and to have a lot of money. Some of the villagers were very bigoted. It was a strange place, but I loved it. And, one-on-one, the local people were fine.

In the sixties, some fine buildings were demolished to make room for new schools. One old house was taken to East Hampton. People were saying how terrible it was that they were taking away our history. At the level of the federal government, Sag Harbor's historic district was formed in 1973. At first, the legislation did not have teeth. It was just a nice idea. Many people felt: "This is my home, and I'll do what I want." I think they were worried someone might tell them to mow their lawns and fix their fences.

It took people a long time to realize that preservation would improve their property values.

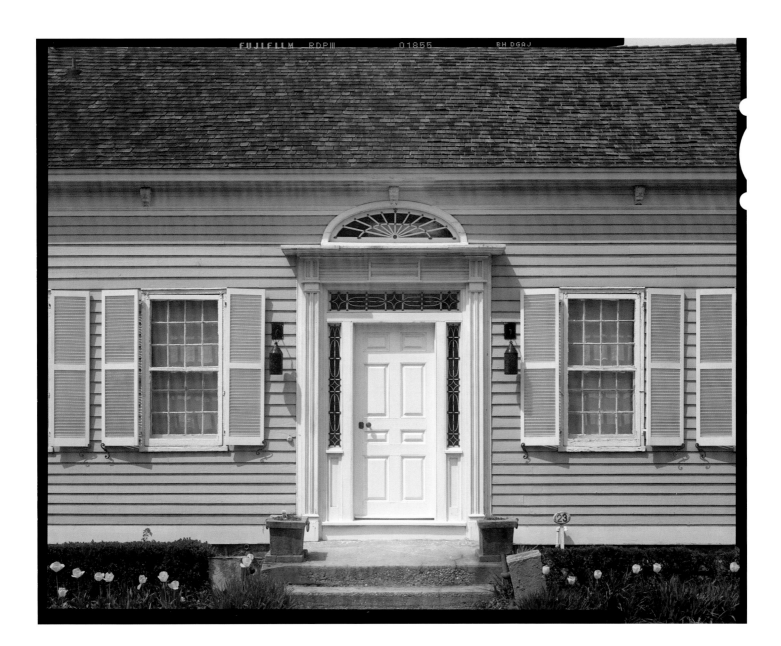

*O*ur town of New Baytown is a handsome town, an old town, one of the first clear and defined whole towns in America. Its first settlers and my ancestors, I believe, were sons of those restless, treacherous, quarrelsome, avaricious seafaring men who were a headache to Europe under Elizabeth, took the West Indies for their own under Cromwell, and came finally to roost on the northern coast, holding charters from the returned Charles Stuart. They successfully combined piracy and puritanism, which aren't so unalike when you come right down to it. Both had a strong dislike for opposition and both had a roving eye for other people's property.

—JOHN STEINBECK, *The Winter of Our Discontent* (1961)

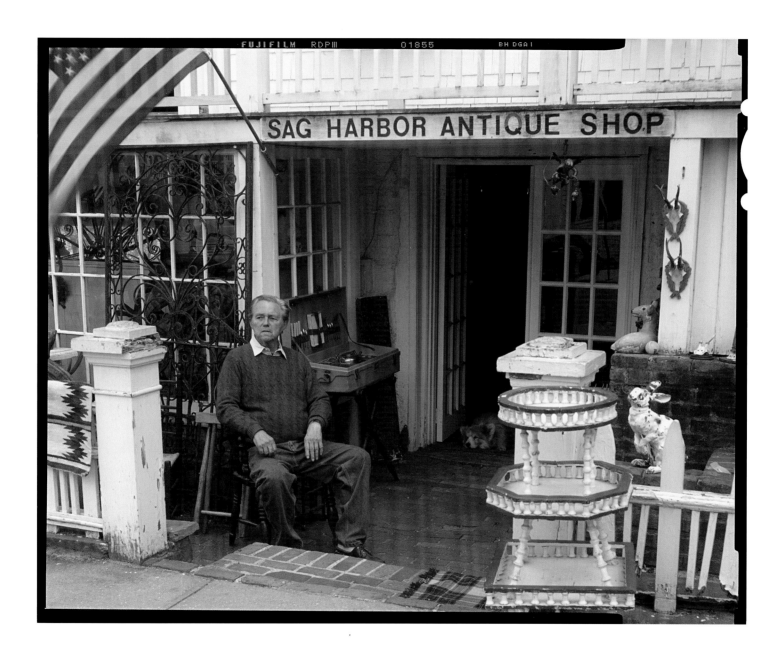

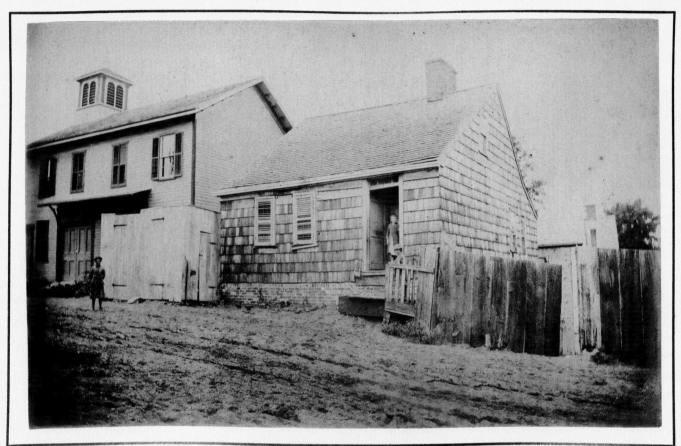

Old House. Church Street.
(Next Village Hall)

David Hand House, next to the old Village Hall, photographed by William Wallace Tooker, early 1880s.
Courtesy of the John Jermain Memorial Library, Sag Harbor.

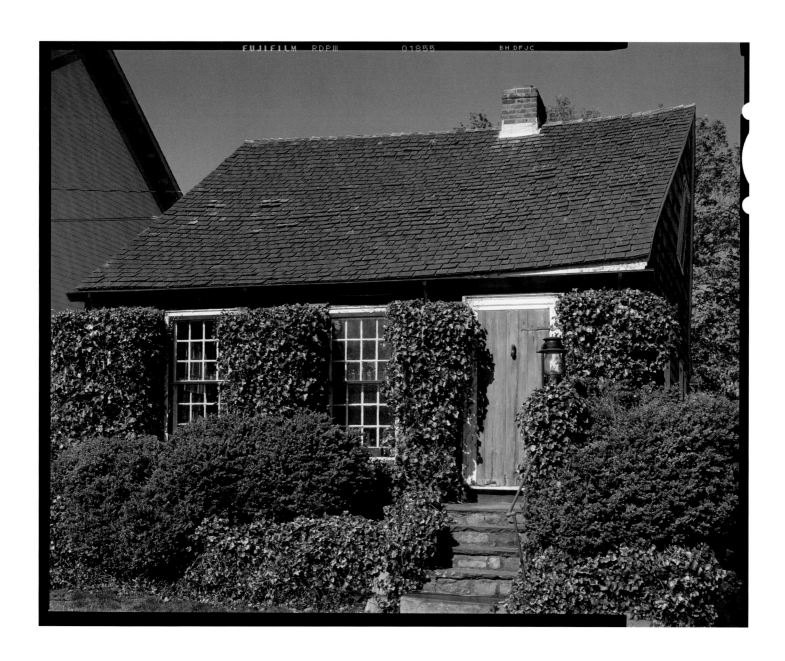

*T*here are still some family names in this area that go way back. My mother, whose maiden name was Annie Burnham Cooper, was from the tenth generation of Coopers dating back to John Cooper, who landed at Conscience Point in 1640. He came with a group from Massachusetts that sailed across Long Island Sound to found the first English colony in New York. This group was known as a commonalty, which is like a corporation, a community of people. My brother was fond of saying that John Cooper was their tavern keeper because he was permitted to buy and sell nine ankers of rum a year, or about a hogshead.

The family graveyard in Sag Harbor goes back to Caleb Cooper. Although he was a cooper by trade, he didn't just make barrels. I have his account book from 1770 to 1809, and it contains directions for making a plow and a whaleboat. It stops at the time of the Revolution, when the British were here from 1776 to 1783, and picks up again on the same page with not a word about the war. Most of the propertied townspeople went to Connecticut to avoid the war, and that's probably what he did.

When Caleb's son William came to Sag Harbor, he built a house, the big dark brown one next door, in 1814. The workshop that was in the back, Mother used to say, went back to 1797. It was taken down in my childhood, but I do remember its marvelous smell of fragrant wood. It was filled with all kinds of mementos, and when it came down in 1914 or 1916 my mother saved many of them. She carried in this old weather vane like it was a dead child. My mother's brother inherited that house and rented it out— he moved to California. The shop was taken down because it needed repairs, and he didn't want to spend the money. But it was where the two generations that followed Caleb, William and his son William H., made whaleboats, starting in 1814. I have their account books, too. I remember the stairway—it was so wooden and so worn—and so many things that were there. The tea kettle is the one over there, the leather buckets from the volunteer fire company, the bellows, the Revolutionary swords and guns. At the time I remember this, whaling had long since finished, and it was just a household place.

The shop was a sizeable building, two stories, with large windows down the side. I remember going in there with my big brother, Cooper Boyd, who was four years older than me. It was a great treat, and

it seemed quite wonderful. It must have been part of the rented property, so it wasn't really ours. But we treated that place as ours, and played there with the three Goldbeck children who lived in the Hannibal French house two doors down the street. The five of us were together most of the time.

This house where I live now was bought in 1870, but none of our family lived in it until 1906. I was four years old and my brother was eight, and from that time we spent every summer here. I have never missed a summer in my life. The rest of the year we lived in Brooklyn, and I went to Barnard, married a professor who was first at Dartmouth and then Minnesota. I got my divorce in 1954, came back to live in New York, and worked in the history department at the New York Academy of Medicine Library for ten years. I retired in 1967 and came back to live in Sag Harbor full-time. I think I was more faithful to this house than to my husband.

When we came out from Brooklyn in the spring after winters in the city, we brought with us our big black cat and four bicycles—Mama's and Papa's, Cooper's and mine. The house would have been closed up all winter and it smelled musty, being all wood, but it was delightful. The swings and the hammocks were here, and there would also be a boat. We would have Sunday dinner on the porch, and Mother would bring out hot corn from the kitchen. My father was in the Oriental rug business, and we would have rugs on the porch. Sag Harbor was a factory village, undiscovered by most New Yorkers, but those who had summer houses here always had friends from the city who would come down on the train and visit. It was a cross to bear.

My mother felt she belonged here, and she was so busy boating and doing all kinds of things with these fascinating Goldbecks, who had this wonderful house with the huge drawing room and the piano and the music and the balls. Those were pretty exciting summers. There was always some cause to raise money for, and we played at concerts. And there was church on Sunday.

At the end of the season, Mother went round on her bicycle and made duty calls on friends. She wanted us to know these wonderful people. They were usually leftovers from earlier families, the widows and the women who did not get married. They had their legacies and their traditions. They had inherited the houses, but they led a dull life. As a child, I inherited that feeling of being Annie's child, which bored other children no end, but some of the feeling rubbed off.

Then there were the visits to the cemeteries, which were rather nice, because we usually combined them with going into the woods at the back of Oakland Cemetery. There were wintergreen berries in the woods, and we would walk to a place where there was a spring. Cooper was a show-off and would get there first. I was afraid of being lost. There were these emotional feelings about the woods and some aura of feeling about ancestors who we were supposed to think highly of. And so I grew up with some understanding of Mother's feeling about Sag Harbor. She wanted to pass it on.

(A 1945 letter from Willey to Frank Lloyd Wright, explaining her early efforts to preserve Sag Harbor buildings, is on page 269.)

*T*here were many like Great-Aunt Deborah early in the last century, islands of curiosity and knowledge. Maybe it was being cut off from a world of peers that drove the few into books or perhaps it was the endless waiting, sometimes three years, sometimes forever, for the ships to come home, that pushed them into the kind of books that filled our attic. She was the greatest of great-aunts, a sibyl and a pythoness in one, said magic nonsense words to me, which kept their magic but not their nonsense when I tracked them down.

—John Steinbeck, *The Winter of Our Discontent* (1961)

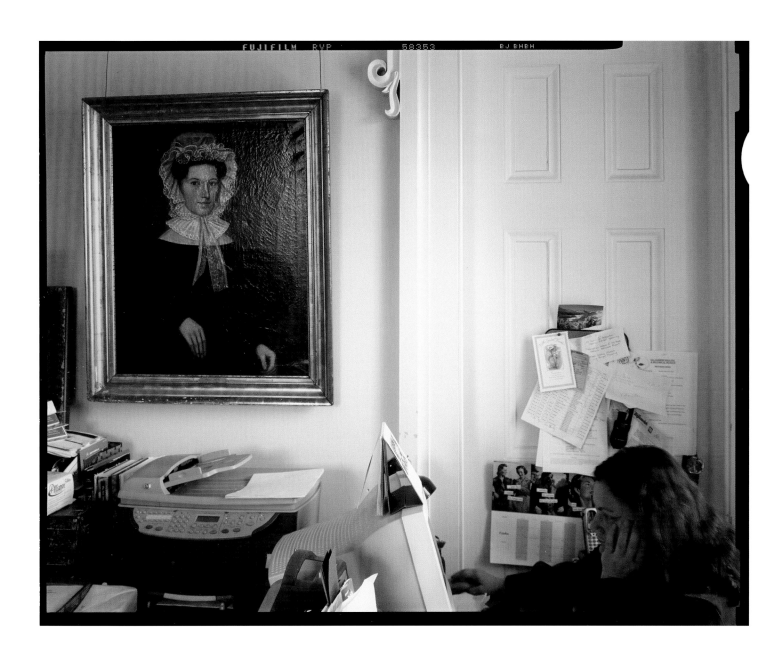

*S*ag Harbor, with its bulging oil cellars, was the Kuwait of its time, and the handful of whaling families, in their great houses along Main Street, were its sheiks.

—Jason Epstein, "Sag Harbor Tour," *East Hampton: A History and Guide* (1975)

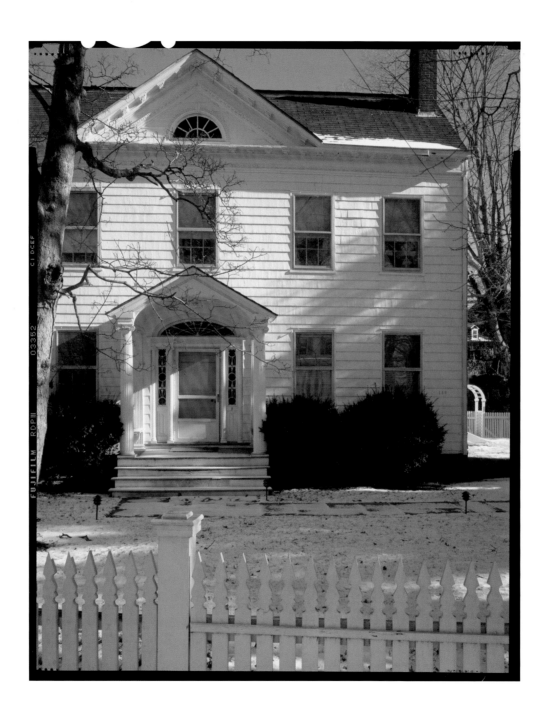

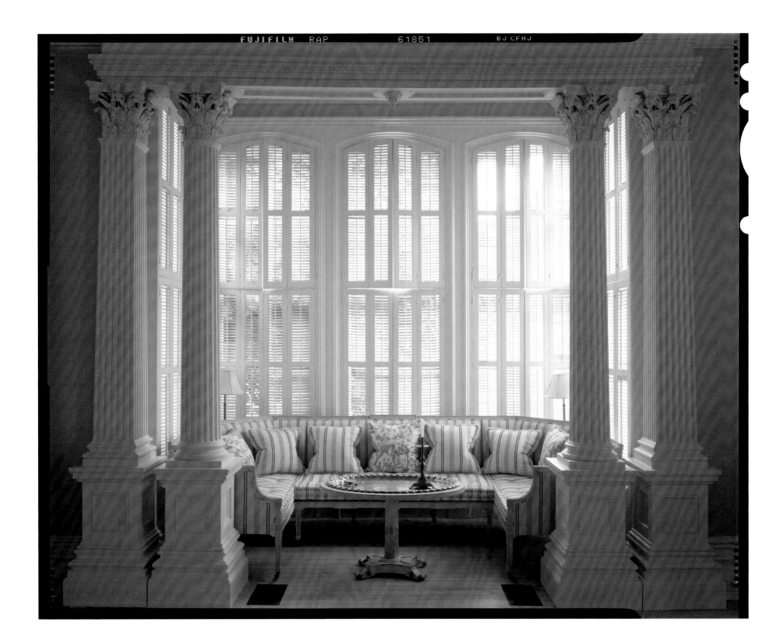

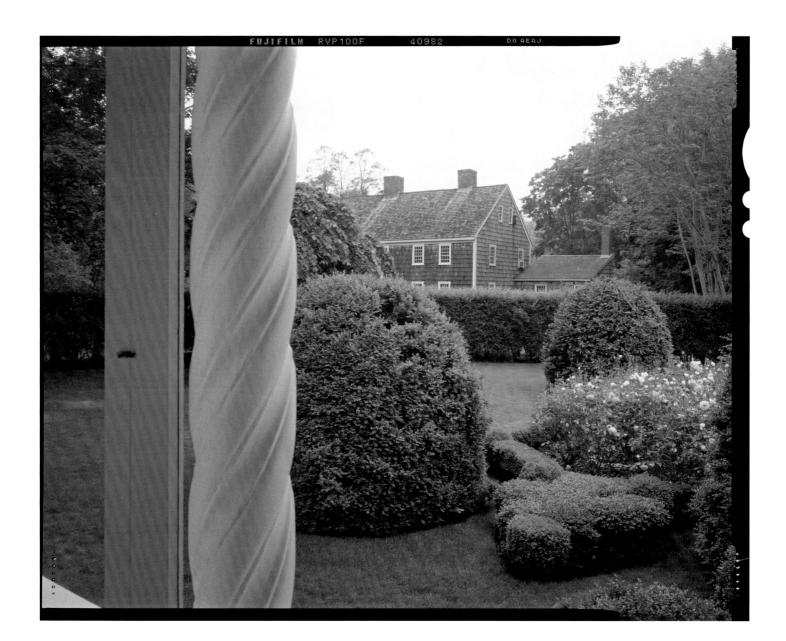

I am not an American Yankee from one of the old Sag Harbor families, but I have done as much as anyone to save this village. My parents came from Ireland, but I am all American. I was born in this country on July the fourth, so they named me Josephine Independence O'Halloran. You know what they say about the Irish: a nation of scholars and poets. That's good enough for me. I think you have to love where you live. The Irish love the land and their homes more than anything. My husband was a Bassett from Amagansett. We settled in Sag Harbor, and I have thought of this as my village ever since.

Way back in the 1930s , when times got bad, some beautiful houses were knocked down. Now they realize they could have cleaned them up and made homes out of them. So, in 1944, some of us ladies got together—Mrs. Willey was one—and talked about what we might do to preserve what was left. That's how the Old Sagg-Harbour Committee started, out of the blue sky without ten cents.

The person who helped us most in those early days was Henry Triglar Weeks, an architect from Bayside who came here to retire. He was a gem. He really cared about historic preservation and tried to make Sag Harbor realize what it had. When the Presbyterian church steeple fell over in the 1938 hurricane, Mr. Weeks got a man out from the Rockefeller Foundation to see if it could be saved, but the church Session didn't think the money could be raised. He wanted the wood saved for restoration, but they wanted it taken away. The Rockefeller man turned on his heel and never came back.

I walked round one day with Mr. Weeks to where the old Custom House was, on the parking lot behind St. Andrew's Church, and he said to me, "Jo-Jo, some day I will get this house and restore it." But he never lived to see it happen. He died in 1947, and our committee did not get possession of the house until 1948. Nobody seemed to realize how important that building was, and the church had no use for it.

Father Zebrowski said, "Mrs. Bassett, you can have this house, but take it off this land." It had been a boarding house for many years, then the church tried to use it for children, but the floors were so weak, and they just wanted it out of the way.

By then, the former Governor of New Jersey, Charles Edison, had restored the Hannibal French house on Main Street. He understood what we were trying to do, and he offered to let us put the Custom House on his lot and to pay the moving expenses. We ladies took on the project and hung on by our fingernails until it was done. We were told not to touch the cellar, and it was the most marvelous cellar, with this part for hams, this part for vegetables, this part for milk. But it would have been a huge job to do the excavation, and already it was costing Governor Edison $7,000 just to move the house, so we had to leave the foundations behind.

The day we opened the house to the public in 1948, one of my members, Mrs. Florence Schoenbern, sat there among the cobwebs and showed a room at a time. She liked doing this so much she didn't mind the cobwebs, and some of them were hanging from her head. Several other ladies had joined our committee by then. We were the house's custodians, and we furnished it with donations from families in the village. We decided to have village house tours to raise money to restore and maintain the house, and we ran those tours every summer to 1975. I had charge of them and, in 1971, I said, "Let's try a winter tour as well." That brought in 750 people from as far as Pittsburgh, Philadelphia, Trenton, and upper New York State. It was the most gorgeous moonlight night. I still remember that one as the tour of tours. We have shown sixty-five houses in this village and but a very few twice. In 1966, we decided to give the Custom House to the Society for the Preservation of Long Island Antiquities. By then, we were all a lot older, one of our members had died, and we were tired.

The Old Sagg-Harbour Committee did a lot for this village over thirty years. We were responsible for a lot of people buying old houses and restoring them. Some have done a beautiful job. Back then you could buy a house for $15,000. Now you couldn't get one for $70,000. But it was a long time before the village board or the local merchants showed much interest in the Custom House, before they realized what a treasure it was and how important it had been to save it. It had been the home of Henry Packer Dering, who in 1791 was appointed by George Washington as the collector of taxes at the port of Sag Harbor. I would like to have lived at that time. Or maybe a little later, around 1845. I do not like this era.

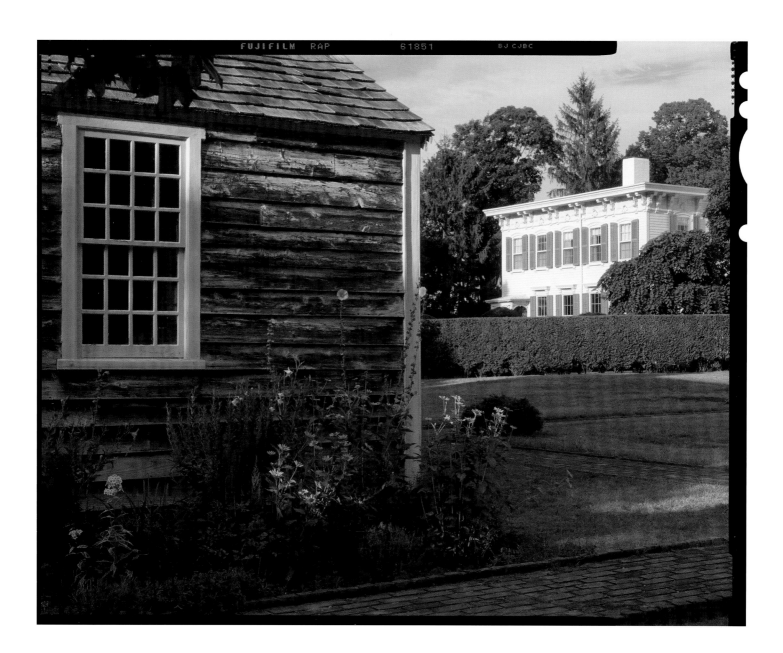

*T*here are two factions in the village. One is opposed to the promotion of new industries and the consequent coming in of new people. It objects to any enterprise that may take away the old conservative character of the village, being content to live in the traditions of the past. The other faction favors new industries and new business, and welcomes the stranger and tries to co-operate with the larger social and religious plans of the village, fully realizing that the coming of the newer element is unavoidable with the growth of the community.

—Department of Church and Labor, Board of Home Missions,
 Presbyterian Church in the U.S.A., *The Sag Harbor Survey* (1911)

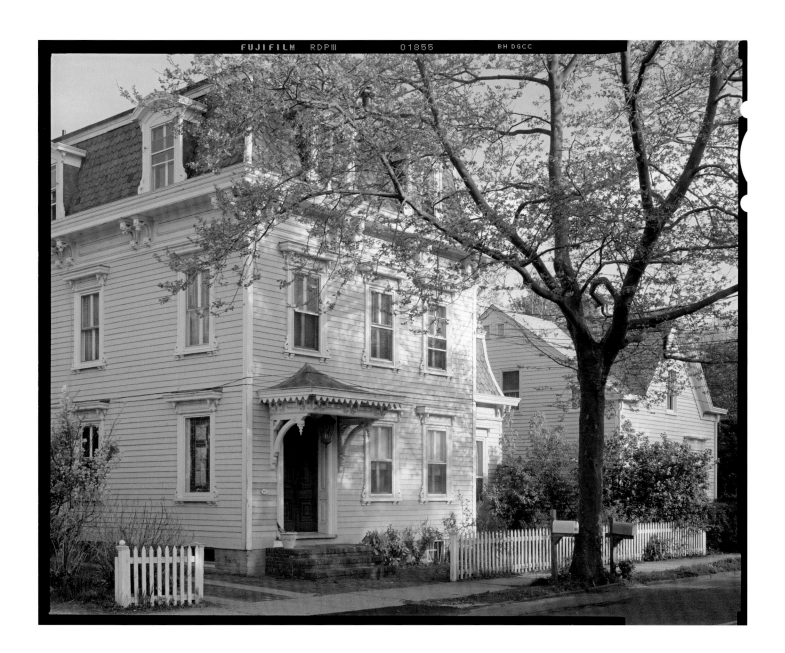

Dorothy Ingersoll Zaykowski, historian; administrator and trustee, sag habor historical society (interviewed in 2005)

I did not grow up with a sense of history. It was my worst subject in school. I didn't acquire a taste for history, especially local history, until my kids were grown. Then, in 1978, I started working in the John Jermain library, and they asked me if I would be interested in organizing the local history department. I said yes. The room was utter chaos. It had been years since anyone took charge of the collection, and I don't think anyone had ever sorted the books and papers and records into categories. Dorothy King, who worked in the history department at the East Hampton Library, was hired for one winter to show me how to do this. At that time, a lot of new material had been given to the library by Nancy Willey, so we worked on that and I got fascinated. I got into genealogy and into my own family history. It became an obsession, and I was there for eighteen years.

There was so much to sort and file. There were handwritten records from the whaling days. In the basement, we had local newspapers that went back to the 1790s. There were scrapbooks of clippings, some of them made out of existing books and pasted over the printed pages. I was fascinated, tracing all this local history. I took down every note on the streets and buildings, the fire department and schools, and sorted them into folders. My first thought was to gather as much material on a specific subject as I could. People would come into the library for information on, say, the Napier house, and, instead of having to sort through masses of stuff, I would have it assembled into one file.

While I was working at the library, I started writing articles on local history for The Sag Harbor Express. *I didn't write under my own name, just the initials D.D., which didn't have any special meaning. For some reason, I don't know why, I didn't want it known that I was the one who wrote those articles. I did the research for them over about eight years, then I did some more research and put it all together in a book,* Sag Harbor: The Story of an American Beauty. *It was published in 1991 and is just going into its fourth printing. I think people find it useful.*

One thing I find fascinating about this village, having traveled to other historic places and seen their restored buildings—places like Williamsburg and Old Bethpage Village and Deerfield—is that most of them don't have half the old houses that we have in Sag Harbor, still on their original sites. And here we have so many.

There are a lot of people into preserving what's here, making sure that wrong decisions aren't made. I see that from people who move to the village. Some of them are very concerned to make their restorations as authentic as possible, and take pride in doing the job right. I think that, if they had not come, we would have a lot of derelict homes in Sag Harbor. Many of the people who grew up here and who are getting old here don't have the financial means to fix their places. But those who are buying second homes, they're wealthy—they have to be.

There was an African-American woman who bought the Cooper house next to the historical society. She came to us asking for early photos of the place, and I found her a lot of them. She seemed very anxious to restore the house to the way it used to look. But, after a year, she sold it and now someone else is working on it. With property prices going up all the time, these things happen.

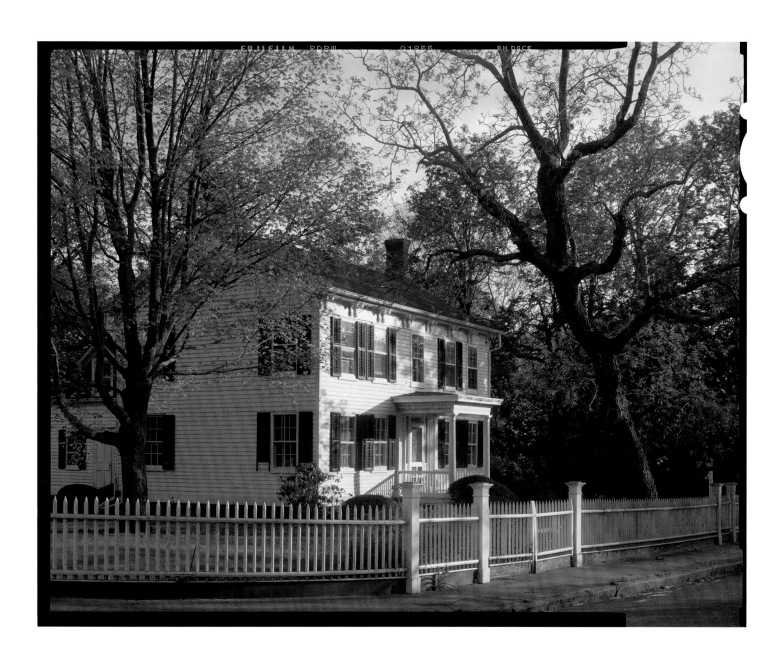

JEFF ANDERSON, CARPENTER (INTERVIEWED IN 2006)

*M*y *grandmother, Anita Anderson, was born in this house in 1904 and died here at 100. Her funeral service was held in the front parlor, as it was for her mother and grandparents, and it was an especially sad time because we all knew that her home would have to be sold to pay taxes. It had been in our family since 1882, bought by my grandmother's grandmother, Frances Lewis Miles. Her husband, Dr. Edgar Miles, practiced herbal medicine in Sag Harbor for more than fifty years. His portrait hung over the mantel in that same room from which he and my grandmother were buried.*

Part of the house goes back to the late 1700s. Nobody knows the exact date, but the framework was post-and-beam construction. In its early years, it was owned by the Beebe family and known as "the flag on the mill house" because of a windmill that stood on a hill in the back (pages 60 and 207). There was even more land surrounding it in those days—back then people owned acres of property—and, every time a whaling ship came into town, a flag would be raised on the mill. As far as we can trace, the house went from the Beebes to a Major Bellows, whose wife later sold it to Dr. Miles. We still have the original deed.

After my grandmother died, there was no way that anyone in the family could have afforded to keep it. We were faced with estate taxes, capital gains taxes, the task of upgrading the electrical work and the plumbing, and a lot of fixing-up. You would have had to take out a mortgage to get the work done, and then to be very wealthy to pay the upkeep of a house like this. My grandmother lived on a fixed income, and, while she was able to manage, she became afraid to spend money on the house. In her nineties, she was still remembering a time when workmen got twenty-five cents an hour, and being faced with paying $50,000 to have the place painted was more than she could think about. But she kept it intact, and it served her purpose. Towards the end of her life, when she was no longer able to get upstairs, she lived very simply in two rooms. If the property had been put in a trust or sold to a family member thirty years ago, it might have been possible to save it. But, back then, nobody knew what real estate would be worth.

This increase in property values has been a double-edged sword. Sag Harbor is losing its quaintness, but the money that wealthy people are bringing in provides work. Although a lot of local people cannot afford what they grew up with and feel invaded, these same factors are paying their mortgages and putting food on the table. As a man in my thirties who had to move away from Sag Harbor, I have a struggle to pay for my quarter of an acre of property and my thrown-together house farther up the island. But you have to go with what you have and make the best of it.

My grandmother lived a very privileged life here. She never had to work, traveled the world, had a husband who doted on her and a family who took care of her after my grandfather died in 1984. She had an iron will, never gave up, drove a car until she was about ninety, and kept her home the way it had been most of her life. Sag Harbor was not prosperous when she grew up here. It was a factory village, but most of these larger old houses had already been built on whale oil. In this one, you can see the changes and additions that were made over the years. Even in my grandmother's childhood, there would have been no electricity or indoor plumbing. This was a very rural area.

Of the people in my family, I had the most attachment to her house. When I was young, I loved going through all the old items in it. So many of them had been passed down from earlier generations that it was like growing up in a family museum. My grandmother encouraged me to go into drawers, seek things out, and ask questions.

We saved a lot of old things: furniture, photographs, letters, anything we felt important to us. I am living with some pieces of my grandmother's house in my 500-square-foot bungalow, and my parents are living with others. We have two items that have been in the family for 300 years, which came on the boat from England: a wooden bowl and a wood and glass salt and pepper set. We have a pewter collection, some old glassware, and other assorted items. It has not all gone.

Parting with some of the other things was hard, but you have to face reality. When my grandmother passed away, something was taken from this house, and, after that, it could never be the same for me. Of course, I'll miss the familiarity of walking into the rooms, seeing things I grew up with, and the family gatherings at Christmas. But I am happy that the new owners are willing to spend time and money to take care of this place, even if that means rebuilding it. In the end, the only things you can keep in this world are memories.

*U*sually we sat five at table: My Uncle Edward, Aunt Ida—she was gregarious, head of every society worth mentioning—my mother, father and me. He was a chaser at Alvin Silver Company in the Bulova Building. They made silver teapots, loving cups, mirrors, and worked a six-and-a-half-day week. He always walked home for lunch, the main meal of the day. First he read the Bible then we ate: a roast, calves liver, bay scallops, two vegetables and potatoes. The butcher delivered every day and left the order on the kitchen table. No liquor ever in our house, but we drank wine. Didn't like beer and brushed our teeth with bottled water.

My uncle would go down street and pick out roses. He cooked roasted fowls. The ducks came by ice on the train. The fish man came around Sag Harbor in a pony cart. A washer lady came with her little red wagon. Everyone walked in those days. My mother did the ironing—heated a flat iron on the stove.

The seamstress, Hazel Wallace, came for the day with her *Vogue* pattern book. I never liked dolls but we cut paper dolls out of those old books. We had the first vacuum cleaner, an Electrolux. My mother never touched it; she was not mechanically minded, nor was Aunt Ida. At night we played cards, Old Maid, Parcheesi, cribbage.

—ANITA ANDERSON, INTERVIEWED BY PRISCILLA DUNHILL, *The Sag Harbor Express* (2005)

Stacy Pennebaker, associate real estate broker (interviewed in 2006)

What many buyers today will do with an old house like this is gut it, then renovate it. That means rearranging almost everything: opening up the space and updating the plumbing and wiring, the heating and cooling, while trying to preserve many of the original details. Sometimes, features that have been hidden for years are uncovered in the process.

Here in the Anderson house, part of the second floor has been taken down to eliminate those tiny back bedrooms with sloping ceilings and to give the kitchen a high peaked ceiling going right up to the roof. The dining room fireplace will be moved, so people can see it as they walk in the front door. A modern wing will be enlarged to give the owner more house, making room for a master suite upstairs. Wherever possible, the original moldings, doors, and windows will be reinstalled. I don't see a problem with the juxtaposition of old and new. Opening up this house will be a huge relief, and it will look really nice.

There will be little change to the front of the house, as it's seen from the street, because this is in the historic district and the architecture has to be preserved. When new windows are needed, the architectural review board likes people to use old-fashioned ones: six-over-six or nine-over-six. You used to be allowed to use the kind with false dividers between the panes, but now there is more authenticity in the building trades, and they make old-fashioned windows. But under Sag Harbor's present law, you can do almost anything inside the house and take down practically every bush and tree in the yard.

People who buy houses like this want a historic exterior, but inside most want an open design and a huge kitchen. They want to be able to talk to one another through the rooms, to move freely from one area to another. The way the Anderson house was built in the 1800s, conversations were confined to restricted spaces. That isn't what today's buyers seem to want. What used to be three rooms in an old house might become one huge kitchen with a fireplace, a large dining area, plenty of room to sit around, and access to a little courtyard or porch. Many people might spend their entire day in such an area.

A lot of people fix up these old Sag Harbor houses so they can come here for a couple of weekends a month and maybe a few weeks' vacation a year, then rent them in the summer to pay the expenses. With property prices going up, there's a whole new category of summer people who would rather rent than buy. When you do the math, it's often cheaper. A good summer rental might be a historic house with a pool in the main part of the village, renovated with a wide open feel so that the definition between rooms is no longer there, and decorated in neutral colors. The kitchen is very important. So are the size and number of the bathrooms. You'd never find a historic house built like that. In the 1800s, a family of six might have one bathroom, inside or out.

Other people redo these old houses with every intention of reselling them within a year or two, hoping to make a big profit. Some of these real estate investors may own several houses at once. For many, it's a better investment than the stock market. Perhaps ten of the houses sold in the village in a year will be redone and back on the market in another year or two. In the fifteen years I've been in this business in Sag Harbor, the buying and selling of houses has become a commodities market. It's no longer about people seeking primary homes.

BOB WEINSTEIN, ADVERTISING EXECUTIVE (INTERVIEWED IN 2006)

*I*t is our intention to keep the house looking much the same from the outside. We also understand that it has changed many, many times over 200 years. You can see what has been added on and what has been changed. We are not doing a historical restoration, but we are trying, with great respect, to create a house that we can live in and enjoy, that is open and filled with light, and as energy-efficient as possible. We will restore the old pumpkin pine floors that we have uncovered, but we will not furnish the house with antiques. We will probably furnish it with eclectic, mid-century modern. Eric and I have a loft in the city decorated in that style that has been photographed for a couple of design magazines. I think the same approach will work beautifully in this historic home. We have an irreplaceable situation here, with the property and the house. We will do everything we can to stay. It is a place we both hope to enjoy for the next thirty or forty years. We are not considering this a restoration, but a revitalization.

"Will the clerk resume the reading of the minutes," said the mayor.

"…and she stated that the Mortimer house is one of the largest and finest Greek Revival structures remaining in the village and it would be a shame to lose it," the clerk intoned. "Mr. Porter on behalf of the Conservation and Planning Alliance provided the Board with photographs of the Mortimer house and stated it is a treasure which must not be sacrificed to commercial interests. Mrs. Bunshaft stated that the people who support this condemnation are all artists and aesthetic types who do not have to work for a living. As a business woman and a taxpayer she pointed out that it hurts the rest of us to have prime business property taken off the tax rolls and if the village went around condemning everything she would be out of business as a realtor.

"Mr. Bundy agreed and stated that historians do not use his marina but yachtsmen do eat hamburgers," the clerk chanted. "Mr. Merriweather stated that he was a realtor like Mrs. Bunshaft but realtors should be conservationists too or what will be left to attract buyers here? Officer Baker declared that it will be a good thing for the police officers to have a place to get hot food and milkshakes on the graveyard shift. Mr. Snibb stated that what the village is talking about is nothing but arbitrary and capricious confiscation without constitutional basis and his client will not stand idly by if this goes through. Mrs. Grisbie stated that if you lived in that house you'd want to tear it down too. Mrs. Grampus indicated that she was all for historic preservation but not if it cost money."

—Val Schaffner, "The Whaler's Gift" (2003)

*T*he landmark buildings of Sag Harbor represent all periods of the village's history. But the truly outstanding feature of Sag Harbor architecture is that the buildings between the landmarks are landmarks themselves, authentically portraying the era in which they were built.

—SUFFOLK COUNTY PLANNING DEPARTMENT, *Sag Harbor Study and Plan* (1971)

I have a steel engraving of the Old Harbor chockablock with ships, and some faded photographs on tin, but I don't really need them. I know the harbor and I know the ships. Grandfather rebuilt it for me with his stick made from a narwhal's horn and he drilled me in the nomenclature, rapping out the terms with his stick against a tide-bared stump of a pile of what was once the Hawley dock, a fierce old man with a white whisker fringe. I loved him so much I ached from it.

"All right," he'd say, in a voice that needed no megaphone from the bridge, "sing out the full rig, and sing it loud. I hate whispering."

And I would sing out, and he'd whack the pile with his narwhal stick at every beat. "Flying jib," I'd sing (whack), "outer jib" (whack), "inner jib, jib" (whack! whack!).

"Sing out! You're whispering."

"Fore skys'l, fore royal, fore topgal'n't s'l, fore upper tops'l, fore lower tops'l, fores'l"—and every one a whack.

"Main! Sing out."

"Main skys'l"—whack.

But sometimes, as he got older, he would tire. "Belay the main," he would shout. "Get to the mizzen. Sing out now."

"Aye, sir. Mizzen skys'l, mizzen royal, mizzen t'gal'n't, mizzen upper tops'l, mizzen lower tops'l, crossjack—"

"And?"

"Spanker."

"How rigged?"

"Boom and gaff, sir."

Whack—whack—whack—narwhal stick against the waterlogged pile.

As his hearing got fuzzier, he accused more and more people of whispering. "If a thing's true, or even if it ain't true and you mean it, sing out," he would cry.

Old Cap'n's ears may have gone wonky toward the end of his life, but not his memory. He could recite you the tonnage and career of every ship, it seemed like, that ever sailed out of the Bay, and what she brought back and how it was divided, and the odd thing was that the great whaling days were nearly over before he was master. Kerosene he called "skunk oil," and kerosene lamps were "stinkpots." By the time electric lights came, he didn't care much or maybe was content just to remember. His death didn't shock me. The old man had drilled me in his death as he had in ships. I knew what to do, inside myself and out.

—John Steinbeck, *The Winter of Our Discontent* (1961)

*T*he losses and sacrifices incurred in the whaling industry can scarcely be comprehended, nor the wide world cruising that is involved. These North Pacific grounds extend from North America to Asia and to Alaska and the Bering Sea. In the summer of 1844 there are more than five hundred ships cruising over these grounds and more than one thousand men killed, to say nothing of the wounded.

What a thought for contemplation is this, that a thousand men are lost in one season, sinking away upon an instant into the depths below and ships constantly sailing over them.

—Erastus Bill, *Citizen: An American Boy's Early Manhood Aboard a Sag Harbor Whale-Ship Chasing Delirium and Death Around the World, 1843–1849, Being the Story of Erastus Bill who Lived to Tell It* (1978; written in the 1840s)

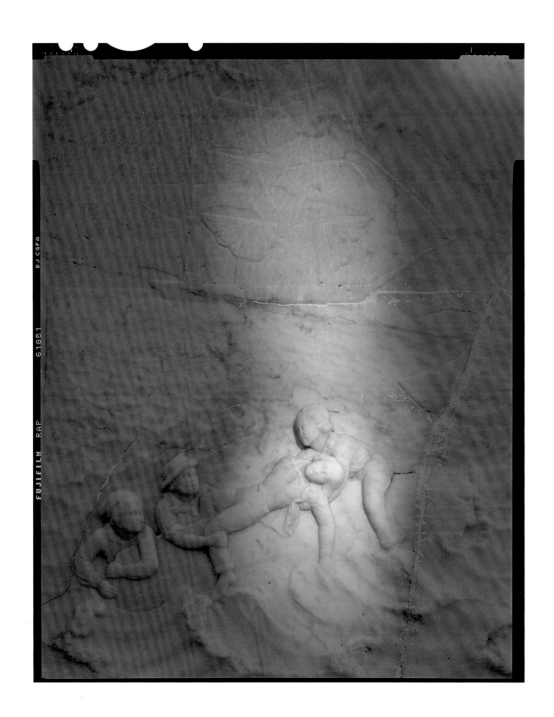

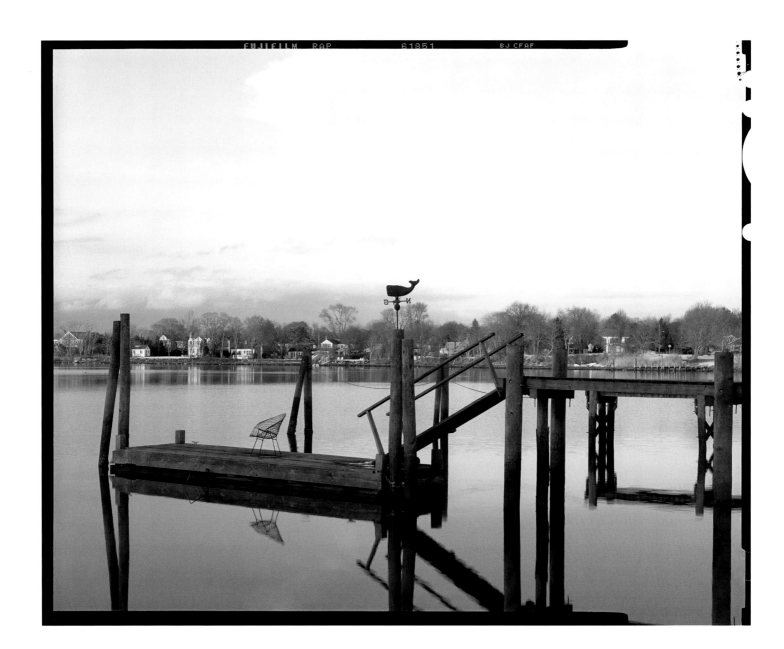

The calm of the morning reminds me of a scene which I forgot to describe at the time of its occurrence, but which I remember from its being the first time that I had heard the near breathing of whales. It was on the night that we passed between the Falkland Islands and Staten Land. We had the watch from twelve to four, and coming upon deck, found the little brig lying perfectly still, surrounded by a thick fog, and the sea as smooth as though oil had been poured upon it; yet now and then a long, low swell rolling under its surface, slightly lifting the vessel, but without breaking the glassy smoothness of the water. We were surrounded far and near by shoals of sluggish whales and grampuses, which the fog prevented our seeing, rising slowly to the surface, or perhaps lying out at length, heaving out those peculiar lazy, deep, and long-drawn breathings which give such an impression of supineness and strength. Some of the watch were asleep, and the others were perfectly still, so that there was nothing to break the illusion, and I stood leaning over the bulwarks, listening to the slow breathings of the mighty creatures—now one breaking the water just alongside, whose black body I almost fancied that I could see through the fog; and again another, which I could just hear in the distance—until the low and regular swell seemed like the heaving of the ocean's mighty bosom to the sound of its heavy and long-drawn respirations.

—RICHARD HENRY DANA, JR., *Two Years Before the Mast* (1840)

The whales were so ruthlessly hunted they became shy and wary and more and more difficult to take, necessitating going farther and farther to sea after them as they were driven off the coast.

—HARRY D. SLEIGHT, *The Whale Fishery on Long Island* (1931)

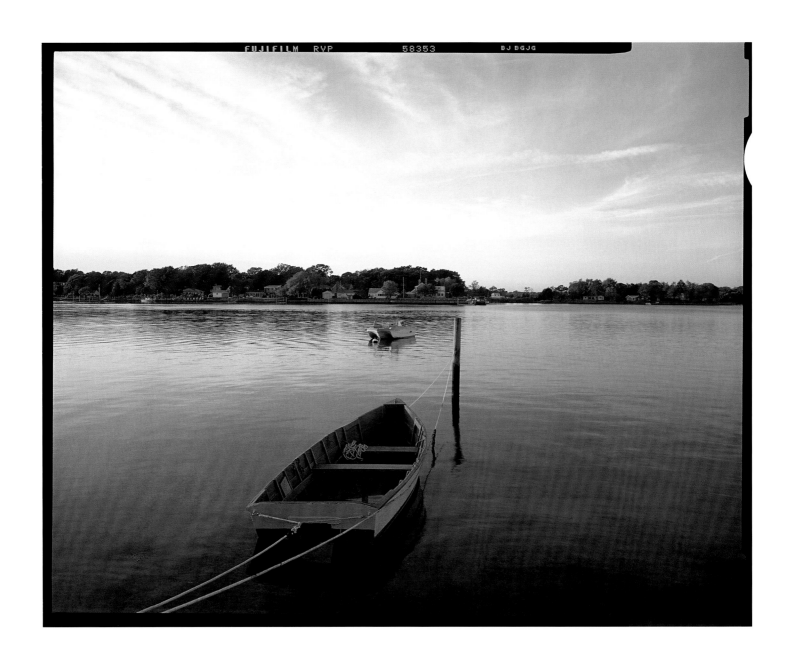

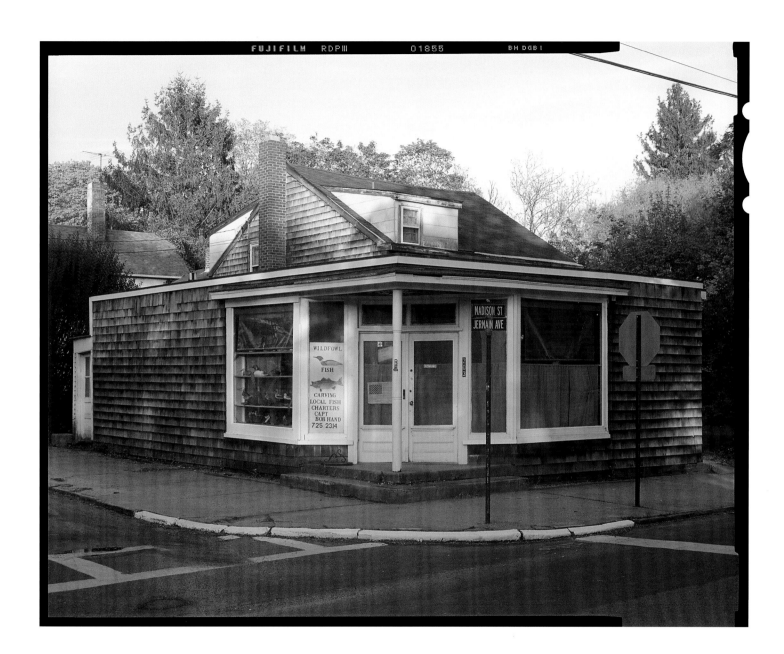

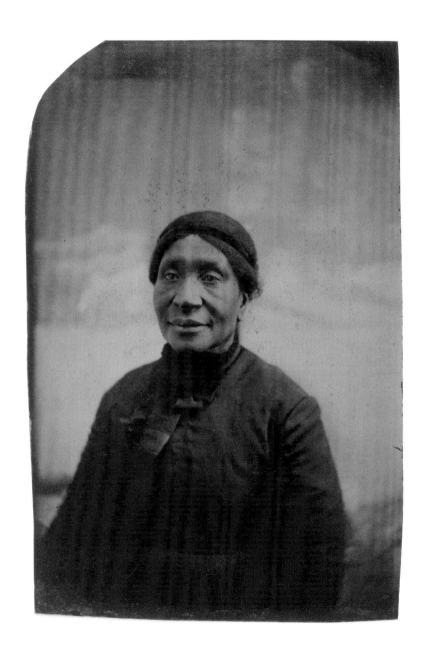

Hand-colored tintype found in a photo album on the property shown opposite, possibly Mary Jane Hempstead, ca. 1900, photographer unknown. Courtesy of the Eastville Community Historical Society, Sag Harbor.

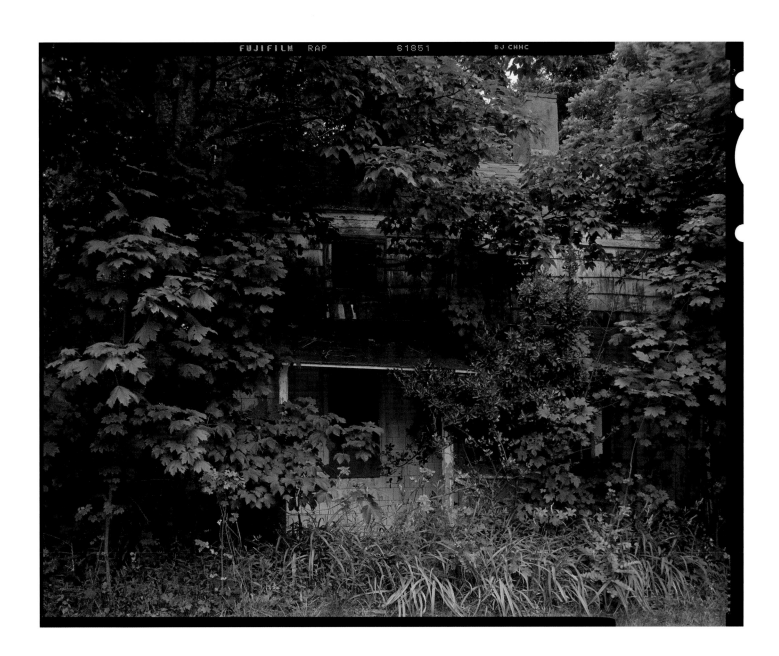

*A*new era also dawned upon Sag Harbor, but on entirely different lines of wealth and beauty. It began a new existence, became the home of luxury and culture; magnificent residences now adorn its streets and avenues; the sand hills of its suburbs have been converted into boulevards; every variety of merchandise may now be procured in its bazaars. Its harbor and bay, once filled with whaling ships, are now filled with yachts and motor boats, and altogether, there is no more charming spot for summer residence, or for the permanent home of the man of leisure and retirement than Sag Harbor.

—Daniel M. Tredwell, *Personal Reminiscences of Men and Things on Long Island, part one* (1912; written in 1880)

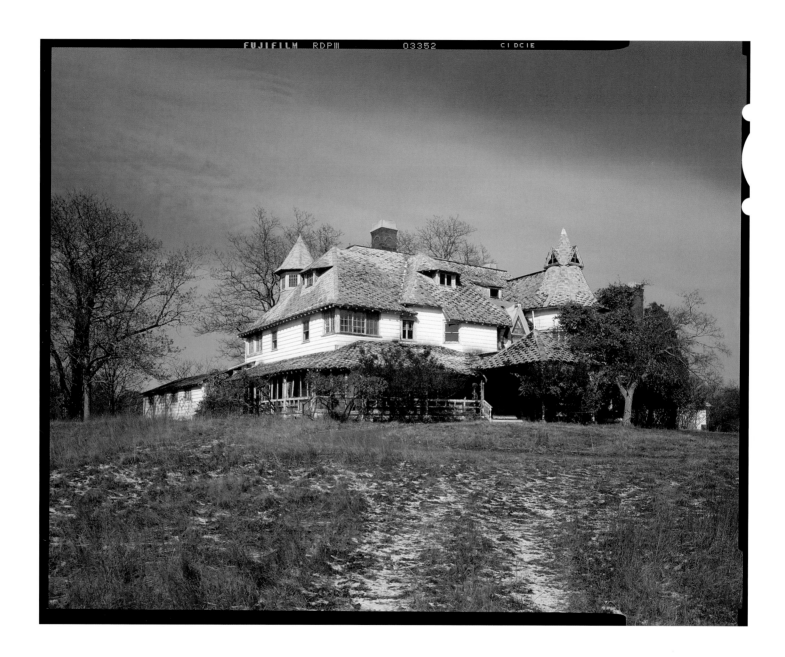

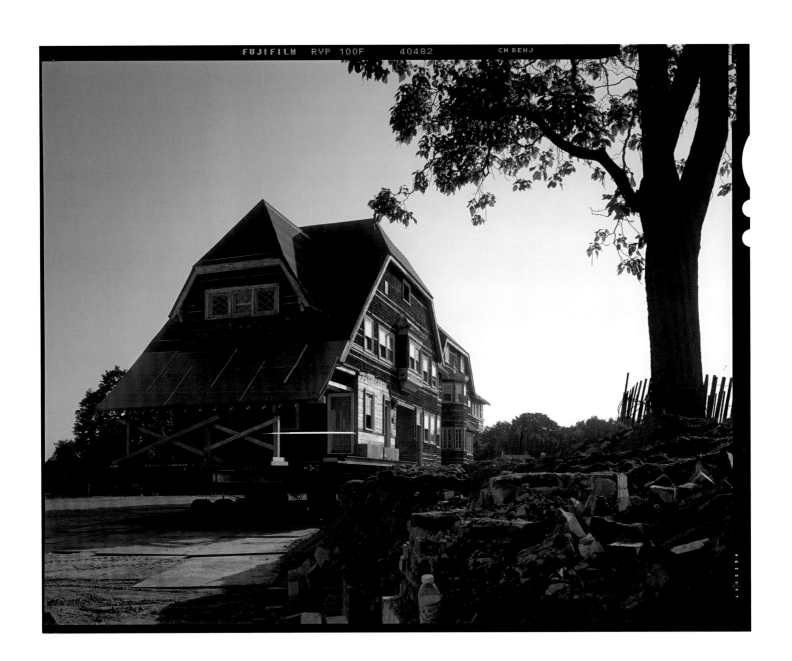

Bob Tortora, renovator of historic houses; member, Board of Historic Preservation and Architectural Review (interviewed in 2006)

*W*hat I love about working on these old Sag Harbor houses is you don't have to worry about perfection. When you do a modern house or apartment building, every line and seam has to be perfect, but the art in building an old house is to make it imperfect. We just renovated a house on Glover Street that had the original cedar siding from 1850, but it needed fixing. It had a wonderful patina, and we salvaged old wood from the barn to fix it. The trick is to make the house look like you were never there.

You can take some license because, if you truly restore an 1850s house, the cost will be double the cost of renovating. Restoring is only for a museum. Renovating is making a house beautiful and practical to live in. People don't realize how important minor details are: things like windows and window moldings. The village is losing most of its original windows because keeping the old wavy glass is not as practical. It means you have to have wooden storm windows, which is a beautiful solution, but more expensive and more work.

The architectural review board is constantly battling against making the village's small houses bigger. But there needs to be a compromise. People are paying a lot of money for these places, and they want space. Most of the houses I am renovating I make bigger. Usually I don't change the footprint very much, but add a dormer here and there, put on a small extension. And I try to salvage the hardware that comes out of old houses. On land I own I'm building two new ones, and when I do that I make them look as though they have been there a long time. I usually put in a swimming pool, just a small one because village plots are small. Pools are garden ornaments, nobody uses them. It's just the idea of having water in your back yard and being able to get wet. Anyone who complains that a pool I put in is too small doesn't belong in Sag Harbor.

Most of the historic houses around Main Street have now been renovated, and the unrenovated ones are priced so high there's no business opportunity in fixing them up and reselling them. In the historic district, people think the houses that are left are more valuable than they are, but renovation is so costly that often it doesn't make sense for someone like me to buy. The sellers don't realize the time it takes to get all the permits and inspections and parts. There's always a board that will hold you up. There's always a neighbor who doesn't like what you're doing. It can take more than a year before you're able to start work. There's a house on Main Street for sale at two million. Say it sells for one point eight. You'd need to put $800,000 into it, and, with closing costs and taxes, that will bring it up to three million. And it's worth two. At those prices, you have to be desperate to buy. You have to want that house so bad that there's no other option left for you.

Every house I've done so far has been for somebody from Manhattan because that's where the money is. If you make $10 million a year as a stock trader, what's five million for a house? It's all relative. But, for most people, the historic district is way out of price, and that is putting pressure on the newer developments at the edges of the village.

What Manhattan people like about Sag Harbor is living in a village, being part of a community. They want to go shopping on their bicycles, to know their neighbors, and they don't mind that their neighbors are close. East Hampton is like the Upper West Side, Southampton like the Upper East Side.

This is Greenwich Village. More and more people are living here year-round, working far from their jobs, and servicing the Manhattan market from home. And that changes their social lives. Although mine is still in Manhattan, it is becoming more and more here. I now know about a hundred people in Sag Harbor.

I got into this business after I rented here one summer, fell in love with the village, called a broker and told her I wanted to buy a wreck near the water. It was 1998, and for half a million dollars I bought an abandoned house that had been built in 1972 by a used car dealer from Queens. It was at the end of a cove, a mile from open water, in such bad shape that nobody wanted it. I rebuilt it, and that led to my doing others.

At first, I had little competition. Now, when an old house comes on the market, there's others interested, too. I do my best to buy as many houses as possible and fix them up and sell them because I need the money to buy the next one. I figure there's another five years left to get through the bulk of the historic houses that need to be renovated. Then, I could move on to the commercial buildings. Some of them are a disaster. What excites me about Sag Harbor is that it's constantly improving and that it's so old and so beautiful.

Some people have been critical of me for adapting historic houses for today's market. But, if I didn't do it, someone else would, and perhaps not as well.

*O*f the inhabitants of Sag Harbor as a class little can be said. They are just what one would suppose from a population made up in the manner they were; there is no marked famous or infamous class. But there are many learned and cultured people here brought here through interest, and it was this class that gave status and character to Sag Harbor society. There are many wealthy and respectable citizens of Sag Harbor who commenced their career as ordinary seamen and rose to the rank of commanders, who are now retired capitalists, and who still maintain that the highest honors belong to those who have passed and graduated through the curriculum of a voyage around Cape Horn.

—DANIEL M. TREDWELL, *Personal Reminiscences of Men and Things on Long Island, part one* (1912; diary entry of July 1843)

Ephraim N. Byram, a native of this village, is a self-taught mechanic and philosopher,—a sort of prodigy in practical science, and worthy of honorable mention. His attainments are certainly very considerable, and there are few subjects which he has not explored to some extent. He has rarely ventured beyond the limits of his native village, except at short distances. He visited New York City in July, 1846. His attention is chiefly confined to mechanical and scientific pursuits. He invents and executes the most complicated machines, as clocks, telescopes, and musical instruments, and even makes many of the tools with which his other works are constructed. Without the advantages of family influence, education, or wealth, he has attained a wonderful degree of accuracy, in many things, which would seem nearly impossible. Among other contrivances, planned and executed by himself, is a *planetarium*, which exhibits the relative position and motion of bodies in the solar system, equal to any thing done before. The revolution of those bodies is shown in beautiful and harmonious order, which proves the inventor to be deeply imbued with correct notions of astronomy and the physical sciences. There is a delicacy and finish about this machine worthy of admiration.

—Benjamin F. Thompson, *History of Long Island from its Discovery and Settlement to the Present Time*, 3rd ed. (1918)

This edifice will honor and ennoble the owner and his coadjutors. Its ponderous machinery will pulsate through every artery of the village. It will attract from abroad the intelligent and skilled workers in silver and gold. It will allure the scholar from his study and the artizan from his shop to gaze upon strange workmanship in precious metals. The recompense paid for labor will be diffused in great streams through the channels of mercantile exchanges. In this healthy climate workmen need fear neither fever nor contagion. Its towering chimneys will gladden the eye of every traveler. We look to a bright future.

—SAMUEL L. GARDINER, SPEAKING AT THE LAYING OF THE CORNERSTONE OF JOSEPH FAHYS AND COMPANY, 1881

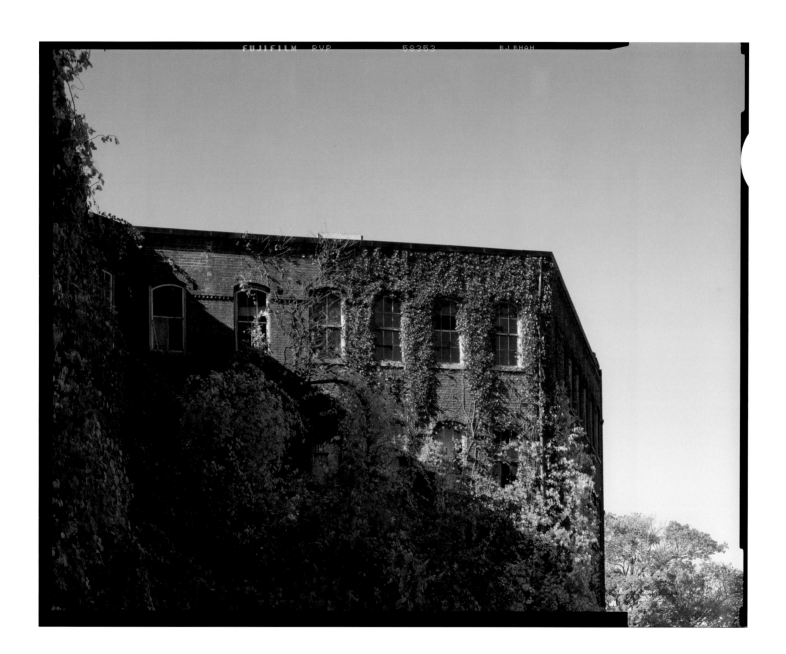

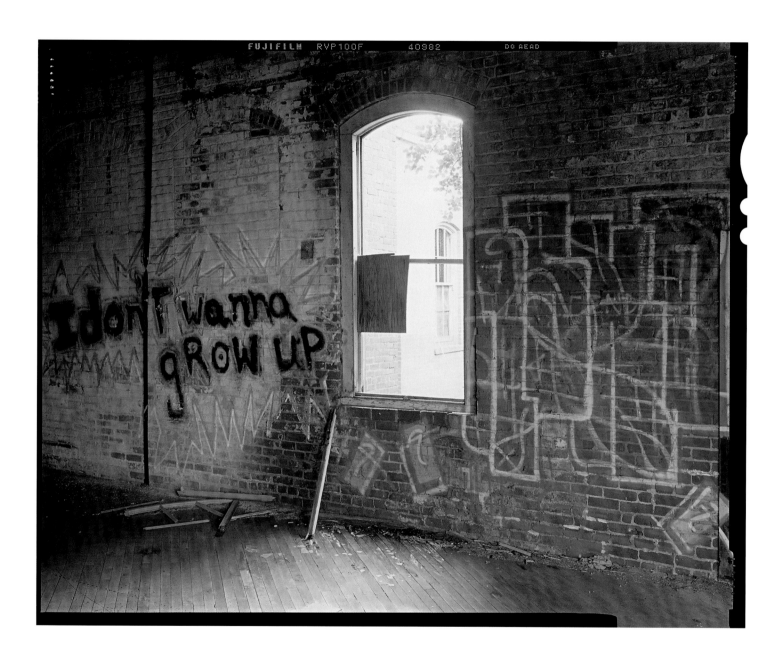

Thomas Horn, Sr., longtime member and former chairman, Board of Historic Preservation and Architectural Review (interviewed in 2005)

I was born here. My grandfather came from Stuttgart, Germany—stowed away on a ship when he was eleven years old. I don't know what brought him to Sag Harbor, but in the late thirties, when Hitler was in power, I remember him writing to his family saying he didn't want to hear from them any more. He became the foreman of the brick yard on the turnpike. A lot of buildings in the village have those bricks on them. My father told me he rode on the wagon with his father when they delivered the bricks for Pierson High School. That would have been around 1907, the year the cornerstone was laid.

This was a community that was trained to work in factories. In my time, Bulova was the big one, and there were smaller machine shops that kept changing hands. There was a hotel at the bottom of Main Street, the Bay View, that was derelict from the time I was a kid (page 231). It just went broke in the Depression, and the owners walked away from it, leaving the tables still set. It stood where the bank is now. Next to that was a garage, and next to that was a bar. Sag Harbor was not a trendy place.

My father had an electrical shop on Main Street, and my mother worked at Bulova. So did I, for seventeen years. I was a polisher there. Nights and weekends I helped my father. My wife worked for the telephone company, so in the fifties we did three jobs between the two of us.

Working for Bulova wasn't bad. It was a job. You made some money. It was a piece-work shop. If you were working, say, on watch cases, they would come a hundred in a box, and what the Bulova people did was to figure how many you could work on in a day, and make an hourly rate out of it. There were periods when you could do all the overtime you wanted, and times when they would bring you in for a couple of hours, then let you go home, and not pay you for the rest of the day. Sometimes they had as many as 600 workers, so, when Bulova closed, it was not only Sag Harbor that was affected, but the whole East End.

Like any place, there were people you got along with, and, if you were lucky, you got to know some of them pretty well. Some men met their wives at Bulova. Marriages and families came out of it. Now, the cost of housing is driving young people away. In my youth, we could all afford a house. Most people scrimped and saved and bought a lot before they put a house on it. But the banks were very tight, and, at one time, they would turn down local people. Even the factories weren't helpful then.

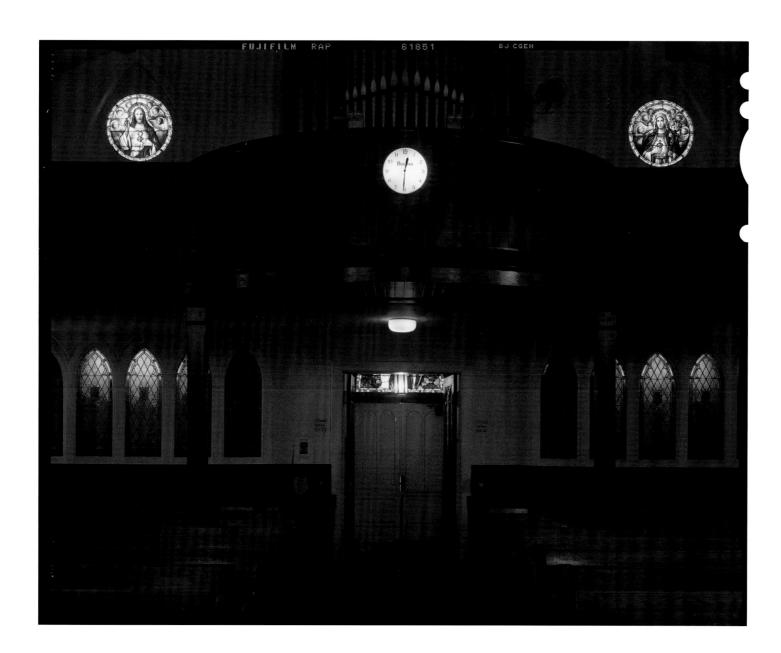

S t. Andrew's was built in 1872. Many of the early parishioners were Irish refugees from the potato famine. Some of them went into farming, some into construction. There was a lot of building at that time. When I came here in 1960, seventy percent of our parishioners were of Irish, Polish, Italian, and Lithuanian descent, and some of their families went back to the whaling days. The villagers intermarried, very few went to college, and most of them worked in the trades of their parents.

In the 1960s, Sag Harbor was a very small, compact village: an enclave, an oasis, separate from the Hamptons. Everybody knew everybody else, and when you went to the post office to get your mail, the people you met there knew everything that was happening in town. You scarcely needed to buy the local newspaper. They were good people, and they supported one another. I came from a parish farther up Long Island where there were many poor families. Every week someone would be asking for assistance. But Sag Harbor people were so self-sufficient that, although they were not rich, none of them came to the rectory. They would rather help one another. And there was no class distinction in the village. You might see a millionaire sitting on a bench talking to the village drunk. Now, the people coming in keep to themselves and have their own social groupings. They come from the city, they have built houses, or, if they have bought them, they have knocked them down and built bigger ones.

I used to feel I knew a lot of people in the parish. Even many of those who rented in the summer-time were friends and relatives of parishioners, Catholics from Queens and Brooklyn. In the seventies, that began to change. This became a vacation area, and now it's a different class of people buying in. I don't know where they get their money, but the village is crowded at weekends even in winter, and businesses have opened up to cater to them. That's good for the economy, and it's needed. This community will keep surviving as long as there is money coming in. There's not enough to be made by serving one

another. But, with the increases in real estate taxes every year and the high price of food here, I don't know how some of our own people can afford to stay, especially the old ones living in the houses where they were born. Some of the farmers sell off a few acres every so often to keep going. Soon, perhaps those who have always lived here will not be able to maintain the houses they have. They will find other places to live, there will be a glut of property on the market, prices will go down, and it will go in a cycle. If you move to the other side of Riverhead, they say you can live for half the price. But people like to live near the water, and it's still a good life here.

In my early years in Sag Harbor, people were better able to live off the land. Wildlife was plentiful. The scallops were unbelievable. In half an hour, you could get a bushel of flounder at Cedar Point. But this whole East End is built up now, and that has brought some poorer people into the area because there is work to be had on the private estates. Landscaping keeps a lot of men employed. Almost every Catholic church around here has a Mass in Spanish for the Latin Americans.

In 1973, four of us priests built a house on the edge of the village for our retirement. Now, I am the only one left here. I live alone and I like that. I have been retired since 1994. I get a pension from the diocese and my Social Security, and every year I cash in one of my CDs to pay the property taxes. Taxes used not to be a burden. Now, with increased real estate values, they are. If I can't go on paying them, I will have to sell the house. The diocese has a retirement home for priests, and I could go there. But I feel comfortable here. Every once in a while, I am asked to say a funeral or a baptism. When you are in the same parish so long, you have married some of the grandparents of children now in school. That's why I want to stay here. You may not be needed any more, but you are wanted.

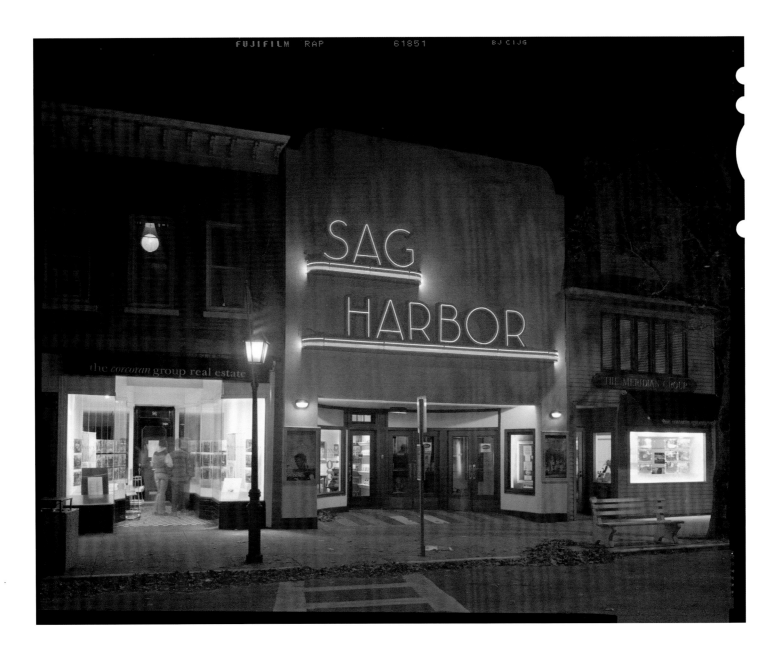

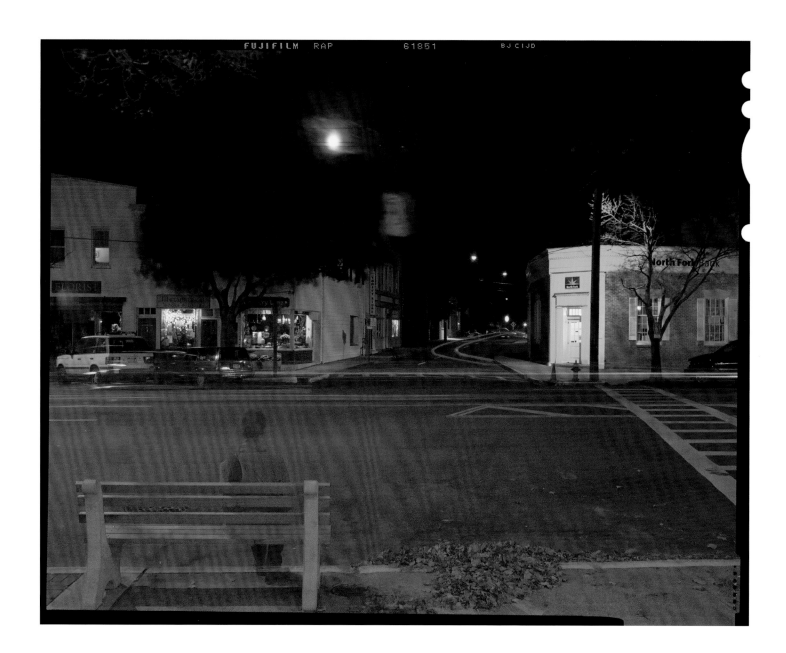

DAVID LEE, RETIRED JEWELER AND WATCHMAKER (INTERVIEWED IN 2005)

Here I can be myself. I can do anything I want, and I don't have to be answerable to anyone. I've lived in cities—Manchester and Sheffield, England. You're nobody in a city. Maybe it's because I couldn't get to college, maybe it's an ego trip to be recognized, but people in Sag Harbor recognize me. I've left my mark here. And that's something for a poor struggling Englishman of Jewish faith. I helped to found the Chamber of Commerce and to put this place on the map as a tourist attraction. Without tourism, it wouldn't exist. When I was president of the school board, I extended the school district towards Wainscott, which increased the village's tax revenue. Things like that are possible in Sag Harbor. You'd have to buy a spot in the city to open your mouth.

When I came to Long Island in 1948, just out of the British Army, I found this tiny village that was suffering from peace. There hadn't been an infusion of outside money for a long time, and a lot of people were unemployed. The Grumman plant wasn't making aircraft parts any more. Bulova stopped making luxury goods during the war and hadn't got back into peacetime production. There was a little factory on Jermain Avenue, Eaton Engraving, that had been making glass for submarine periscopes, but they were no longer needed. Sag Harbor was in sad shape: a factory town with very little work.

I got a job at the jeweler's store. I was a watchmaker by training and finished my apprenticeship here. Then, Rowe Industries opened up, so I was moonlighting there at night. Rowe started to grow—I worked my way up and became its vice president. Later, I opened my own jeweler's store. By the sixties and seventies, this place was booming, and there was so much work that people at Bulova were moonlighting at Rowe Industries, and people at Rowe were moonlighting at Bulova.

Today, with the tourist industry and the second homers, Sag Harbor is even better off, except there are no affordable homes for those who work here, and hardly any place to build them. It bothers me terribly that, as we try to provide housing for the people of this village, others come in and buy houses in order to knock them down and build bigger ones. That doesn't sit well with me. It's conspicuous consumption, a showing-off, in your face. But it does provide a tremendous amount of work for carpenters. And there's a kind of magic about the East End. I don't think it will ever crash.

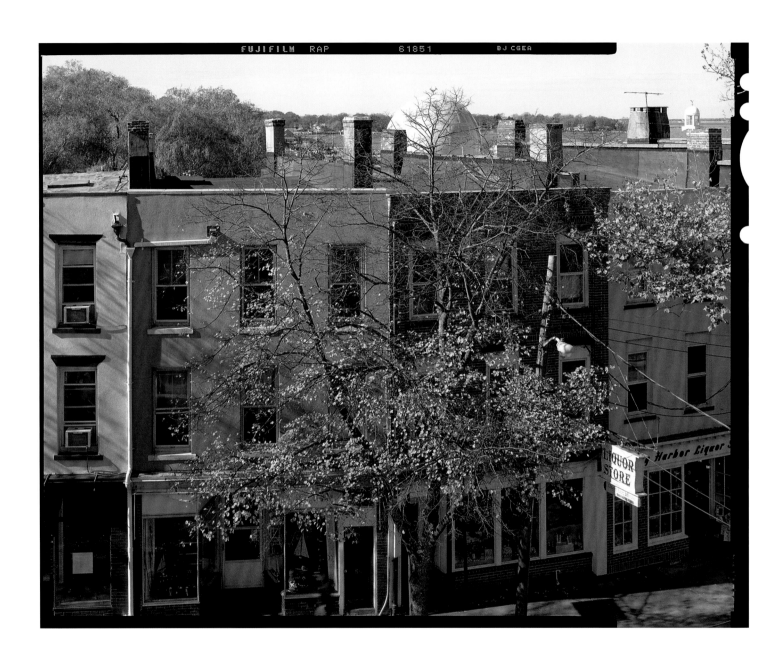

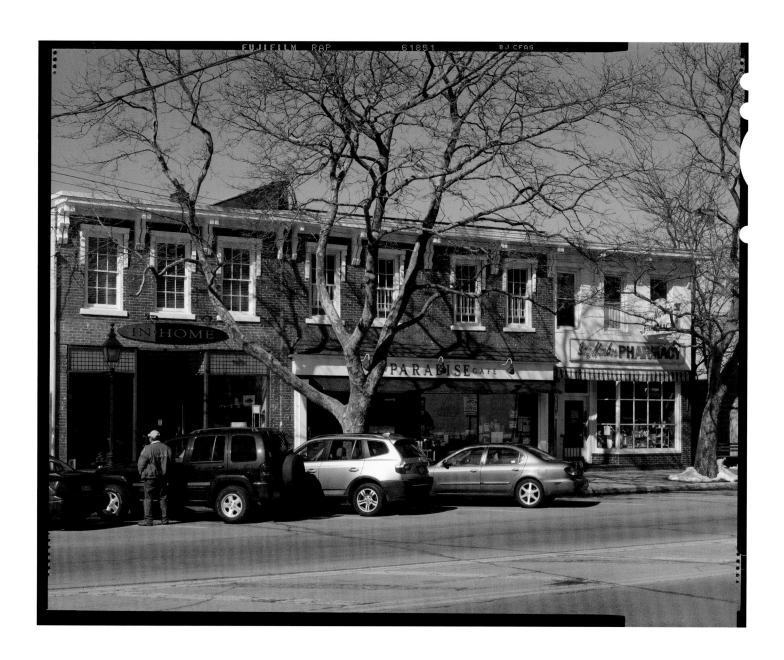

Walking up Main Street you can get a sense, under today's picturesque veneer, of the village this used to be. In the early 1800s, Sag Harbor was a booming whaling town, a veritable Long Island Las Vegas, teeming with foreigners and locals making high stakes gambles on whale oil. After long stints at sea, the whalers would return to port hungry and horny and causing all manner of ruckus. The former brothel today houses a florist shop. And like Las Vegas (and unlike today), early Sag Harbor was not particularly religious. Indeed, the earliest known Sag Harbor society was the Infidels, whose purpose was to attack Christianity. Yet Christianity was not the threat that fire was. A series of conflagrations alternately trimmed or leveled Sag Harbor, fostering a steadfast local spirit and an incredibly populous and enthusiastic volunteer fire department. The town alarm induces a frenzied response and near lethal traffic surge as every able bodied male races to douse something. When the whale oil market deteriorated, Sag Harbor turned to watch case making (a Bulova factory), torpedo testing (in conjunction with the Bliss torpedo factory in Brooklyn), and rum-running. Today it is a major manufacturer (perhaps guardian) of quaint. Looking at old photographs you realize that, despite the fires, the general look of downtown defined by the American Hotel and Municipal Building is largely unchanged.

—LAWRENCE LAROSE, *Gutted: Down to the Studs in My House, My Marriage, My Life* (2004)

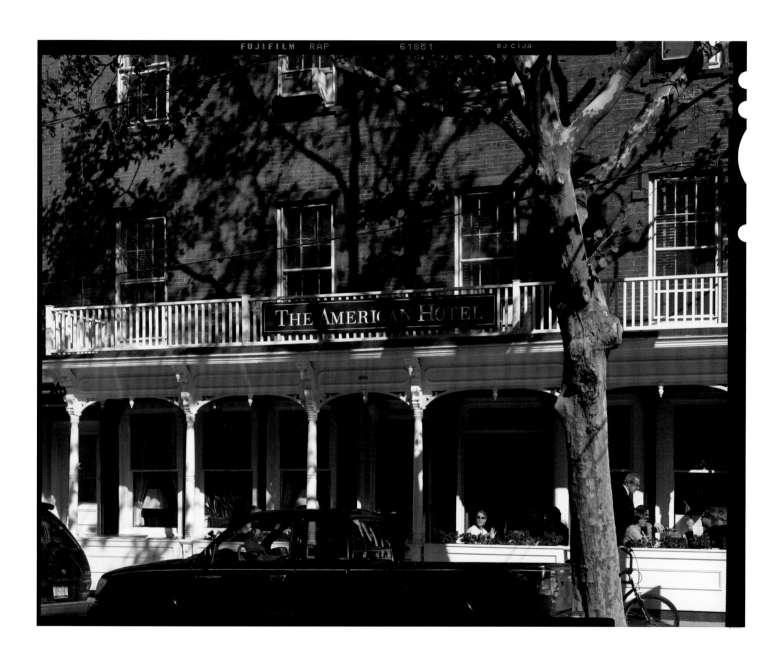

I *don't mind any of the changes here, to be honest. The great thing about Sag Harbor today is that you can go down the original Main Street and there is not an empty store. An empty store is the worst thing for a small community. There might be different faces behind the windows, different kinds of people. But not really. They wouldn't be in Sag Harbor if they didn't enjoy being in business for themselves—if they didn't like meeting people and talking to them.*

—THOMAS HORN, SR. (INTERVIEWED IN 2005)

One may trade in Sag Harbor as cheaply as in the larger cities and the display of goods is often as fine and varied.

—*Sag Harbor: In the Land of the Sunrise Trail, 1707–1927* (1927)

Before the Second World War, my father used to rent out his field to the circus for fifteen dollars. That went on for twenty-odd years, and every year my father got a pass for the whole family. The last circus that came had seventy trucks and fifteen elephants and all kinds of animals. The main tent was close to 400 feet long and took half the field. The circus people would take the elephants to the cove so they could go bathing. They loved the water, those elephants. The morning the circus came, all the cows lined up from one end of the fence to the other and stood there watching. They were amazed to see such a thing.

—DOMINICK CILLI, DAIRY FARMER (INTERVIEWED IN 1976)

(See page 276 for Dominick Cilli's account of his family's dairy.)

Old Parker House (Umbrella House), Division Street, photographed by William Wallace Tooker, early 1880s. Cyanotype on fabric.
Courtesy of the East Hampton Library, Long Island Collection.

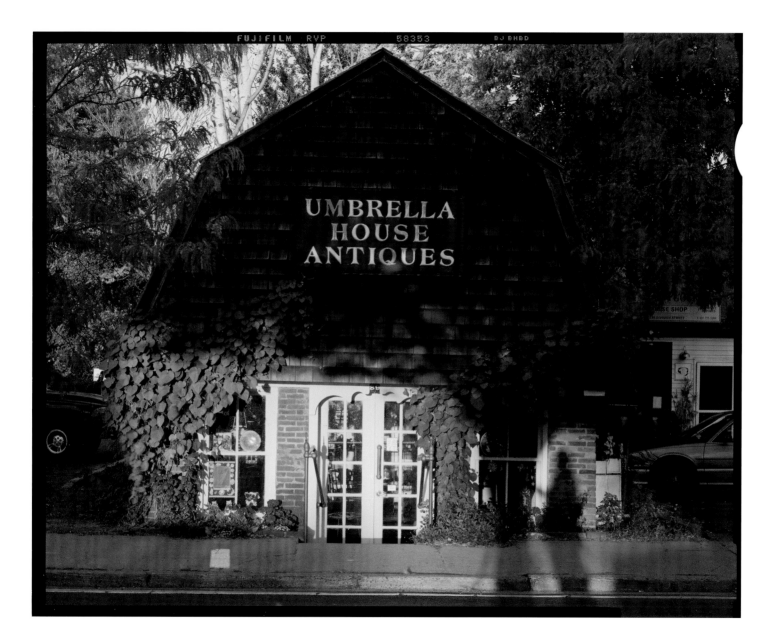

Joy Lewis, collector (interviewed in 2005)

I *was born in Kansas, then lived in Wyoming, places with no visible history. From childhood I sup-*
pose what I wanted was civilization. When I went to Boston at thirty-three, it was a culture shock
to be with things of an earlier time. I met my husband Robert there. I remember a friend inviting the
two of us for a weekend in an eighteenth-century house in Little Compton, Rhode Island. It was the first
time I had stayed in a house that early, and I was deeply moved. The way it was sited to make the most
of daylight, the way the plaster was laid on the walls, you could tell it had been made by human hands.

Bob was an interior designer with a strong architectural background, and he was very excited by
the restoration movement. Soon after we married, we bought a run-down 1790 house in Maine that we
used for weekends. We restored it together, and it was the most satisfying thing either of us had done.

We both loved New England, and, even after our work brought us to New York, we thought we
would go back. But then we found Sag Harbor, and I realized New England was here, too, about seven
layers down. We drove out one day in 1976 and saw this ancient little house that was leaning forward,
about to fall into the ground (pages 156 and 157). As Nancy Willey described it in her guidebook, it
looked as if it were made of gingerbread, standing in an enchanted wood. The realtor's brochure described
it as a derelict ruin. We thought someone had to save it and bought it that same day. We read all we
could about the house and its place in the village, then consulted an architectural historian and had the
thrill of seeing the documentary evidence confirmed.

This six-post structure had been built near the wharf in the 1750 period as a ship's store for the elder
John Hulbert's sloop Mehitable, *which traded with the West Indies. In 1774, a year before Hulbert died,*
a man named Ichabod Coles was granted permission by the Town of Southampton to improve the land
where Hulbert's store stood on the waterfront and to make it his dwelling for as long as he lived there.
The building was moved to its current location on Hampton Street around 1790, the year Coles died.
The architectural historian we hired dated the chimney to that same time, right after the move.

The house was being sold by the next-door neighbors, descendants of the Coles family. They asked $20,000. We paid a bit less, then spent $100,000 just to save the structure. It had no foundation and was sitting on a locust-wood crotch set on piles of stone. The space underneath had been open until about 1840, when it finally silted in with sandy soil. The base of the house was too weak to be jacked up, so our contractor had to lift it by its shoulders while a crawl space was dug and footings were poured. The walls hung like draperies until the house could be lowered with great care so as not to damage the chimney and its beehive oven. Underneath the house we found broken dishes, venison bones, shellfish shells, a tiny eight-row corn cob, a shoe put together with wooden pegs, a pumpkin stem, a coconut shell, and a small dish, broken in two, with the motto "A Reward for Innocence and Truth." There was a rat's nest with mid-nineteenth-century textiles in it. But the best discovery was the iron ball, about the size of a golf ball, that fell into my hand when we had to take the old ceiling down. It was amazing to realize it could have been there since Colonel Meigs's raid in 1777, shot from a British schooner in the harbor.

Interesting as the structure was to us, so were the lives of those it had sheltered. I realized how much people need to bond with the place where they live when I saw how we did. We couldn't wait to move into the house and camped in it for a while until the work began. In our fantasy renovation, we wanted to make this house large enough for our family of four. Fortunately, by the time we had funds to finish the project, ten years later, we realized that putting on a big addition would have been wrong. It was meant to be a small house, and enlarging it would have diminished it.

As soon as a project like this was finished, it would be over for Bob, and he'd want to move on to another. I get attached to things and places, but he lived in the process. Every house in Sag Harbor had been restored in his mind. Walking down the street, he would be busy thinking about the math of a structure: this dormer should come off, this detail should be put back. He had the vision. It was not just a hobby for him, it was a life.

Next, we bought a beautiful Greek Revival house on Madison Street, built about 1840, and Bob worked on that and made a glorious garden. But it was several years before we could bring ourselves to sell the little house on Hampton Street. A lot of people are clever and flip houses, but that was not what we were doing. If you honestly restore a house, it will not be profitable.

One day we saw a "for sale" sign on a fence outside the Greek Revival house where I now live, and this became Bob's last project. It had been built around 1830 for Charles T. Dering, who was a nephew of Henry Packer Dering, the customs collector of the port of Sag Harbor, appointed by George Washington. Charles Dering was a whaling agent and ship owner. James Fenimore Cooper was one of his business partners. We had been collecting Sag Harbor art and antiques throughout our time in the village—nineteenth-century portraits by Orlando Hand Bears and Hubbard Latham Fordham, a pair of Dominy armchairs, a clock made by Ephraim Byram—and they all came together in this house. We were pretty passionate collectors.

When Bob died in 1999, the house was not quite finished, but he had left so much of himself here that I wanted to complete it. Sometimes it feels too big for me, but I will never have another chance to live in a house that he made truly wonderful. It makes me want to stay here for the rest of my life.

Time passes. Listen. Time passes.
Come closer now.

—DYLAN THOMAS, *Under Milk Wood, a Play for Voices* (1954)

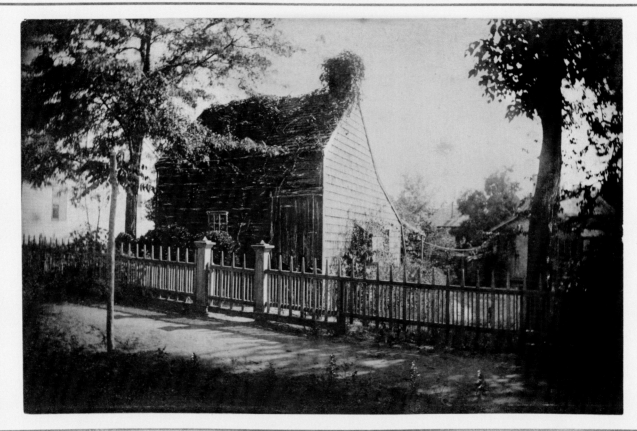

Thaddeus Coles House, Hampton St.
(Built about 1790)

Thaddeus Coles House, Hampton Street, photographed by William Wallace Tooker, early 1880s.
Courtesy of the John Jermain Memorial Library, Sag Harbor.

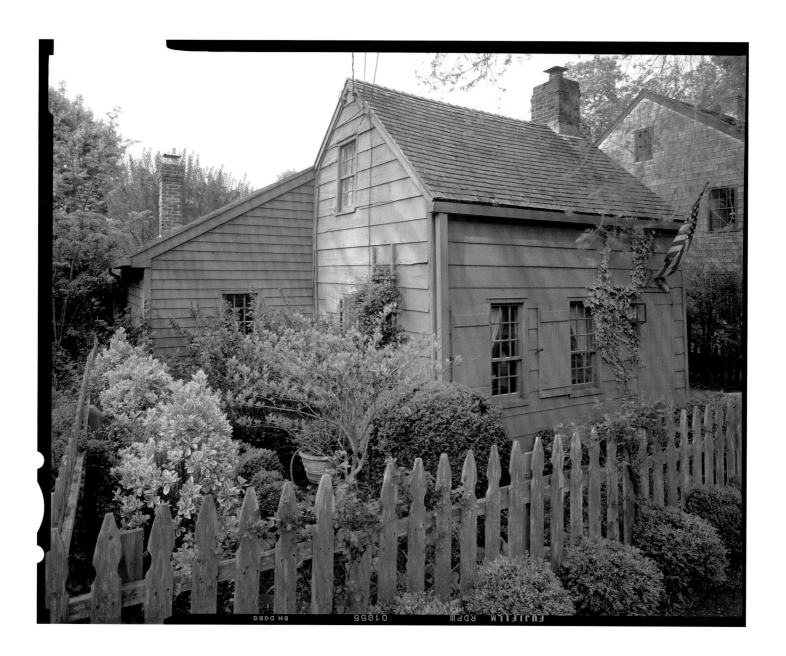

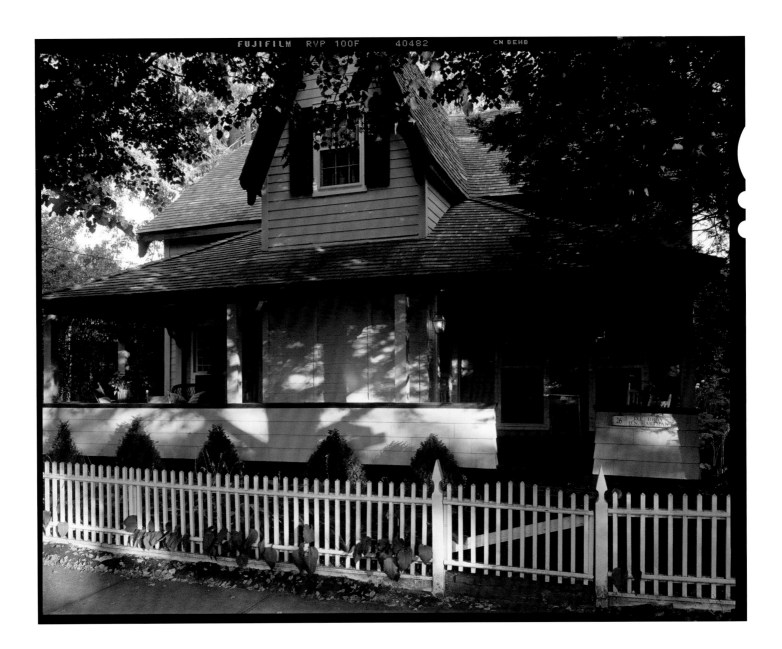

DAVID BRAY, REAL ESTATE BROKER (INTERVIEWED IN 2006)

*Y*ou can call Sag Harbor home even if you are only here for the weekend. But it's a bit like going to the opera—you wouldn't make the effort if you didn't like music. And you wouldn't settle in this village if you weren't a romantic at heart. I moved here thirty-five years ago when I was vice president of a New York advertising agency, rented for a time, retired from my business, and started selling real estate in Sag Harbor because I was innately interested in houses.

My first Sag Harbor house was a very modest one on Bay Point. Three years into owning it, we sold it and bought a dilapidated old house on Henry Street for the same price. It was being offered by the family of a local woman who had recently died. The roof was collapsing, and I imagine that, after I signed the contract, they celebrated that anyone would pay $47,000 for a place that needed so much work. It was a house that nobody else wanted, but it had so much romance attached to it that I couldn't resist it. When the asphalt roof and the asbestos shingles came off and the clapboard was exposed, there was the miracle of this 1849 Gothic Revival house with five working fireplaces. One thing I've loved about it was that I could have three or four fireplaces going at one time. And often, in the summertime, I've sat on my front porch with a drink in my hand and such a feeling of contentment and reverie. You don't live in such a house without becoming a part of it.

It says a lot for this village that, going on twenty-nine years ago, two men moved into this house and restored it, and at no point in all this time did we not feel welcome here. Two men living together on a very visible street was not the most common thing when we moved in. But this is a village where you have celebrities walking down Main Street, and nobody pays any attention. Some of the occupants of the village are the cause of Sag Harbor becoming popular, people from the literary and publishing worlds telling their friends about the wonders of Sag Harbor, and bringing them out for weekends. It is a case of this village being exposed, and put on the front page, by people in the public eye.

The appeals are numerous: the architecture, the coziness of it, the ability to walk down to the harbor and look at the boats, to stroll down Main Street and say hello to people, to go into the Old Burying Ground and look at the names of those who lived here long ago. You can take your time and let your eye feast on the wonderful physical characteristics of this village. It has retained all the wonderful physical characteristics it possibly could despite the pressures of the outside world. And the strange thing is that those who come here and fall in love with it feel they are the first to discover Sag Harbor and wonder how others could have been so naive as to miss it.

Now that it is a historic district, anybody who buys a home here wants to follow the rules. They want the architectural review board to look at work they are doing and okay it. If they start violating the code and doing things that are inappropriate, they will be ruining their own purchase. The people I've sold houses to have been substantial people with an interest in old houses. There are very few huge houses here, and some very wealthy people live in rather modest homes. To buy into this village, with houses so close, you have to be bitten by the Sag Harbor bug. But there is no one type of individual who settles here. Each has his own story.

Some of the locals bemoan the price of real estate and the fact their children and grandchildren cannot afford property in the village, and I understand their concerns. It happens in any resort community where you have second home owners and wealthy retired people. The people who wait on tables and service the community have to live some distance away. But these socio-economic problems are not unique to Sag Harbor. The real estate story of the village is one that can be told in many places. What has also happened here is that people with money have come in and bought some wonderful old houses that were falling down and saved them.

Now I'm seventy, we're selling the Henry Street house to simplify our lives. We have a cottage just outside the village, and we spend the winters on Key West, so cutting the umbilical cord from Henry Street has been less painful. But that house was my child, and I loved it.

*T*his house came with a legacy. There's a feeling of benevolence here, a sense that good people lived good lives and left a resonance. I feel it in every room and in the garden. It's always been a simple house. Benjamin Glover built it in 1842 for the tinsmith David Jeremiah Youngs. (See their contract on page 260.) When it came up for sale in 1976, I bought it in five minutes. I draw historic houses (page 201), and I wanted to live in one.

I've changed very little because it felt so right. I did add an arbor. It took months to design, and it looks as if Glover supervised the job. When I replaced the nineteenth-century clapboard siding on the front, a child's catechism and shoes and an ink bottle fell out of the wall. I put them back with some things of my own for someone else to find.

The house was built for a family of artists and mavericks. David Jeremiah Youngs made everyday objects, and he made them beautifully. Some of his utensils are still in the kitchen. His brother-in-law, Orlando Hand Bears, painted portraits. David Jeremiah's granddaughter, Laura Youngs, was the last of the family to live here. She drove one of the first cars in Sag Harbor. Once, riding her brother Harry's motorcycle, she set her skirts on fire. That shed in the backyard was her garage. Now it's being held up by the trees around it, and I like it that way. I think she would like that I am in her house, and I like being part of the family.

In the sixties, the house passed on to Rocco Liccardi, who told me it was haunted. Laura's dead sister, Clara, had been seen wafting through in her World War I nurse's uniform. I've never seen her, but a friend's cat used to sit for hours looking up the stairs with her neck hair raised. I feel close to Laura out in her old garage, and I feel close to the artists who came before me here.

Last year, a developer put a modular house on the lot behind mine, where there used to be woods. It was designed to look like an old one, but it arrived in four pieces, wrapped in plastic, on four trucks, and they put it together with cranes—huge hunks of house flying through the air. It seemed a parody of what the historic district was meant to be. It took away the trees and critters and my view of the sunrise. I hope those precious remnants of the Youngs family haven't left, too.

This house has always looked after me, with its energy and its spirit. But I may be the last one to keep it the way it is.

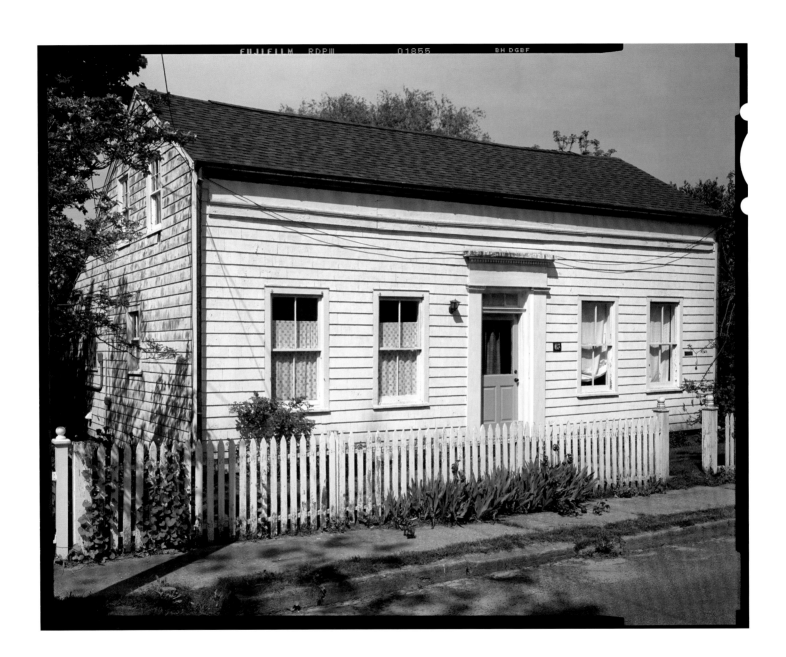

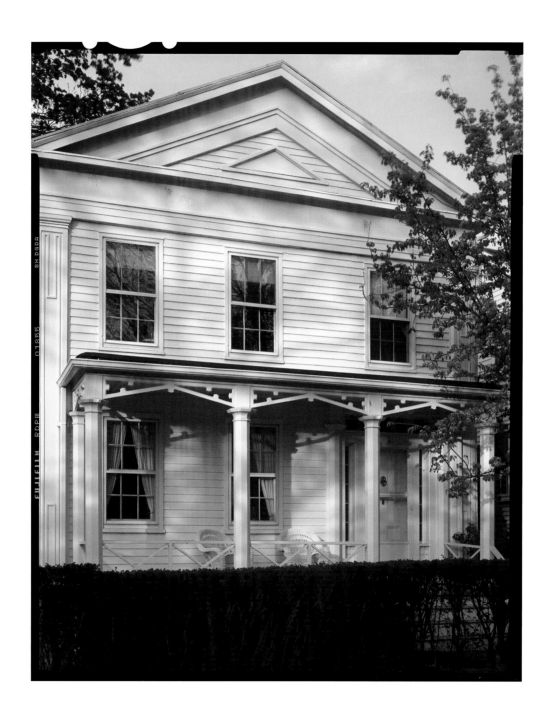

Rocco Liccardi, antiques dealer (interviewed in 2006)

*I*t's money that's destroying these old houses. What saved the architecture in Sag Harbor for so many years was that people who came here in the sixties and seventies had very little funds. They painted their houses, and that was it. They didn't put the insides in a dumpster. Now people will pay $2 million for an elegant old house, order two dumpsters, put a portable toilet outside, and tear out the interior because they want the space to flow. Well, it wasn't meant to. I'm also against the swimming pools they put in. There's at least a dozen of them behind Main Street houses alone, and they don't belong there.

For years we were saved in Sag Harbor because the mentality of buying a house for an investment didn't hit here. There were very few real estate offices. Houses were bought and sold out of people's homes. Then, as prices got higher and higher in the Hamptons, people were lured here, not by the water, but by the property prices. In the sixties, people bought Sag Harbor houses the way they bought Sag Harbor antiques, not because they were old, but because they were cheap. Or because they were restoring a house and trying to create an atmosphere. Back then, it was a happy project to restore an old house. Now, it's a nightmare.

There are no Sag Harbor antiques to be had any more, not in the shops. When I do get something that has come out of a Sag Harbor house, I won't sell it to just anybody. I couldn't do that. Years ago, it was easier to get stuff. People would call you when somebody in the family died and they wanted to clear out the place. And you'd pick up things at the village dump. One time, when the Napier House was being cleaned out, there were old trunks from the attic being emptied into the dump, and inside them were silverware, lace, and two books signed by Robert Frost. That's where I went shopping. All of us went, even the elegant ladies with their canes. At the East Hampton dump, they put up a tent so you could sit under it and wait.

The mentality used to be to get rid of things you couldn't get fixed: wicker that needed a little repair, but nobody knew how to do it. Worse things happened to some of the buildings. On Hampton Street there used to be a magnificent mansion with a little chapel, the Academy of the Sacred Heart (page 237). *In the late sixties, the nuns sold that whole complex to the Sag Harbor school district, and the house and chapel were torn down. You couldn't open your mouth to criticize anything like that because a lot of people in town were happy to see it happen. They thought it was progress. There used to be the most wonderful molding on the outside of the Bulova watch case factory. The owners threw it in the dump and were so proud that now the building was maintenance-free. It was shocking.*

Things still sell in the antiques business, but there's too much competition for us with the yard sales and the tag sales and that crazy eBay and people buying over the telephone. People who buy these $2 million houses can't keep them unless they rent for the summer, and that means having functional stuff. Old or new, it doesn't matter. Antiques that belong to Sag Harbor don't mean anything to them. Sometimes their decorators come into the shop and buy a few pieces, mostly curiosities.

A lot has changed on Main Street. First of all, there are no more characters in this village. You become a character if you stay in one spot long enough, and nobody does that any more. You used to know everybody's name, and the shopkeepers were all friends. We would buy things from one another and have dinner together. That doesn't happen now. There's a real estate office across the street, there must be forty agents there, in and out like bedbugs, but not one of them has ever come in my store. I haven't had a local person buy anything for years. Without the weekend people, the New Yorkers, we would all starve.

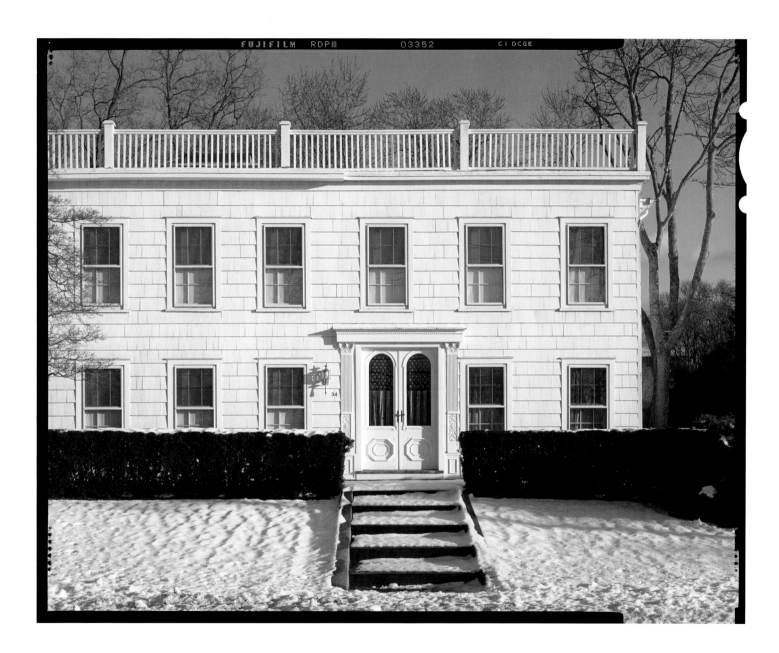

AL DANIELS, BUILDING INSPECTOR (INTERVIEWED IN 2006)

We have come from being a Mom and Pop village to a full-blown tourist village. Not so many years ago, we used to worry about how to attract merchants here. Now, we're one of the most prestigious places east of the Shinnecock Canal, as sought after as any of the Hamptons. A nicer place I don't think you'll find, and the best thing this village has to offer is its people. You can come here from anywhere, you can be a movie star or a bum, and you'd feel welcome.

I've been Sag Harbor's building inspector for fifteen years, and I have three of these jobs. I do Sag Harbor in the morning, North Haven in the afternoon, and Dering Harbor on Shelter Island nights and weekends. Sag Harbor keeps me busiest. There's an inordinate amount of work going on here. Every street in the historic district has four or five building projects. We have technically run out of land, and that automatically puts up house prices by twenty-five or thirty percent. There's still a lot of work that needs to be done. But it isn't always possible to restore houses as they were—the monetary constraints are excessive. And you cannot expect someone who buys an old house to live in it as is. With any luck, the buyer will find an architect who is sensitive to the building. It takes money and time.

Some people still think they can do whatever they want with their own property, but most are sincere about keeping the character of the village. I get a lot of help in my job from the public. There are hundreds of eyes out there watching, and people tell me things: "I saw someone deliver timber." "I heard a chain saw running." "I heard someone working late at night." "There's a dumpster next door." "They delivered a load of dirt across the street. What are those people proposing to do?" If one person doesn't call me about a possible violation, an hour later someone else will. And if someone blatantly builds something without a permit, I issue a stop-work order, then they have to go through the system. You can't get away with much in this village. We are not doing a bad job.

In the building trades today, this is one of the few places that is booming on Long Island. You can make more money in Sag Harbor and the Hamptons than anywhere else. But it's unusual today to see an established, old-time builder from the neighborhood. Most of the work force comes out here from further west, just like it did in whaling days. It's a bit like history repeating itself.

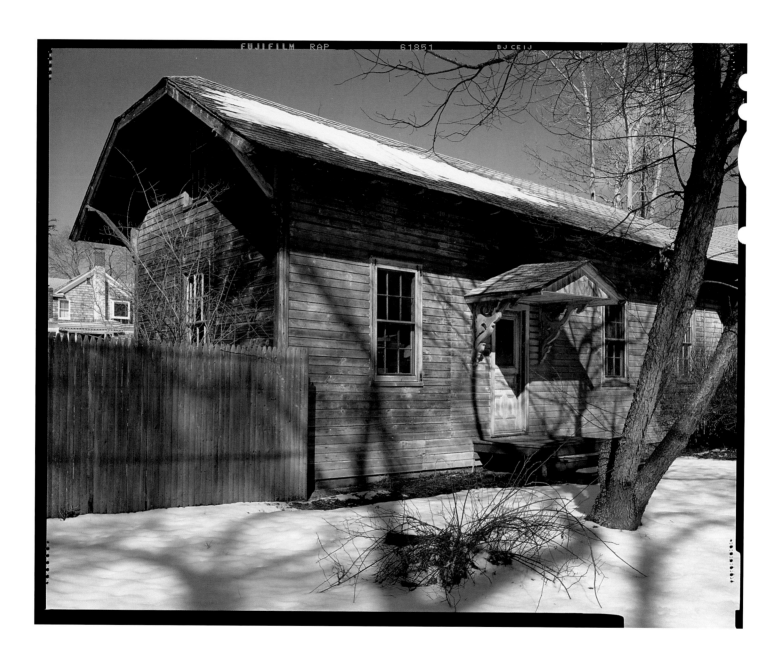

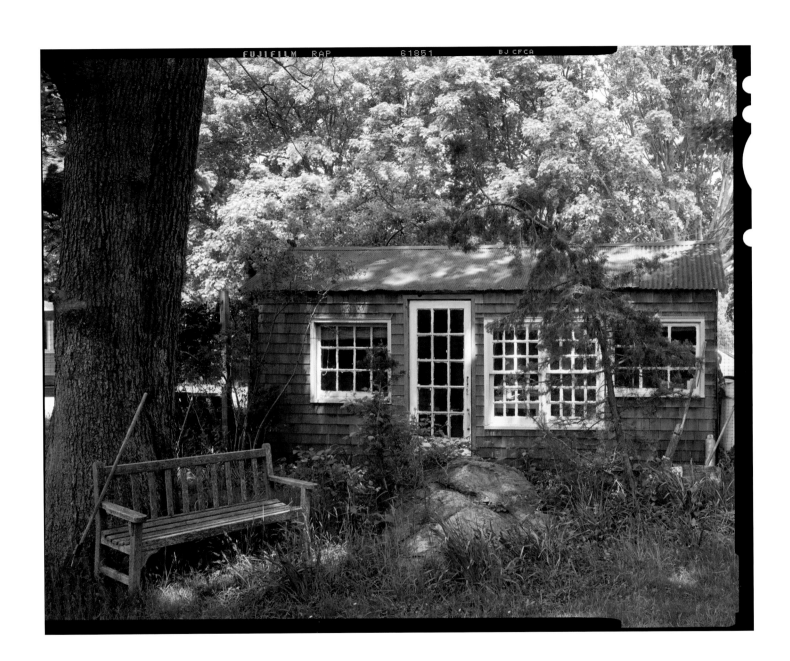

My parents came to Sag Harbor in 1957, and for many years I spent every summer, every weekend, and every holiday there. Back then, it was a charming, sleepy place. "A little village at the end of Long Island, but don't tell anyone" was how my mother used to describe it. This village of my childhood was a self-contained world. My father would meet people who had never been to New York City, never been beyond Bridgehampton. It was a place where the summer afternoons dragged on, people drifted around doing things, and the only sense of urgency was when the noon whistle went off and the factory workers went home for lunch. For me, the people in the village were a sort of extended family because I had such a very small family of my own. There are many who remember me as a child, and, now that I'm leaving Sag Harbor, there is comfort in that.

There was a sense of mystery about some of the places and people: houses that might be haunted, strange people on the street, a sense of there being a story that you would never quite know. The Napier house (pages 69 and 183) used to look gloomy and mysterious, like a Charles Addams house, painted a dark Gothic red. My mother became curious about it, wandered on to the front lawn, saw a hand pulling back a curtain, then the hand beckoned her to come in. Dr. Napier, who had been a distinguished surgeon in New York City, had long since died, and the house was inhabited by his relatives. Some of them were very strange, and the house was in various stages of disintegration with paint peeling and toilets that didn't work. Dr. Napier's niece Laura took my mother up to the widow's walk on the roof and told her that, when she was small, she would go up there with her sister and want to push her over the edge. That's when my mother decided it was time for her to leave.

My father became very much part of the village. He was very respectful of all the tradespeople. There was a black man who used to do yard work for him. His name was Mildred Cousin, and he lived in a chicken coop behind a woman's house on Route 114. He had a pot-bellied stove in there, the community looked after him, and he seemed perfectly happy. In the summertime, he wore three layers of wool shirts to keep the heat out. He worked very slowly and charged five dollars a day. No matter what the job was or how long it took, it was always five dollars. He was very fond of my father, and my father

of him. My father would give him lunch: a hamburger and a beer. People on the street would wave to Mildred, and he would say, "Everyone loves me." He was such a gentle soul. In the winter, my father would worry about him and go to the chicken coop, and this man would come out in his bare feet, smiling. One winter when we were away from the village, he died. There had been no funeral, so my father went to see Mrs. Cuffee in the black community, and she found a place in the cemetery to bury the ashes. The gravestone cutter who used to be on the corner of Jermain Avenue and Suffolk Street insisted on contributing his labor. These are the things about Sag Harbor that I like to remember.

I remember, too, how in the village there was always the ability to have social interaction. A trip to the post office was a social event in itself, and you could assuage any loneliness you might feel by going downtown for ten minutes. There was a dignity among the villagers and a cohesiveness, no matter what their level. Until my mother died in '92, I had never experienced death in a small town, and I was moved by the way people responded. Every twenty minutes, the doorbell would ring and someone would be there with a chicken pot pie from the Sagg General Store. Always a chicken pot pie, always from the same place.

The character of the village began to change not long after that. It was a change that had been brewing since the early eighties, when the fields around Sagaponack and Bridgehampton began to disappear and new houses took their place. Being separate from these villages and already built up, Sag Harbor was able to withstand urbanization for longer. But lately the village has begun to feel like a real estate opportunity, with a total lack of sensitivity in the size of houses being built. It reminds me of the period of the robber barons, and what we are seeing is the deracination of a village.

There was always resentment between the locals and the summer people, but over time they came to appreciate one another. Now, we have summer people who have such an air of entitlement about them that they have alienated many of us who feel deeply a part of this place. The villagers have come to feel that, since these newcomers are here, they may as well make as much money from them as they can. This has changed the character of Sag Harbor, and it no longer has the same feeling of a community.

I sold the family house in 2004, five years after my father died. "It's the end of an era," one man said to me. It started out as a captain's house of 1835, and people added on to it over the years. Many people in the village hoped I'd keep it. Instead, I bought a little ranch house on three-quarters of an acre and lived there for two years, but it didn't feel right. This is no longer the peaceful place I want my daughter to grow up knowing. Superficially it looks the same, but the feeling and the tone are quite different.

I realized how different one Saturday last summer when I ran out of milk. In what used to be a five-minute drive to the store, we got stuck in bumper-to-bumper traffic, waiting to get over the bridge. When we turned on to Main Street, there was nowhere to park. That incident—and, of course, my father's death—fueled my decision to move. I sold the ranch house and with the same money bought twenty-six acres upstate with a stream, a pond, a panoramic view, and a sense of the country that has been lost around Sag Harbor. But I feel badly about moving away. It has been hard to leave my parents behind in the cemetery. I sometimes wonder why I did that, and I am constantly awash in nostalgia for the village I used to love.

I cannot say for sure that I will not be back.

FUJIFILM RAP 61851 BJ CHJI

Tho Boreas' winds and Neptune's waves
Have toss'd me to and fro,
By God's decree, you plainly see,
I'm harbor'd here below.

—GRAVESTONE OF FAVIECO MAECEIA (D. 1858),
A PORTUGUESE SAILOR, BURIED IN OAKLAND CEMETERY

At the end of our streets is sunrise;
At the end of our streets are spars;
At the end of our streets is sunset;
At the end of our streets the stars.

—George Sterling, "The City By the Sea" (1922)

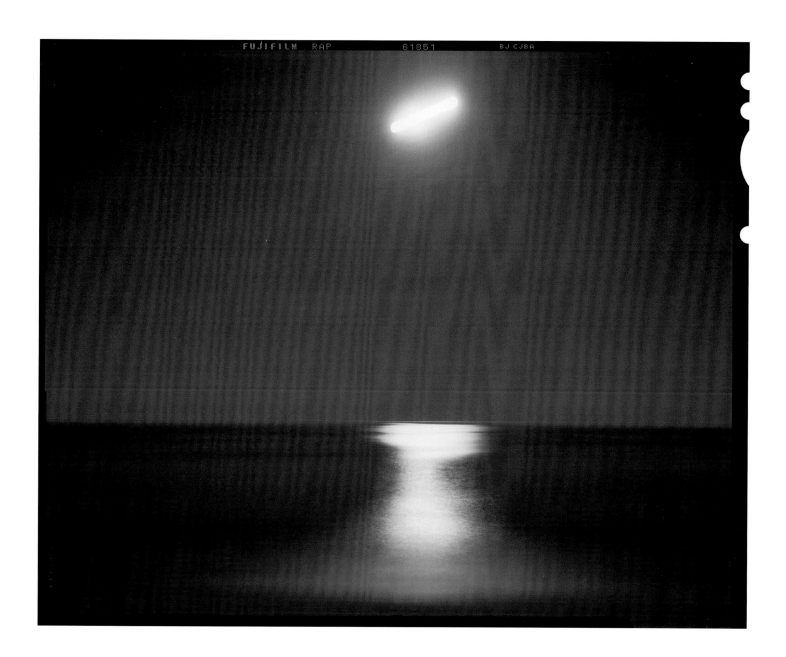

Where Houses Are Historians

The places we have known do not belong only to the world of space
on which we map them for our own convenience. None of them
was ever more than a thin slice, held between the contiguous
impressions that composed our life at that time; the memory
of a particular image is but regret for a particular moment;
and houses, roads, avenues are as fugitive, alas, as the years.

—MARCEL PROUST, *Remembrance of Things Past* (1913)

Looking Back

SAG HARBOR TURNED 300 IN 2007. Venerable as that sounds, it makes the village a late
bloomer for Long Island's East End, where many communities date back to the
seventeenth century, the result of Puritan migrations from New England intended to
discourage the Dutch settlements around New Amsterdam (soon to become New York) from
spreading too far east.[1] The English colonies at Southampton and East Hampton—founded,
respectively, in 1640 and 1648—were Sag Harbor's parents, yet the port's beginnings were more
organic than either of these carefully planned communities, whose boundary line it straddles.
(Until Sag Harbor incorporated in 1846, monthly town meetings in the two colonial centers,
each some ten miles distant, were the prevailing local governments.) While the surrounding
Hamptons were guided by their churches, Sag Harbor's church was commerce.[2]

The village is justly proud of its architectural heritage, yet none of its current buildings stood
there in 1707. Sag Harbor had no permanent structures at that time, or for some time thereafter.
At least one house dates back to 1693 (page 51), but its first years were spent several miles up the

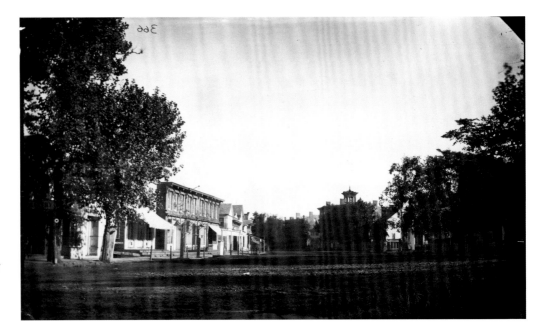

Main Street, Sag Harbor, ca. 1880, photographed by George Bradford Brainerd. Courtesy of the Brooklyn Museum/Brooklyn Public Library, Brooklyn Collection. (Brainerd's negative numbers appear reversed because they are scratched into the emulsion side of his glass plates and print backward as a result.)

road, in the oceanside farming community of Sagaponack, from which the port derives its name. The house was moved five times along the way to its current Union Street location—an old Yankee habit rich with the thrift that built such proud and simple dwellings. It will not be moved again, provided Sag Harbor keeps its current historic preservation laws on the books.

The village had few, if any, lasting structures before the mid-eighteenth century. Legend has it that the first white settlers, possibly fishermen, dug crude shelters into the side of the long-vanished Turkey Hill, which stretched south of the harbor just east of Main Street. Its soil was used to fill the marshland that originally covered today's downtown. Early Southampton settlers called the area Great Meadows and valued its marsh grass, or "salt hay," as winter forage for their livestock. The colony's "proprietors," who collectively owned its common lands and parceled them out among themselves in occasional land lotteries, clearly did not anticipate a built-up port in 1680, when they divided some of the meadows into large, privately owned lots for gathering the forage. (At the same time, they divided the adjacent peninsula of Hog Neck, today's North Haven—purchased fifteen years earlier from the Manhasset Indians on neighboring Shelter Island—into agricultural plots.) The small lots that would establish Sag Harbor's familiar

pattern of modest houses and surrounding yards were not created until 1745, with a further allotment in 1761.[3]

Several tall houses, built around 1790 in the Federal style, are set into a gentle incline at the southeast edge of the business district, where Main and Madison Streets converge. These hillside houses may owe a debt to the early "dugouts." With three stories up front but only two at the back, there is room for a shop in the exposed basement of the Peleg Latham house (page 145). Once a grocery, it sold antiques and clothes for many years under the name of Latham House. The business has moved on, but the old-fashioned hearth remains, a furnace to warm the entire structure. Several buildings of this vintage survive in Sag Harbor, but very few are older, except for the handful moved here from neighboring hamlets that predate it.

The only settlement of any size nearby in the harbor's first days was probably seasonal—a pattern destined to last, though the Indian village of Wegwagonock did not. Early land deeds and archaeological evidence place this encampment at the east edge of the harbor, but its use evidently declined within the first years of white settlement. The Algonquian name translates "the place at the end of the hill," according to William Wallace Tooker (1848–1917), a self-taught expert on local Indian language and culture who excavated the site, now built over, in the nineteenth century.[4] The prolific deposits of shellfish shells he unearthed help to explain the site's popularity among native people for millennia. Tooker was also Sag Harbor's pharmacist and a talented amateur artist and photographer, who left a visual record of its earliest buildings still standing in his lifetime (pages 35, 58, 148, 156, 211, and 230).

The harbor may not have had a year-round community much before 1730; by mid-century, it is said to have had three houses, all long gone.[5] But the port was active earlier, a visit the New London merchant Joshua Hempstead recorded in his journal for June 1714 makes

"Early House, Division and Rector Streets, Sag Harbor" (now Murph's Back Street Tavern), photographed by Kathryn Abbe, 1944. Courtesy of the photographer.

clear.[6] His purpose: to sell a barrel of rum. The port's first known bill of lading dates to 1731, for "the good sloop called the *Portland Adventure . . .* now riding at anchor in the harbour of Sagg, and by God's Grace bound for New York" with a cargo of "Five barrells of Beef and nine barrells of Pork, two Furkings of Butter, two ditto Cranberry, and one ditto of Eggs."[7] Clearly there was traffic in and out of Sag Harbor before the *Portland Adventure* requested divine assistance to reach New York harbor, lending credence to the rumor that the port's earliest shipping went undocumented, evading British taxes unpopular among East End merchants.

The merchants who traded in pre-Revolutionary Sag Harbor didn't necessarily live there. A ledger the Bridgehampton shopkeeper John Hulbert kept in the 1760s, now in that hamlet's library, chronicles the whaling and shipping business he conducted from Sag Harbor. His son, Colonel John Hulbert (1738–1813), earned lasting local fame by leading a company of Minute Men at the outset of the Revolution. For much of the twentieth century, patriotic East End historians believed this second John Hulbert carried the first American flag as he marched British prisoners of war from Fort Ticonderoga in upstate New York towards Philadelphia in 1775. The tale is now as tattered as the flag, which hangs in the Suffolk County Historical Society in Riverhead, but the two Hulberts remain key figures in early Sag Harbor.[8] When Long Island was lost to the British in 1776, Colonel Hulbert headed for Connecticut, like most East End patriots who could afford to. Many sailed from Sag Harbor, where he settled after the war, working as a saddler.

The port first enters the historical record in 1707, when the Southampton Town Trustees and New York's colonial governor both sent representatives there, to investigate land and shipping claims, respectively. The trustees, representing the town's "freeholders and inhabitants," paid someone three shillings and sixpence, "for going to Sag Harbor to evidence for ye town," their account book notes. One theory has it they were trying to evict a squatter.[9] Perhaps they were settling an early surveyor's bill, since the border with East Hampton was disputed early on. But no survey has survived, and the historical record is silent on the details. Even less information is available about the governor's inquiry into Sag Harbor shipping, though it is well known that a tug-of-war was underway between East End merchants and crown representatives in New York over customs taxes on local shipping.[10] Together, these two 1707 visits sketch the dim outline of a new kind of settlement for the East End, a mercantile port operating by its own rules.

Whatever their errand's purpose, Southampton's trustees were the first to call the fledgling port by name, at least in print. The tercentenary celebrated in Sag Harbor in 2007 does not com-

memorate anything so formal as a founding, but the birth of a place-name and perhaps a concept: a mercantile port for the farming and fishing communities of the Hamptons. By contrast, the founders of Southampton, the oldest English colony in New York, made a compact to live in community before sailing from New England. They treated their common land as stock in a corporation, effectively sealing their borders against newcomers they did not invite. Sag Harbor's birth was far less deliberate, a response to developing trade relations.

Long Island shipped 4,000 barrels of whale oil in 1707, much of it landed and "tryed out" on its ocean beaches.[11] There is no record how much of this valuable commodity passed through the new port of Sag Harbor.

The East End colonists began whaling as an off-season business soon after they established oceanfront communities in the 1640s. The settlers took advantage of "drift whales" that accidentally beached while feeding close to shore on their annual winter migrations down the eastern seaboard. At first, the colonies required all members to take part in the chilly job of keeping lookout for the stranded marine mammals. They also shared the more onerous tasks of "cutting in" and "trying out" the whale's thick insulating layer of fat, or blubber, as it was boiled down into oil in iron kettles along the shore. The oil was shipped in casks to Boston and then London and used to light lamps. The whale "bone," or baleen, found in the jaws of the "right whale"—the one that didn't sink when it died—was valued as a flexible support for women's clothing and household goods.

The Englishmen took a cue from their Indian neighbors—dubbed the Shinnecock in Southampton and the Montauk, or Montaukett, in East Hampton, after local place-names—who also enjoyed this bounty, though the Indians presumably appreciated the whales as a food source; something whites seldom, if ever, did.[12] The Montaukett reserved the "fynnes and tayles" of drift whales in an early treaty with the East Hampton colony—portions for which the settlers had little use.[13] Indian bows made of baleen survive; similar tools may have been used to hunt the animals from which they were taken, before English blacksmiths crafted iron harpoons.

Soon, the colonists began to pursue whales feeding inside sandbars along the shore in double-ended rowboats they daringly launched into the surf with crews of six or seven. The men rowed right up to the vast creatures, so a harpooner in the bow could hurl his "dart," attached to fathoms of line, and begin the chase. The whale might sound and surface, towing the boat

through the icy water, until the exhausted animal could be lanced and tugged back to shore. The agile whaleboats, nearly thirty feet long, are reminiscent of those Basque whalers used on the coasts of Labrador and Newfoundland in the late sixteenth century. The Dutch also had seasonal whaling stations along the shore of western Long Island and may have ventured farther east, before the English arrived.

Opinions differ about how many of the skills of "shore whaling" the East End colonists learned from their Indian neighbors and how much contact the native people may have had with other European whalers before the settlers arrived, but the two groups clearly had different interests in the hunt. Nevertheless, the settlers were employing Indians as crew members in their winter whaling "companies" by 1670, perhaps earlier.[14] This employment practice would continue when shore whaling was replaced by deep-sea whaling in the mid-eighteenth century. Once the whales grew shy of land, the portable whaleboats were loaded aboard larger sailing craft so the hunt could proceed farther from home.

WHALE PRODUCTS were hardly the only commodities shipped from the East End's landings at the outset of the eighteenth century. Cod fish and cord wood were also significant trade goods, as was produce, including meat, from the region's farms. In its first decades, the new landing was often called "the harbor of Sagg," after Sagg, now Sagaponack, the nearest farming hamlet, six miles south towards the Atlantic Ocean.[15] Sagaponack is named for a ground nut or potato-like tuber that the Indians gathered nearby. Fittingly enough, potato farming was the staple of its economy for most of the twentieth century. Against considerable economic odds, it remains a farming community, its only downtown business the general store that shares premises with the post office.[16]

Although Sag Harbor's early cargoes included farm produce, farming was never its leading business. Nathaniel Prime, one of Long Island's first historians and the village's first Presbyterian minister, explained why in 1845: "The site of the village is a perfect sand-bed; and, consequently, agriculture presented no motive to the settlement of the place."[17] This distinguished it from the surrounding Hamptons, whose first business was farming, whatever else they did in the off-season. Sag Harbor has usually had one or two small farms, as it does today. (See the story of the Cilli family's dairy on page 276.) But a recently organized farmer's market, where produce of the region is sold beside the harbor, is much more in keeping with its historic role in local agriculture.

"Carriage House (built 1797) for Nathaniel Prime's Parsonage, Sage Street, Sag Harbor." Drawing by Joan Baren, 1973. Courtesy of the artist.

By the time British troops occupied Long Island for the seven years of the American Revolution, Sag Harbor was their eastern stronghold and clearly the region's leading port, strategically located in sheltered water near the mouth of Long Island Sound, the gateway to New York. Many of the property owners who evacuated to Connecticut sailed from Sag Harbor's Long Wharf, which the towns of East Hampton and Southampton had built on their dividing line in 1770, replacing smaller wharves of the 1740s and 1760s.

The occupying force was received even more equivocally than today's "summer people." Residents who stayed behind had to pledge allegiance to the King of England and supply his troops with food and shelter. As a result, they were deemed traitors and plundered by patriots

from the mainland. Rebel privateers repeatedly attacked the British encampment from Connecticut, burning its ships and supplies. In the most famous of these attacks, Lieutenant Colonel Return Jonathan Meigs crossed Long Island Sound and Noyac Bay with a fleet of thirteen whaleboats (portaging them across a narrow spit of land on the island's North Fork) in May 1777. Arriving in Sag Harbor by night with a force of 130 men, Meigs captured some ninety British soldiers without sacrificing any of his own, set fire to a dozen British vessels and their provisions on Long Wharf, and returned home just twenty-five hours after he left. The victory earned him a Congressional sword and the praise of General Washington, who a year earlier had surrendered Long Island to the British at the Battle of Long Island, the first and largest battle of the Revolution, fought on Brooklyn Heights. Meigs's raid remains a source of local pride; it was re-enacted in 2002, in honor of its 225th anniversary.

A British blockade of Gardiner's Bay in the War of 1812 interrupted Sag Harbor's early whaling trade and resulted in several military installations to protect the port (including the vanished arsenal shown on page 35, which later served as its Custom House). This time the British attacked Sag Harbor only once and were repelled, but not before they had shelled the Umbrella House (pages 148–49). A repair to the masonry can be seen on the harbor side, where the cannonball struck. William Wallace Tooker believed this unusual brick barn, named for the shape of its low gambrel roof, predated the Revolution, though subsequent local authorities have dissented.[18] By 1791, it housed a hat factory. An early postcard calls the Umbrella House "the oldest Historical House in Sag Harbor," and it's hard to argue with that. A threat to the beloved building helped Sag Harbor firm up its preservation statutes in 1985.

Whaling took off in earnest after the War of 1812, a three-year assault on American shipping. Beginning with the *Argonaut*, Sag Harbor's ships rounded the tip of South America at Cape Horn, extending their hunting grounds into the Pacific. With fifteen-foot swells and occasional icebergs, this meeting place of the Atlantic and Pacific oceans was not for the faint of heart. But it had its rewards: the *Argonaut*'s Captain, Eliphalet Halsey, brought back 1,500 barrels of whale oil in 1816, persuading others to follow.

Except for a few hand-drawn maps (page 204), there is no pictorial record of the port's first century. A late-nineteenth-century watercolor by Anna Frances Sleight (page 203) survives, but the original on which it was based—called the earliest example of Long Island landscape art—has been lost.[19] The image shows an oil warehouse and cooper shops along Sag Harbor's cove, with the Long Wharf proudly pointing out to sea.

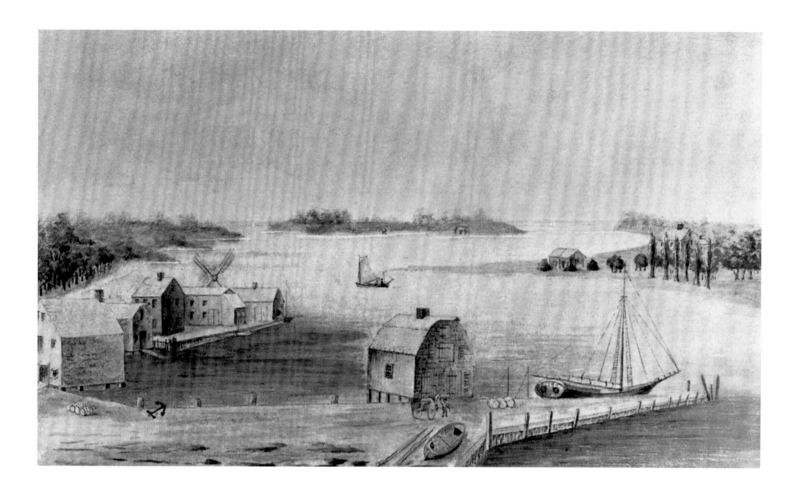

New York's first English colonists landed several miles west of the future site of Sag Harbor when they sailed to Southampton from Lynn, Massachusetts, in 1640. They called their landing place Conscience Point and the bay they crossed to get there North Sea, since it bordered their new home to the north. Sailing to North Sea involved navigating several tidal channels to reach a shallow inlet of the Peconic Bay, which separates the East End's two forks of land—hardly a promising site for a port. By the late seventeenth century, East Hampton had developed a more accessible (but not much deeper) landing at Northwest, just east of where Sag Harbor would develop. The shore whaler and merchant Samuel Mulford (1644–1725) had a wharf and ware-

Long Wharf, Sag Harbor in 1803. Watercolor, ca. 1895, by Anna Frances Sleight, based on her ancestor Elizabeth Sleight's 1803 view of the waterfront. Original in color. Courtesy of the John Jermain Memorial Library, Sag Harbor.

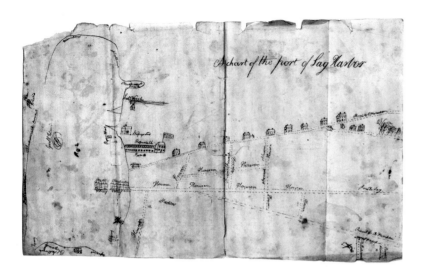

"A chart of the port of Sag Harbor," ca. 1800.
Courtesy of Eben Fiske Ostby.

house inside Northwest Creek as early as 1702.[20] Although he commuted from East Hampton, a farming community developed at Northwest. By the late eighteenth century, it was large enough to merit its own schoolhouse. Now, all that remains are a few cellar holes and family graveyards in the woods and the spectacle of a road not taken, returning to nature.

The presence of Northwest Harbor, so close to early Sag Harbor, makes one wonder why Sag Harbor developed at all. By land, the "harbor of Sagg" was far more accessible to Southampton, which lacked a convenient trading place, and it was the only one of the South Fork's early landings with deep enough water for the large square-rigged vessels on which deep-sea whaling would rely. The East End's earliest maritime trade routes focused on New England, using smaller sloops and schooners called "coasters" because of the way they ranged up and down the Atlantic coast. Some ventured as far south as the West Indies, one of Sag Harbor's key trading partners before the Revolution halted commerce.[21] These vessels exported surplus goods to supplement the local farming and fishing economy and imported necessities from New England. Local historians once idealized the East End's colonial period as a time of pastoral isolation, but recent history suggests its Puritan settlers were mercantile in their aspirations from the outset.[22] Once growing trade relations inspired the development of Sag Harbor, where deeper water allowed for larger vessels, there's little doubt about it. Otherwise, there would have been no incentive to the enormous landfill operation that created downtown Sag Harbor.

EARLY EAST ENDERS, like some of their descendents, did their best to ignore New York City, which was Dutch, not English, when they arrived from Massachusetts Bay. The East End colonies attached themselves to Connecticut in their first decades and felt closer to New England, as indeed they were, not only by religious persuasion, but also by sea, the quickest way to travel at the time. Soon after New York became British in 1664, it annexed Long Island, although the Dutch took it back for a year a decade later. Whereas Connecticut viewed the East End colonies as part of the larger Puritan experiment in the New World, New York's governors—

put in place by the newly restored English monarchy, which had just survived the challenge of Puritanism—clearly saw these outlying communities as a source of revenue and taxed their trade, particularly shore whaling, making East Enders regret this enforced alliance.

An active civic leader, Samuel "Fishhooks" Mulford was a captain in the colonial militia, an East Hampton Town Trustee, and a representative to the colonial assembly in New York. He spent the first two decades of the eighteenth century protesting unpopular taxes on East End shipping and whaling, which he considered little more than graft. A speech he delivered to the colonial assembly in April 1714, which William Bradford printed as a broadside, argued his objections to the requirement that East End vessels clear customs in New York City, even if they were headed in the opposite direction to New England.[23] He requested a custom house closer to home and relief from the licensing fees New York's governor had placed on shore whalers. Mulford earned his nickname in 1716 on the second of two trips to London protesting these fetters on colonial trade. After falling prey to one of the capital's notorious pickpockets, he sealed his tailcoat pockets with fish hooks and snagged one of the villains, legend has it. The ensuing celebrity reportedly allowed him to address Parliament, where he discouraged pickpocketing the thriving colonial whaling trade. No record of this speech survives, but, soon after his visit, the licensing fees were revoked. Mulford and the colonists he represented clearly saw themselves as Englishmen living abroad, not second-class citizens off whom the nobility could improve its wealth. His protest was a forerunner of the widespread colonial objections to taxation without representation that greeted the Stamp Act of 1765.

East Enders had been promised unfettered rights to fish as a provision of the land patents they were compelled to purchase to re-establish their town governments after being annexed to New York. Prior land patents, or grants, had been nullified in the process, over vociferous protests. (Although they were instructed to bargain with the local Indians and to pay a fair price, the East End's first white settlers required permission from colonial authorities in New England to own land which the crown claimed for itself.) Named for the royal governors of New York who issued them, the Andros patents of 1676 and the Dongan patents of 1686 remain the founding documents of the East End townships, whose governments predate the United States. When whales proved valuable, later governors declared them "Royal Fish," excising a portion of the profits. To this day, trustees of the East End towns protect the rights of residents to use communally-owned underwater lands, and to this day beleaguered local fishermen argue that state regulations cannot deny them rights guaranteed in perpetuity by the early patents, which New York's

Constitution is bound to honor. The argument seldom prevails, since the state can also amend its laws, but Mulford's protest still has echoes.[24]

As THE EARLY PERIOD of shore whaling declined—probably from overfishing—its practices were gradually transformed into the new industry of deep-sea whaling. The small, seaworthy whale-boats were shipped on larger craft, over whose sides they could be lowered, much like the modern lifeboats that mimic their design. At first, the host vessels were mid-sized sloops, used to search for whales along Long Island's ocean shore: "the back of Long Island," some early mariners called it. As voyages grew longer, the fore-and-aft-rigged sloops were replaced by larger, square-rigged vessels, insuring the success of Sag Harbor, the East End's deep-water port. (See Luther Cook's 1837 account of the origins of Sag Harbor whaling on page 257.) Killing the whale remained a matter of hand-to-hand combat with harpoon and lance, though it happened in the open ocean, sometimes out of sight of the mother ship. Deep-sea whaling targeted a broad spectrum of whales, as the surface-feeding right whale became scarce. The clear oil of the sperm whale was especially valuable, but its teeth tore open boats and men. (See page 266 for a note-worthy example.)

Once killed, whales were lashed alongside the sturdy ships and carved into slabs of blubber. Initially, these were brought home to be tried out, or reduced to oil. A set of iron caldrons called a try-works stood on the shore, just east of today's North Haven bridge, in Sag Harbor's early days. By all accounts, the stench was memorable. The innovation that allowed whaling vessels to wander far from home, with three or more boats on deck, reached Sag Harbor soon after the Revolution, several decades after it was pioneered on Nantucket craft. The twin try-pots were loaded back-to-back on deck, on a brick-lined furnace that made the ships floating oil refineries—and serious fire hazards. It also relieved the harbor of their noxious black smoke. Each vessel's hold was stacked with hundreds (later, thousands) of barrels for oil, many of them assembled aboard ship from staves of Long Island white oak that a cooper had cut on shore. Each barrel held roughly thirty gallons; back in port, a man called a "gauger" would determine the precise amount. When the hold was full, the bricks from the furnace were thrown overboard. A cask was hoisted up the mast, announcing a full ship. On average, a right whale might yield three dozen barrels of oil.[25]

The oil was brought back to Sag Harbor's Long Wharf, which in 1821 had been extended to 1,000 feet. Ringed by workshops, it was the hub of a bustling trade. While awaiting transit to the New York markets (and, perhaps, a better price), oil was stored in warehouses along the water-

front and packed in wet seaweed so the barrels wouldn't dry out and leak. These could be dangerous places in a port afflicted by fire. A warehouse belonging to the firm of Mulford and Sleight—on the same location where Mobil Oil kept its tanks for much of the twentieth century—went up with a bang on the night of July 4, 1860, in an inferno so intense it ignited the rigging of nearby ships, as well as a supply of "bomb lances." These explosive harpoons made deadly bottle rockets and a memorable noise. They were the invention of a Sag Harbor captain, Thomas Welcome Royce, who lost a hand testing his handiwork.

In 1848, as Sag Harbor's whale fishery was slipping into decline, Royce guided the bark *Superior* through the Bering Strait between Alaska and Siberia, extending the whaling grounds north into the Arctic Circle. At 275 tons, the *Superior* was smaller than many whaling vessels of the period. The crew filled its hold in a mere thirty-five days, probably hunting day and night under the ceaseless arctic sun and killing, on average, a whale a day. These frigid waters kept New Bedford whalers busy for decades after the Sag Harbor captain opened the door. Twice in the 1870s, the daredevil fleet got trapped in polar pack ice, with dozens of ships broken up and lost. Some of the sailors escaped to other vessels, but the cargoes went down with their ships.

LIKE THEIR PURITAN ANCESTORS, Long Island whaleship owners of the eighteenth and nineteenth centuries relied on local Indians, as well as African Americans, to help make up their crews. There must have been competition for skilled harpooners in the early days, since seventeenth-century Southampton and East Hampton ordinances forbade colonists from overpaying the Indians they hired, expressing particular concern about reimbursing them with firearms. In the early days, Indians were often paid on credit, with goods, at rates that guaranteed they would end the season in debt—a form of peonage not unlike Southern sharecropping after the Civil War. By the nineteenth century, a whaler's pay was a "lay," or percentage, of the catch, less the cost of his outfit and perhaps some life insurance, payable to the ship's owner, of course. Given how little a sailor might expect from a 200th lay, latter-day Indian whalers, or "green hands" of any color, earned

Beebe Windmill, Bridgehampton, 1978, photographed by Jet Lowe. Courtesy of the Library of Congress, Prints and Photographs Division (Historic American Engineering Record).

little more than their keep. After an unsuccessful voyage, they, too, might end up in debt to the ship. The easiest way to repay such a debt was by signing on for another voyage, hoping for better luck. (Sag Harbor's "Indian jail" was the anchorage off North Haven where crews were sequestered the night before sailing to keep them from deserting, since many sailors could not swim.) Despite this exploitation, whaling was one of the few jobs available at the time that had no color bar and offered minorities some opportunity for advancement.

Many Sag Harbor crewmen came from Eastville, the early mixed-race neighborhood at its outskirts; others came from East End farms. Casualties or deserters might be replaced with natives at the various ports of call, some of them on South Sea islands—so Melville's Queequeg is not altogether imaginary. The Sandwich, or Hawai'ian, Islands were a regular stopover. By 1900, nearly half the crewmen on New Bedford whaleships came from the Cape Verde Islands, off Africa's western coast. John Hulbert's journal of the 1760s contains records of slaves sent whaling by their masters, a little-documented early practice.[26]

Boatsteerers, mates, and captains received progressively larger shares of the catch, an incentive for them to risk their lives and go for the cetacean gold and for less experienced men to aspire to their ranks. Captains might own a share of the boat, improving their odds for fortune. Lest one conclude that the most dangerous jobs were reserved for those at the bottom of the social ladder, captains took their sons whaling, and the kill was the privilege of the most senior man aboard each whaleboat. Sailors of color occasionally rose through the ranks. It's unknown how high they rose on Sag Harbor ships, but abolitionist Nantucket was home to a black captain, Absalom Boston, by 1822, five years before New York outlawed slavery.[27] With its whaling heritage, Sag Harbor had a more open society than the church-run Hamptons that spawned it. It struggles to retain this democratic spirit, despite the current value of its real estate.

THE MAN BEARING the burden at the center of the extraordinary, hand-colored, full-plate daguerreotype (page 31) that may well be Sag Harbor's earliest surviving photograph is clearly dark-skinned, though little can be said of his background. He could as easily be African American and/or American Indian as he could be native Hawai'ian or Portuguese. All of these groups and more participated in the whale fishery. This man's name and story are even less likely to surface than the photographer's, but his face almost survives. It is a blur, like his identity. The scene may be a warehouse on Long Wharf, where a ship was being provisioned; hence, the appearance of a butcher's shop. This stark and remarkably candid glimpse into an unsuspected

corner of the past stunned me when I first saw it. It seemed at once so contemporary and so distant, not to mention the fierce odds against its survival at all.

Unlike photographs printed from negatives, daguerreotypes are one-of-a-kind, the Polaroids of their day. The silvered sheets of copper weren't cheap; most were made by photographers who worked for hire and who seldom exposed a plate without a client. As a result, the vast majority of daguerreotypes are portraits. The process, photography's first, was popular from the 1840s through the mid-1850s, two very different decades in Sag Harbor. Given the port's shifting fortunes, it's tempting to date this picture to the forties. But the photographic evidence, including the mount, puts it close to 1850, on the cusp of the port's decline, after the demise of its whale fishery. The ship being outfitted may be headed for California, part of Sag Harbor's exodus during the Gold Rush.

It's hard to imagine a commercial rationale for making this picture, especially in uncertain times. But if it is the work of a local amateur, what became of the rest of his efforts? And where are the rest of the photographs of the harbor in its prime?[28] Hard times may have spared Sag Harbor's houses, but they scattered its records, since the village had no archive in the nineteenth century. It still faces challenges in this area, despite the dedicated efforts of several local historical institutions. Maybe there was no time for pictures when there were ships to load and unload, no reason to record local life when it seemed unlikely to change beyond recognition. It's hard to avoid seeing the trail of time's fleeting passage in such early photographs, given how completely their worlds have vanished, but did this photographer have any idea how rare his view would be? The historian of photography Keith F. Davis believes this plate may have been exposed by a skilled "camera operator" visiting from New York. If so, the fact that it stayed behind for more than a century suggests he had a local friend or client.[29] It may have been made because Sag Harbor whaling appeared to be an endangered species, like its quarry. Then, as now, photographers kick into gear when they see the past before their eyes.

For a taste of the supplies being loaded by these long lost sailors, whom Sag Harbor's oldest photograph has kept alive, consider the stores the bark *Monmouth* carried on a year's voyage:

60 barrels pork, 60 barrels mess beef, 24 barrels flour, 8000 pounds bread, 2500 pounds pilot bread, 400 pounds ham and shoulders, 300 pounds cheese, 700 pounds butter, 7 barrels vinegar, 3 barrels dried apples, 3 bags coffee, 500 gallons molasses, 300 pounds cod fish, 16 pounds pepper.[30]

Methodist Church, High Street, 1854 (one of fourteen engravings based on daguerreotypes on the Wall & Forrest map of Sag Harbor). Courtesy of the Brooklyn Historical Society.

SOON AFTER THIS unsigned plate was exposed, Isaac Sylvester Van Scoy and his partner, whom we simply know as Douglas, were listed as Sag Harbor's "Daguerrian artists" on the village's first printed map, published in 1854 by the New York City firm of Wall and Forrest.[31] It is ringed with fourteen engravings, showing the village's most prominent buildings, including all five churches (page 210). Each engraving is said to be made "from a Dag. by Douglas & Van Scoy." This handsome map may have been designed to announce that Sag Harbor was still in business, despite recent reversals of fortune. Two new factories, the Montauk Steam Cotton Mills, and Byram and Sherry's Oakland Works, which made clocks and tools, are featured prominently. The daguerreotypes vanished long ago, but the engravings appear to be close copies of these early photographs of Sag Harbor's buildings. The prints include some characteristically photographic flaws, with the north-facing facade of the First Presbyterian (Old Whalers') Church deep in shadow and the front of the Baptist church—also built in 1844, perhaps by the same carpenters—obscured by a tree. A photographer couldn't alter these facts, but an engraver with more time on his hands (or one with access to the original subjects) easily could have done so.

By the time he contributed photographs of three more East End houses to the large map of Suffolk County that John Chace, Jr. published in Philadelphia in 1858, Vanscoy (as his name was spelled this time around) was working alone, in the cheaper ambrotype process.[32] (The Sag Harbor insert from this map is on page 27.) Ambrotypes, advertised as "non-reflective daguerreotypes," mimicked the look and uniqueness of the earlier process on the new photographic medium of glass. The son of a farming family from Northwest, East Hampton's early port, Van Scoy had already been to San Francisco and back, having invested in the ship *Sabina*, which went to the gold fields in 1849 with nineteen former whaling captains on its crew. The captains drew lots to determine who would take orders from whom, the story goes.

A later photograph attributed to Van Scoy shows Sag Harbor's first schoolhouse, built in 1786–1787. It stood on the corner of Jefferson and Madison Streets until it was dismantled almost a century later, in 1872.[33] The local antiquarian William Wallace Tooker made a remarkably simi-

lar drawing (page 211) a few years before it vanished, in 1869, during a year he spent studying with his grandfather, the portrait painter Hubbard Latham Fordham (1794–1872).

Fordham had just finished a stint as keeper of the Cedar Island lighthouse (page 23), the mariner's gatehouse to Sag Harbor. He painted a memorable view of the port from his waterbound window (page 33) while working there in 1866. A still life of shellfish serves as an elaborate joke to explain how he was keeping an eye on the harbor.[34] On an island amidst shoal waters, these creatures were staples of the lighthouse keeper's diet. The crustaceans all have prominent eyes (the painter had only one himself). Having painted Sag Harbor's gentry in its prime, Fordham was now watching over his village—visible in the distance—in a period of decline.[35]

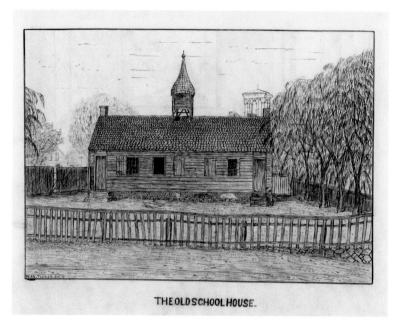

THE OLD SCHOOL HOUSE.

The Old Schoolhouse (demolished), Jefferson and Madison streets. Drawing by William Wallace Tooker, 1869. Courtesy of Nancy Carlson.

THE EXODUS TO CALIFORNIA is best described by another quirky local genius, the writer Prentice Mulford (1834–1891), who began his life in what is now Sag Harbor's Municipal Building. It was the Mansion House Hotel, when his father Ezekiel (a descendant of Samuel) owned it. Mulford ended up living on a whaleboat among the derelict whaleships in San Francisco Bay, in a one-piece garment he seldom changed. In his hapless and hilarious memoir, *Prentice Mulford's Story*, he chronicles his western escapades as a shipboard cook, a gold-digger, and a journalist. He also describes the traveling habits of the Sag Harborites he recalled from childhood, who were more likely to visit Hawai'i than the Hudson:

> Ours was a whaling village. Two-thirds of the male population was bred to the sea. Every boy knew the ropes of a ship as soon if not sooner than he did his multiplication table. Ours was a 'traveled' community. They went nearer the North and South Poles than most people of their time and Behring Straits, the Kamschatkan coast, the sea of Japan, Rio Janeiro, Valparaiso, the Sandwich Islands, the Azores and the names of many other remote localities were words in every one's mouth, and words, too, which we were familiar with from childhood.[36]

To this day, Mulford is acclaimed a mystic by a dedicated following on the West Coast and in Europe because of the prolific spiritualist writings of his later years. He died in his whaleboat on Brooklyn's Sheepshead Bay, headed back to Sag Harbor after several years in New Jersey. Years later, followers set up a memorial boulder on his grave in the village's Oakland Cemetery, inscribing it with the title of one of his books: *Thoughts Are Things* (1908).

Mulford's mid-century community differs sharply from the sleepy one Charles Hanson Towne recorded in 1921 in his travelogue, *Loafing Down Long Island*. By then, the local fishermen found their quarry closer to home, but they still steered clear of Manhattan:

> There are old fishermen here and roundabout who have never been to New York, no, not once in all their lives; yet they would tell one they had had a pleasant time of it, and would not count the years as lost which they have spent in this venerable village.[37]

JAMES FENIMORE COOPER, who is credited with writing the first truly American novels, deserves credit for introducing Sag Harbor to the idea, already tested on Nantucket, of company ships owned by a union of shareholders. This made whaling a communal venture, reminiscent of the early days along the ocean shore, but with a speculative twist. Around 1820, the aspiring novelist spent several years in and around Sag Harbor visiting his wife's relatives, including the whaling agent Charles T. Dering, his business partner in the ship *Union*. (William Wallace Tooker later owned Dering's house; see pages 153 and 155.) Although he lost money on the venture, Cooper's Sag Harbor years yielded invaluable material for his seafaring novels, notably *The Sea Lions* (1849), which includes a portrait of Sag Harbor's doctor, Ebenezer Sage, a member of Congress during the War of 1812. Local readers of the day were also convinced that Natty Bumppo, the hero of Cooper's popular *Leatherstocking Tales*, was Captain David Hand, a colorful Revolutionary War hero who escaped British custody as often as he married (five times each) and moved his modest three-bay "half house" almost as frequently (three times).

The triangular junction of Main and Madison streets, where the Sagaponack and Bridgehampton roads converge in their final approach to the harbor, was called "Hand's corner" before Captain Hand ceded the choice location to his son, moving his modest dwelling to Church Street (pages 58–59 and 213). The handsome Greek Revival house that his son built around 1840 is named for a subsequent and more prominent owner, Oscar Stanton. As a young naval officer, Stanton accompanied Commodore Matthew Perry when he forcibly opened Japan

David Hand House, Church Street,
photographed by its owner, Otto Fenn, ca. 1970.
Courtesy of John Krug.

to U.S. trade in 1854. Ten years later, Stanton fought at the Battle of Mobile Bay, ending his career as an admiral stationed in New London. Fittingly enough, the Civil War memorial stands outside his former home. More recently, it housed the Allan Schneider real estate agency, which opened Sag Harbor to another kind of trade.[38]

THE VILLAGE'S MOST AMBITIOUS BUILDING, its Old Whalers', or First Presbyterian, Church (pages 43–45, 47–49, 214, and 234), was designed for this traveled community by Minard Lafever (1797–1854), a prominent New York City architect who is credited with disseminating the Greek Revival style through his builder's guides. He is also remembered for several Gothic Revival structures, built towards the end of his life, in Brooklyn Heights. The architect Calvert Vaux, Frederick Law Olmsted's collaborator on the design for New York City's Central Park, among other projects, dubbed Lafever "the Sir Christopher Wren of America," a popularizer of historical styles. The first edition of Lafever's handbook, *The Modern Builder's Guide* (1833), was pub-

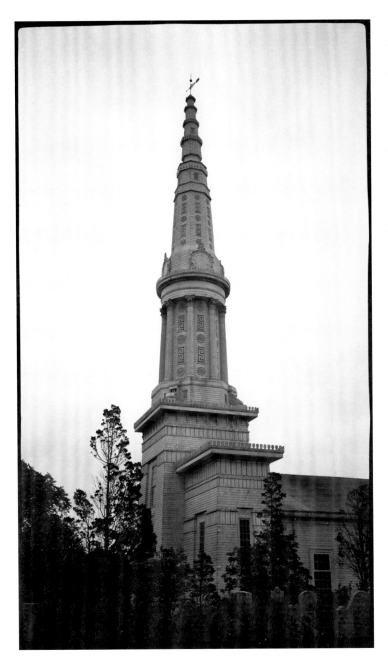

First Presbyterian Church, Sag Harbor, ca. 1935, photographer unknown. Courtesy of the Library of Congress, Prints and Photographs Division (Historic American Building Survey).

lished in New York by a member of Sag Harbor's prominent Sleight family, who had a relative on the building committee planning the village's new church.[39]

A rare example of the Egyptian Revival, the massive church was completed at the height of Sag Harbor's prosperity in 1844, in the midst of a religious revival that had sailors taking temperance pledges. A year later, the harbor burned. The building can seat a thousand in a pinch, but it rarely has been asked to. Its most prominent feature is a distant memory: the steeple (page 214) so tall it was visible from Montauk Point, where the lighthouse George Washington commissioned in 1795 greeted returning mariners at Long Island's craggy easternmost tip, twenty miles away. Many old Sag Harbor houses contain relics of this wedding-cake spire, retrieved after it lifted off in the hurricane of 1938. It landed on the church's front walk, then toppled into the Old Burying Ground next door. Nearly 150 feet tall, the telescoping confection was a mix of architectural styles, in homage to the whaler's exotic ports of call: part Chinese pagoda, part Turkish minaret, on an octagonal base inspired by the work of the first Sir Christopher Wren (1632–1723). The monolithic church, as white as whalebone, is now reduced to its essential lines (page 43), echoed in the shape of the organ within (page 49), a New England meeting-house that fell in love with an Egyptian temple. A little at a time, it is being restored. The interior is brighter than it has been in years (pages 47–49), after a coat of paint and new windows, replacing glass that had purpled with the years.

"Before I die," insists Randolph Croxton, a parishioner and the architect of the restoration, "I'm going to get that steeple up." This is Sag Harbor's version of the old Passover vow: "Next year in Jerusalem."

One of the silver name plaques on a front pew in the church belonged to Benjamin Huntting, a ship owner who commissioned Lafever to build him a Greek Revival mansion down the street (pages 37–39 and 65). Like the church, its roof is flanked with ornamental blubber spades, modeled on the tools whalers used to peel the valuable fat from their defeated quarry once the animals were lashed beside the ship, carving it into "horse pieces," "blanket pieces" and "bible leaves," to be boiled down on deck. Blubber spades were also useful in fending off sharks, which often gathered to watch. Hoisted to the sky, the tools are a graphic explanation of the family's considerable fortune, a heraldic coat of arms. This roofline, more ornate than the church's, also includes hand-carved sperm whale teeth and occasional harpoons. Benjamin's father, Colonel Benjamin Huntting, was the village's inaugural whaling magnate and a member of the New York State Senate. The brig *Lucy*, which he owned with Stephen Howell, the other patriarch of Sag Harbor whaling, returned from a year on the Brazil banks in 1786 with 360 barrels of oil, the port's first big haul.[40] The Huntting and Howell men remained captains of the local whaling industry in the next generation and built houses to match their stature in the community (pages 52, 67, 69, and 183).

John Howell is remembered on the elegant Broken Mast Monument in Oakland Cemetery, a memorial to six young whaling captains lost at sea. All came from prominent local families; none was over thirty. In language reminiscent of the solemn tablets Melville's Ishmael finds in a New Bedford church at the outset of *Moby-Dick*, the inscription tells how they "periled their lives in a daring profession and perished in actual encounter with the monsters of the deep." This cenotaph commemorates more than six brave men who died too young. When it was erected in 1852, six years had passed since the last of them had died, and it was twelve years since John Howell, whose name is carved larger than the rest, encountered a sperm whale and his death in the Pacific. A more recent loss was Sag Harbor's whaling fleet. This is a memorial to a culture— "that noble enterprise, the whale fishery"—which had acquired Homeric proportions in retrospect, from the patrician vantage of owners retiring with full ships and a conspicuous shortage of sons. With its marble coil of line and crossed harpoons around the central column of its broken mast, and with its bas relief (page 105)—showing a whaleboat crew clinging to the overturned craft that is their captain's funeral bier, the mother ship and an escaping whale both visible in the

background, scratched into the stone like scrimshaw—the monument is so refined that one local expert wonders if Lafever didn't design it, too.

THE CELEBRATED ARCHITECT has been credited with contributions to several more Sag Harbor houses, but none of these attributions has stuck. In the mid-twentieth century, Lafever's name was associated with portions of the interior of the Italianate Hannibal French house (pages 70, 72–73, 77, and 121), across Garden Street from the Huntting house, chiefly its grand ballroom (page 72). It would have to have been a posthumous commission, if it came from French, since the house did not come into his hands until the early 1860s, after the architect had died. Like Sag Harbor's other truly grand mansion, the Howell-Napier house (pages 69 and 183)—once called "Boxwood" for its historic slow-growing hedge (since removed)—the French house wasn't rebuilt in its current form until after the decline of whaling, when the rest of the village was pinching pennies. "A society is at its best *after* its wealth has been accumulated," wrote Nancy Boyd Willey, a local preservationist who grew up playing with children from the French house. Her own family's modest summer home (page 60) was just two doors down Main Street. (A 1976 interview with Willey is on page 61; a letter she wrote to her friend Frank Lloyd Wright in 1945, confessing her interest in preserving Sag Harbor's early buildings, is on page 269.) Hannibal and his brother Stephen French, a close associate of President Chester Arthur, owned Sag Harbor's last whaleship, the *Myra*, and some of its first steamships. Hannibal also served as the village's postmaster, an honor once reserved for its customs collector.

The Custom House, the home and office of Sag Harbor's longtime early customs collector, Henry Packer Dering, sits alongside the French house like a garden ornament (pages 73, 77, and 121). It was moved to the property in 1948 at the invitation of Charles Edison, the inventor's son, who had restored the French house and wanted to protect another Sag Harbor landmark from destruction. (Edison founded one of the village's smaller factories, Sag Harbor Industries, which is still in business making parts for electrical motors.) Another house recently connected to Lafever is the Gothic Revival Mulvihill house, farther up the stretch of Main Street that realtors like to call "Captain's Row" (pages 162–65). Except for an early portion at the back, it, too, post-dates his death, though it may owe a debt to one of his published plans. Many grand Main Street houses were built onto smaller early ones. Recycling houses is an old Sag Harbor tradition that is taking on new forms in these days of reconstruction.

In 1907, the Huntting house became the summer home of Margaret Olivia Slocum Sage (1828–1918), the village's leading philanthropist and one of the wealthiest women in the nation at

the time. Universally known as Mrs. Russell Sage, and locally dubbed "Lady Bountiful," she was redistributing the fortune her husband, a financier of the robber-baron era, had amassed and continues to do so posthumously, via the Russell Sage Foundation.[41] She had several neighboring houses moved to enlarge her property, giving them away. She also gave the village the brick library across the street, with a classical facade to echo the portico of her "Harbor Home." The library (pages 80 and 217), built in 1910, was named in memory of her grandfather, Major John Jermain, who served in the Revolution. Before buying the Huntting house, Mrs. Sage had restored his former home, one of the earliest on Main Street (page 53), dating to about 1790. She also financed Pierson High School (which celebrated its centennial in 2007), and the village park. Today, the Huntting-Harbor house has blubber spades inside and out,

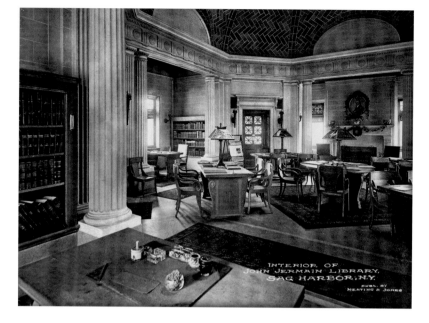

Reading room, John Jermain Memorial Library, postcard ca. 1915. Courtesy of the Wisconsin Historical Society, Madison (Albertype Collection).

and a right whale's jawbones framing its front door (pages 37 and 39); since 1936, it has been home to the Sag Harbor Whaling and Historical Museum. A modern replica of a rowed whaleboat sits under cover in the yard, and many local treasures are displayed within (pages 38 and 65).

Most Sag Harbor buildings are not the work of architects whose names we know. Architecture, like landscape architecture, was just being formalized as a profession in the United States in the mid-nineteenth century. Even Lafever was self-taught, and his popular handbooks were directed at skilled builders with design aspirations. Local carpenters, many of whom had shipbuilding experience, signed their houses with eye-catching details, but seldom with their names. Sag Harbor's mantelpiece front doorways, with their elaborate fanlights and leaded head- and side-lights, are the classic example. The spare building block of a house built in the Federal style and named for Captain Jared Wade is the perfect frame for its front door (page 55). Just two blocks away, on Garden Street, sits a distant cousin with the same five-bay proportions, but with a much simpler doorway. Is it a poor relation or a riff on a different page in the same pattern book? Many family relationships can be found among Sag Harbor's houses.

Such ornamental entrances would not have been found in the same period on plainspoken Quaker Nantucket, the port's closest analogue in many ways, but they would be quite at home on lower Manhattan's Washington Square. The son of a Sag Harbor rope maker, Samuel L'Hommedieu, even built himself a fashionable brick townhouse on the village's upper Main Street, announcing his readiness for his little city to develop into a bigger one.

JARED WADE, whose family owned a shipyard just inside Sag Harbor's cove, is remembered for sailing to California in 1849 in the schooner *San Diego*, the smallest craft yet used for such a long trip. Blown back from Cape Horn, he sailed instead through the narrow Strait of Magellan, reaching San Francisco in a mere seven months, in those days before the Panama Canal. It was not his only colorful act. The story has been passed down through his family that Captain Wade took his bride, Harriet, on a honeymoon whaling cruise to China, where a silversmith crafted their "table silver" from silver dollars they brought along.[42] When whaling voyages began to keep captains away for several years at a stretch, it was not unheard of for their wives to go along. Ships carrying women were dubbed "hen frigates." Martha Smith Brewer Brown, a captain's wife from Orient, on Long Island's North Fork, kept a journal of her 1847–1849 voyage aboard the Greenport whaleship *Lucy Ann*, including the several months she was dropped off in Honolulu to deliver a baby while her husband Edwin went on to the North Pacific whaling grounds.[43] While on board, she tried to keep the sailors devout, urging them to pray and study scripture.

Sag Harbor's most celebrated early contact with the Far East was the whaleship *Manhattan*'s unauthorized visit to Jeddo (Tokyo) harbor in 1845, after its captain, Mercator Cooper (1803–1872), rescued some shipwrecked Japanese sailors. The only western ships the Japanese allowed to land in those days were Dutch trading vessels, and only at Nagasaki. Captain Cooper was kept on board under a polite armed guard while the *Manhattan* was reprovisioned with the emperor's compliments. He brought back several keepsakes of his four-day captivity, including a scroll depicting the Japanese coastline that one of the shipwrecked sailors accidentally left on board. It was the first detailed account of its kind to reach the United States, and it may have helped prepare Commodore Perry for his return voyage nine years later. The favorable impression Cooper made in Japan—although he was told never to return, even if he came across more of its sailors in distress—helped prepare the reclusive island empire to accept trade relations with the United States once Perry arrived, heavily armed, to propose them. The chart and a Japanese artist's portrait of the *Manhattan* are in the New Bedford Whaling Museum, along with portraits

of Cooper and his wife, Maria, by the Sag Harbor painter Hubbard Fordham. A whale hunt is visible outside the window in the portrait of the captain, as if glimpsed in his mind's eye.[44]

As befits a man given a map of the world for his name, Mercator Cooper earned another geographical "first," making the first landing on Greater Antarctica, at Victoria Land, while captain of the Sag Harbor ship *Levant* on a whaling expedition in 1853. Cooper's brief visit to the cold continent must have been a bit like the first moon-landing, in his world and time.

ONE SAG HARBOR master builder's name that has survived is Benjamin Glover. His own house—like the one he built for the photographer Van Scoy on the corner of Main and Jefferson Streets, with one of Sag Harbor's most elaborate doorways—has a gambrel roof, its many windows artfully arrayed on the gable end (page 120). Like most of its neighbors along Glover Street, which the builder developed, this 1810-era house has been rebuilt in recent years. It now sports additions front and back.

A rare builder's contract survives (see page 260), describing the modest three-bay "half house" Glover built nearby in 1842, on another new street, Oakland Avenue, for the tinsmith David Jeremiah Youngs (page 166). It is representative of many small houses in the village, designed for its population of artisans. The contract expresses a functional approach to both architecture and business, promising "The whole to be of good materials, and every part tight." Also passed down through the Youngs family were Glover's receipts for the gradual payment of his bill: $200 upon completion of the house, the first one on its block, then another $150 a year later. It appears to have been a buyer's market back in the harbor's prime, with builders extending credit, effectively offering mortgages on the houses they erected. Perhaps this is what it took to sell a new house without the help of institutional lenders. In 1845, three years after the house had been completed, Glover signed a final receipt for $90 "for repairing house." He credited the payment to Youngs, but noted that it came "by the hand of Orlando H. Bears," the tinsmith's brother-in-law.

Orlando Hand Bears (1811–1851) was a talented portrait painter—and a distant cousin of Hubbard Fordham—whose sister, Frances, was married to the tinsmith. The incandescent portraits he painted of prominent Sag Harborites can still be seen in several local homes (pages 155 and 169) and in the village museums (page 65), alongside the work of his more polished and prolific cousin, who may have taught him a thing or two. The Youngs house is ascribed to Moses Bears, the father of Orlando and Frances, on the 1858 map of the village (page 27), made seven

years after the painter's death at thirty-nine. Perhaps this small house was home to an extended family. An early addition enlarged a room on each of its two floors and brought the cellar stairs indoors, long before such alterations were a matter for civic debate. Is this the "repair" for which Bears paid? He eventually joined his brother-in-law in the tinsmithing business, probably when daguerreotypes cut into his commissions for miniature and full-size portraits. Several of his paintings remained on the walls of the Youngs house in the 1960s, when Laura Youngs, David Jeremiah's granddaughter and the last family member to live there, was still alive. Since 1976, it has been home to another Sag Harbor artist, Joan Baren. (She discusses the house on page 167; one of her drawings of another simple structure in the village is on page 201.)

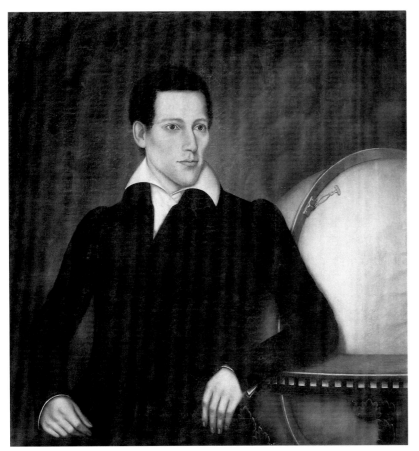

Ephraim Byram with his globe, painted by Orlando Hand Bears, 1834. Original in color. Photograph by Kathryn Abbe.

A VIEW OF THE HARBOR by Bears, which the Hartford, Connecticut, lithographer Daniel Wright Kellogg turned into a handsome print (page 25), may be the earliest surviving image of Sag Harbor. The only known copy is in the Connecticut Historical Society Museum in Hartford, but the original painting may no longer exist.[45] The rare print provides what no photograph can: a glimpse of the harbor in its prime. Long Wharf is ringed by ships, including one "hove down" for refitting between voyages. Another is "on the ways" on dry land to the left. Judging by the skyline and other factors, the undated print was made in 1840, when the harbor was in full swing.

Several of the buildings along the waterfront are carefully described, but most of them are gone. Although no photographs of Sag Harbor from the 1840s survive, the engravings from the 1854 Wall and Forrest map, based on Douglas and Van Scoy's daguerreotypes, help to identify the toy-like churches in the Bears-Kellogg print. The most prominent is the new Methodist Church, a Greek temple sprouting a Yankee clock tower, perched on a hilltop at the center left (page 210). Today, it is located on Madison Street downtown and looks quite different, having been

moved and redesigned in the early 1860s. Here it sits on its original High Street location, atop Sleight's or Methodist Hill, where it was built in 1835. But the tower clock that was clearly visible from the harbor—a key feature of this print—was not added until 1839.

This was the first tower clock designed by Sag Harbor's first clockmaker, Ephraim Niles Byram (1809–1881), who kept a careful record of its manufacture.[46] Although the dials were set up in January, the clock was not set striking until late August. It's possible that Bears, who twice painted Byram's portrait (page 220), anticipated the clock's centrality in the village, but it seems more likely that he was showing a key feature of the local landscape. So the painting on which this print is based is unlikely to have been made before the final months of 1839.[47] Steamship service to Sag Harbor began that year, ferrying passengers to the North Fork, Connecticut (Bears had a Connecticut wife), and New York City. A steamer approaches Long Wharf in the lithograph—further evidence that the artist was showing off the accomplishments of his thriving port community.

Ephraim Byram's "Oakland Cottage," ca. 1852.
Daguerreotype by an unknown photographer.
Courtesy of Peter Davies.

A brilliant, self-taught engineer, Byram later built tower clocks for New York's City Hall and the military academy at West Point, in the Hudson Valley, among other civic buildings. Communities set their watches by his clocks, considered models of accuracy. He also repaired chronometers, the tools that let ships determine longitude, relative to the prime meridian in Greenwich, England, by keeping accurate time as they sailed around the globe—something no pendulum clock could do aboard a swaying vessel. In 1852, Byram built himself a distinctive Italianate house with park-like grounds, at the edge of the village, alongside the new Oakland Cemetery (pages 123 and 221) and his short-lived factory. His "Oakland Cottage," inspired by the influential landscape architect Andrew Jackson Downing, included a tower (page 124), where he tested pendulums and made astronomical observations, sometimes penciling them on the wall. The presence of such homegrown autodidacts as Byram and Bears speaks well for Sag Harbor's society in its whaling prime. Their small world was remote but well-connected. Byram, who seldom traveled, built himself a room-sized model of the solar system (page 125), called an orrery. The Bears-Kellogg print is also a model of the known universe, on a much smaller scale.

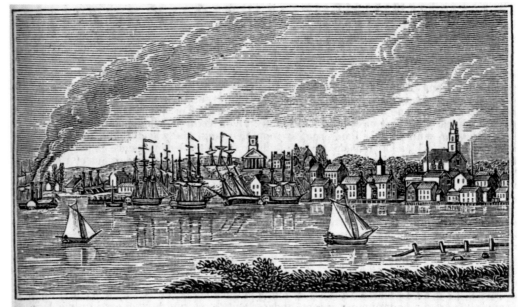

Northern view of Sagg Harbor, Long Island.

The lithograph lacks the village's most prominent steeple, so it clearly predates the Old Whalers' Church of 1843–1844. A feature so prominent as this cathedral-like spire could hardly have been excluded in a realistic depiction. At the center of the print is the lower, crown-like tower of the prior Presbyterian church, built in 1817 (visible in the photographs on pages 225 and 233) and soon to be sold to the Episcopalians, who did not build their own church until 1884. The Bears-Kellogg lithograph was clearly the basis for John Barber and Henry Howe's much smaller wood engraving, "Northern view of Sagg Harbor, Long Island" (page 222), a cropped view of the same scene included in their popular *Historical Collections of the State of New York* (1841). This helps to triangulate the date of the Bears-Kellogg print. If the original painting is unlikely to have been made before late 1839, the lithograph was clearly made by 1841, for a copy to have been published in that year.[48] Barber had previously published a collection of Connecticut prints and was doubtless familiar with Kellogg's work. So the Bears-Kellogg view must date to 1840, just as photography—invented a year earlier in France and England—was entering the United States.

Given the similarity of the two prints, one might wonder if the copying didn't go the other way around, but the visual evidence is clear. In the foreground, along the North Haven shore,

both pastoral images show a water-fence, designed to keep livestock from straying by wading in the bay. The fence is truncated in Barber and Howe's tiny version, a vestigial relic of the larger, more accomplished print, where it serves as a visual echo of the wharf. The Bears-Kellogg lithograph, similarly titled "Sag Harbor, L.I. N.Y. View from the North," shows more of the North Haven shore, with a building at the right that looks like a tavern, though John Budd's oil warehouse stood nearby—hence the barge heading in that direction with barrels of oil. North Haven is linked to Sag Harbor by the 1831 penny toll bridge (page 223), nicknamed "Payne's draw" for Charles Watson Payne, the North Haven resident who arranged for its construction. Comparable boats appear in both prints, including the steamer and the whaleships at the wharf and on the ways, but Barber and Howe cloned the fishing sloop in the foreground and added reflections of the boats to the surface of the water—an implausible touch, given the blowing steam and clouds, and further evidence that their image is not drawn from life.

The structures just right of the wharf look more like *Monopoly* buildings than real ones in both prints. Approximations or portraits, they burned a few years later, leaving no visual record of this once busy area, the site of the port's first try-works. Masts and steeples blend in a forest of

spires, with the Liberty Pole, an early fixture at the foot of Main Street, just discernible among them. Now, the only building in the vicinity is a reproduction, built in 1970, of one of the windmills that dotted the shoreline when this was a working harbor. In season, it serves as a tourist information center, powering a new industry.[49]

THIRTY YEARS after these prints were made, the harbor was pictured from the same vantage in a drawing by Harry Fenn, which John Karst turned into a wood engraving (page 224) for the popular 1872 album *Picturesque America*. This invitation to armchair tourism was edited by the poet William Cullen Bryant and published serially by *Appletons' Journal*. Fenn illustrated the chapter on eastern Long Island, among others; *Appletons'* previewed two of his East Hampton images in March 1871. Landscape artists typically traveled in summertime, so he probably visited the area in 1870.[50] The train also reached Sag Harbor that year, bringing the first tourists. As if seeing through their eyes, Fenn makes the harbor's work look like leisure. Several gaff-rigged sloops, probably from the local scallop fleet, cruise the bay while a fisherman mends his seine net on shore, his "sharpie," or rowboat, pulled up alongside. The locomotive at the bottom right puffs one of this picture's several clouds of steam, echoed by a steamboat at the wharf and the steam cotton mill tucked in the background nearby. The watchcase factory would take its place a decade later, after this first factory, built in 1850, burned down in 1879 (page 225). The skyline had developed since Bears painted it: the steeple of the Old Whalers' Church now dominates the village. At night, it shone a light to guide homebound mariners. To its right is the Italianate cam-

Sag Harbor, wood engraving from Picturesque America *(1872), from a drawing by Harry Fenn. Courtesy of the Brooklyn Historical Society.*

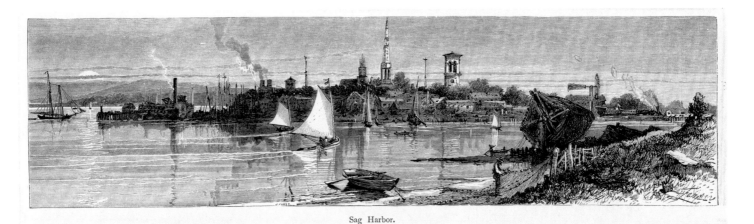

Sag Harbor.

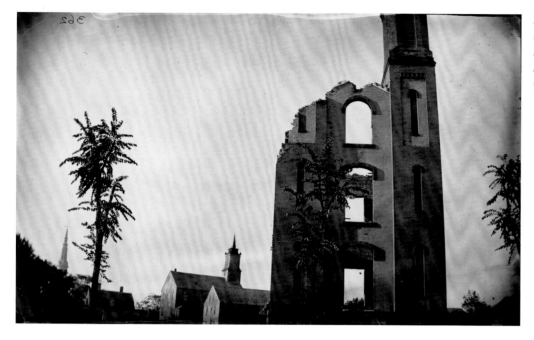

Ruins of the Montauk Steam Cotton Mills, Sag Harbor, ca. 1880, photographed by George Bradford Brainerd. Courtesy of the Brooklyn Museum/Brooklyn Public Library, Brooklyn Collection.

panile of the rebuilt Methodist church, in its current downtown location.[51] This vision of a working village on the water remains Sag Harbor's self-image; it adorned the masthead of *The Sag Harbor Herald*, a newspaper of the late 1980s. Sag Harbor's railroad line was reduced to a spur of track when the main line of the Long Island Rail Road continued east from Bridgehampton in 1890, but Long Wharf was the end of the line when Fenn arrived.

The Brooklyn wet-plate photographer George Bradford Brainerd (1845–1887) rode out on the train in 1878, a year after another nasty fire, and photographed the harbor from much the same vantage point again (page 206), attesting to the accuracy of Fenn's framing. (The photographer, who visited many Long Island communities, made a series of striking photographs of Sag Harbor; see, also, pages 196, 223, 225, and 233.[52]) Brainerd shows a gated dock near the site of the vanished water fence from the earlier prints—a restriction against wandering tourists, not livestock, and a harbinger of future development.

By the 1870s, according to the Sag Harbor *Corrector*, this was "a finished village. It stopped growing a quarter-century ago." The remark is prescient, architecturally, but local businessmen must have worried that their village was finished in more ways than one, as a generation of young men left town, seeking opportunities in the West. "Since 1847 disaster and decay have

Sag Harbor from Long Wharf, ca. 1880, photographed by George Bradford Brainerd. Courtesy of the Brooklyn Museum/Brooklyn Public Library, Brooklyn Collection.

"Sag Harbor from east shore of North Haven," 1878, photographed by George Bradford Brainerd (from a vintage print). Courtesy of the Brooklyn Historical Society.

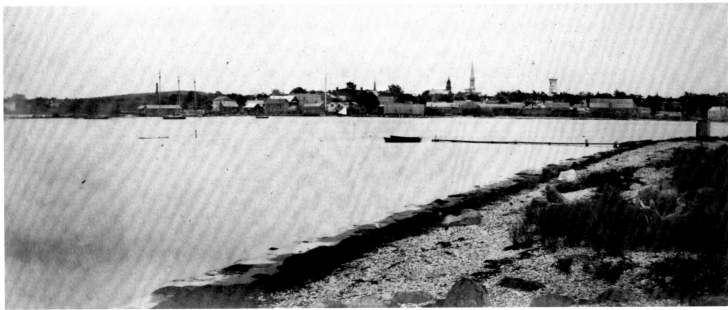

attached themselves to the whalers," the December 9, 1876, newspaper article continues. "Sag Harbor is merely a place in which farmers do a little trading." In just over a century, the port had returned to its humble beginnings.

BY THE 1880s, however, as the new Fahys watchcase factory revitalized the village, a string of grand summer "cottages" for the wealthy were built along Sag Harbor's shoreline and on neighboring North Haven, reminiscent of the colonial manor houses that once controlled the islands off the East End.[53] A polite summer society developed, with sailing and lawn tennis clubs for the handful of estate owners, including the Fahys family and their relatives the Cooks, the local watchcase kings. Both their vast summer homes, once prominently situated on the North Haven shore near the Sag Harbor bridge, are long gone, too large for later budgets to maintain. The Fahys house was taken down in the 1930s, and the Cook house burned a decade later. Several other mansions of the period were bequeathed or sold to church institutions.[54] A few are now back in private hands, marking a new era of extreme affluence.

In one much-discussed transaction, "Maycroft," the summer home of James and Mary Aldrich from 1886 to 1917, was sold in 2004 by the Episcopal Diocese of Long Island, to which its first owners had left it, for $20 million. In the intervening years, it had been a summer camp for urban girls, then an elementary school and summer camp run by a small order of nuns, and finally a nursery school. The eighteen-room "cottage," designed by Edward Lindsey, was in serious disrepair (pages 113), but, with nearly forty-four acres of waterfront property on Sag Harbor's cove, it was a prime candidate for developers. Its new owners are restoring the mansion, after having it picked up and turned around (page 114) to improve their views of the water. In Sag Harbor, the move probably wouldn't have been allowed, but architectural protections are more lax across the bridge in North Haven, even on landmarked structures such as this one. For the community, this outcome was vastly preferable to another subdivision, which seemed more likely. In 2007, one of the last intact North Haven estates went on the market for $80 million, the highest price ever asked for a residential property in New York State. The owner cited the doubling of his taxes after Southampton Town's recent reassessment as the reason for the sale.

IN THE EARLY 1880s, the local pharmacist and antiquarian William Wallace Tooker, best known for his studies of Long Island Indian archaeology and linguistics, made his series of photographs of early houses in Sag Harbor. He put most of them in an album, now in the village's John Jermain Memorial Library, where his personal library formed the basis of the local history collection.

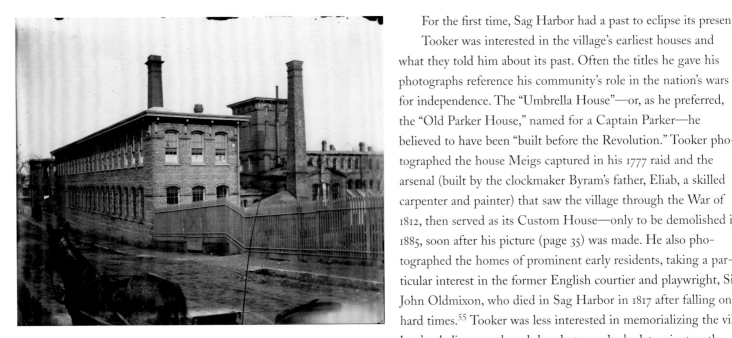

Fahys Watchcase Factory, from Church Street, ca. 1900, photographer unknown. Collection of Otto Fenn.

For the first time, Sag Harbor had a past to eclipse its present. Tooker was interested in the village's earliest houses and what they told him about its past. Often the titles he gave his photographs reference his community's role in the nation's wars for independence. The "Umbrella House"—or, as he preferred, the "Old Parker House," named for a Captain Parker—he believed to have been "built before the Revolution." Tooker photographed the house Meigs captured in his 1777 raid and the arsenal (built by the clockmaker Byram's father, Eliab, a skilled carpenter and painter) that saw the village through the War of 1812, then served as its Custom House—only to be demolished in 1885, soon after his picture (page 35) was made. He also photographed the homes of prominent early residents, taking a particular interest in the former English courtier and playwright, Sir John Oldmixon, who died in Sag Harbor in 1817 after falling on hard times.[55] Tooker was less interested in memorializing the village's whaling era, though he photographed a late-nineteenth-century resurgence of shore whaling along the nearby ocean beaches (page 33),which had resonances with early Indian life.[56] Perhaps whaling was a bad memory in his time, a source of regret as well as pride. When an early Sag Harbor Historical Society, of which he was a founder, erected monuments commemorating significant sites around the village in the first years of the twentieth century, all mentioned warfare, none whaling. A similar effort a century later by today's Sag Harbor Historical Society, a separate entity, marked sites important to the village's famous fishery. Soon, perhaps, there will be a resurgence of interest in the community's factory years, as the long derelict watchcase factory is converted into condominiums and the number of villagers who worked there dwindles.

THE PAST CHANGES with time: it is what we choose to bring in focus. Tooker's photographs were among the first self-conscious signs that Sag Harbor exists in historical time; that it has a past to lose. Today, they look like relics of lost time, yet they clearly represent an effort to keep the past alive. Time is always photography's unspoken subject, since photographs arrest its passage and become the past as soon as they are made. Decay is a recurrent photographic subject, since it,

too, makes time visible. Buildings age like bodies; the lucky ones get renewed, resetting the clock every generation, though it can never be reversed. When a community hears this clock ticking, mementos of lost time become precious.

Tooker's magnum opus, *The Indian Place-Names on Long Island and Islands Adjacent, with their probable significations* (1911), financed by Mrs. Russell Sage, includes an appendix of "Algonkian names suitable for country homes, hotels, clubs, motor-boats, etc.," to help latter-day Long Islanders naturalize themselves and their properties.[57] He provided the name for the park she gave the village, Mashashimuet—the Indian name for the spring that feeds the adjacent Otter Pond, which she soon added to the park. In his book, Tooker notes that Mrs. Sage "revived" this name, which he says he was "given" by two local Indians, including Stephen Pharaoh, the last Montaukett chief in his time.[58] Tooker revived the past by imagining it after consulting all the available facts—a salutary lesson for anyone trying to keep old buildings alive. His place-names, however speculative, dig into and preserve a vanishing history of the land around him.[59] This linguistic archaeology accompanied a lifelong habit of excavating the soil itself.

Imagining the past was no frivolous pursuit to the self-trained scholar, who displayed in his Main Street pharmacy (page 141) many of the 1,250 Indian artifacts he had unearthed or acquired. In 1898, a group of his friends bought his collection for the Brooklyn Academy of Arts and Science (now the Brooklyn Museum) to help finance his writing in retirement. After a difficult passage, some 150 of these artifacts are now in the care of the Smithsonian's Museum of the American Indian, in a warehouse outside Washington, DC.[60] Tooker struggled to decipher the Indian place-names he found in colonial documents using only two vocabularies of the local dialects and existing scholarship on other Algonquian languages. The larger and more reliable of his lists had a mere 162 words.[61] It was compiled by Thomas Jefferson, while visiting General William Floyd at his Long Island estate, fifteen years after they both signed the Declaration of Independence. Clearly, Tooker needed more information, but he had far more than we do today.[62]

One country house whose name he did not suggest was C. A. Lamont's "Hoggennoch," which occupied the peninsula now called Bay Point, poking into Sag Harbor's cove from the west. This was "a supposed Indian name" and an old mistake, Tooker insisted, "a corrupted form of Hog Neck, so spelled by mistake in the Dongan patent for Southampton, Dec. 6, 1686."[63] In early days, the peninsula was called Little Hog Neck, being next to the larger peninsula of Hog Neck, or North Haven. Tooker's photograph of Lamont's country house (page 230) shows a florid version of the classic New England saltbox, with its low roof to windward to keep out the cold. Beyond the low-

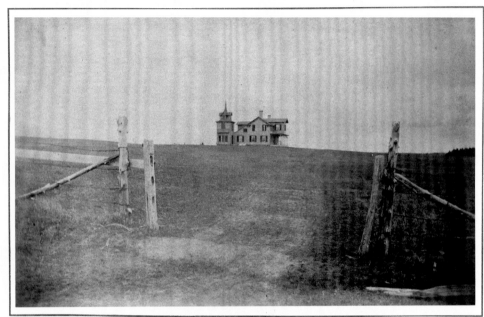

(Hogonock.)
Residence of C.A. Lamont Esqr. N.Y.

lying roof sits an ornate tower—evidence that winter weather is no longer a concern. The new house sits incongruously on a barren hilltop, surrounded by a barbed wire fence better suited to livestock than landscaping. With its natural boundaries, the peninsula had long been used for grazing. Clearly, this is a picture of agricultural land newly transformed into an estate. The impetus for unearthing local history, in Tooker's time as in our own, was a rapidly changing place.

BUILDINGS, LIKE THE MEMBERS OF A COMMUNITY, usually get replaced a little at a time, almost invisibly. In today's Sag Harbor, this process has accelerated, and the community's historic fabric is being replaced wholesale, as properties repeatedly change hands. This puts it at risk of becoming what one restoration architect I know calls a "phony coloney," an old-fashioned place made up of all new parts. Surely one hope of the architectural preservation this community has voted into law is that its members will commit to an ongoing collective archaeology, remembering where and who they are by digging up the stories that have made this place a home.[64] In the

long run, the newly fashioned parts and the newcomers will fit in better if they are well-informed. The process of learning is half the point. If we know where we are, and why, we can all hope to belong in time. Residents are as vital as buildings, the joints that hold a place together. But, in these days of rapid population turnover, their commitments must be renewed as often as the buildings they inhabit.

Looking Forward

THE CONTRADICTIONS of looking back to go forward were very much on Nancy Boyd Willey's mind in 1945, when she wrote Sag Harbor's first architectural guide. *Built By the Whalers*, a booklet filled with local lore, was published that year by the Old Sagg-Harbour Committee and went through several printings.[65] The committee had been founded in her parlor (page 60) the previous summer, as the Old Whaler's Church celebrated its centennial, to promote the village's historic architecture. After the hardships of the Depression—during which the Fahys watch-case factory shut down for six years, before being taken over by the Bulova Watch Company—many buildings were in poor repair and others had been lost. For much of the next half-century, Willey spoke up for the village's early structures and its natural environment, in an effort to protect the defining features of the place she loved. When she died at ninety-six, in 1998, she left the eighteenth-century house she inherited from her mother to the Sag Harbor Historical Society, which was founded in 1985 to watch over the historic district she helped to create a dozen years before.

Willey was descended from one of the village's first families, the Coopers, who made not only barrels, as their name suggests, but whaleboats, too, in the workshop that once stood behind their Main Street house. Her mother, Annie Cooper Boyd (1864–1941), a painter and a dedicated promoter of Sag Harbor's history, saved many relics of this boatshop when it was demolished early in the twentieth century, assembling them as a memorial on the front porch of the early house she turned into a summer cottage beside her family home. (Willey tells this story in a 1976 interview on page 61.) A low stone wall made from the boatshop's foundations still links the his-

"Hotel Bay View, Main Street, Sag Harbor" (demolished), photographed by Kathryn Abbe, 1944. Courtesy of the photographer.

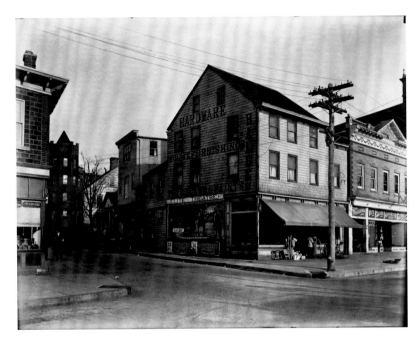

Main and Washington Streets, 1923, photographer unknown. Collection of Otto Fenn.

torical society's Annie Cooper Boyd House with the larger Cooper house next door, but they have gone their separate ways. The Cooper house has been gutted in recent renovations, while the Boyd house remains one of the simplest in the village. In the late 1960s, Willey retired there and dedicated herself to local preservation causes.

Architecture had long been a passion of hers. In the 1930s, when she was married to Malcolm Willey, a University of Minnesota professor, she became friendly with the prominent architect Frank Lloyd Wright (1867–1959). He designed a modest house for the couple in Minneapolis, and Nancy oversaw its construction. She and Wright corresponded over the project and continued doing so for several years. Ten years after moving into the house they built together, while writing her Sag Harbor guidebook, she sent her famous friend a letter of apology, explaining why her efforts on behalf of the early houses in her ancestral village did not alter her commitment to his style of modern architecture. (Her letter is on page 269.) The houses she admired from Sag Harbor's whaling era, like Wright's "organic" designs, are crafted from native materials and local traditions, growing out of the ground and a way of life. Given the two houses she cherished in her lifetime, Willey clearly hoped it would be possible to marry traditional and modern designs in Sag Harbor. But preserving old buildings would result in modern copies, she acknowledged. Her preservation goals have been realized, and so have her fears. Today, new construction in the village is typically designed to look old.[66]

PART OF THE IMPETUS for the Old Sagg-Harbour Committee, a group of women hoping to raise consciousness about the importance of local history in a community with so much of it, was the loss of the Old Whalers' Church steeple in the hurricane of 1938, the worst storm of the century along the Long Island and New England coasts. The hurricane leveled some 100 chimneys and trees in Sag Harbor alone, as well as another church tower, the elegant Italianate campanile of the Methodist church, where Ephraim Byram's first tower clock had been reinstalled after the building was moved downtown in the 1860s. The clock's remains are in the local whaling museum,

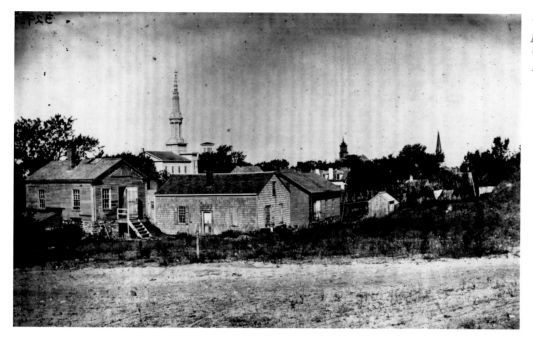

founded two years before the storm. After the hurricane, the Methodists replaced their open bell
tower (visible in the images on pages 211, 224, and 233) with a boxy enclosure, but no one could
salvage the far more elaborate Presbyterian church steeple. Despite recurrent efforts, it has not been
replaced. At the end of the Depression, with the village on hard times, the idea of resurrecting this
proud icon—from the top of which the poet George Sterling (1869–1926) hung a skull and cross-
bones as a mischievous lad—seemed out of reach. Preserving the material remains of American his-
tory was a priority of the federal public works projects of the Depression, and that enthusiasm was
reflected in Sag Harbor, but budgets were stretched too thin for such an ambitious project.

The architect Randolph Croxton, who has studied the church carefully while overseeing
its restoration, believes the steeple failed, in part, as a result of repairs made in 1910 (page 234).
These were another of Mrs. Russell Sage's gifts to the village, to correct a troublesome lean in
the tower. In the process, air vents designed to let wind move through the tall pointed structure
were sealed with windows and louvers, respectively, near its top and base. The purpose was prob-
ably to quiet the echo of rain and the moaning of wind inside the steeple that distracted church-
goers in the nineteenth century. Before these vents were closed, it must have behaved like an

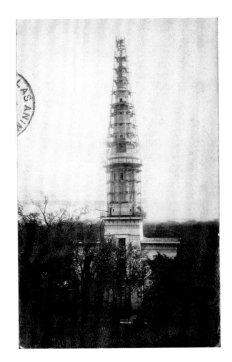

Repairing the steeple, Old Whalers' Church, 1910. Silver gelatin postcard. Courtesy of Jack Youngs.

upended flute. Rain pooled inside the base and rotted the joints where three of the eight vertical beams attached it to the church—hence the lean. (Croxton found evidence of a drainage system designed to prevent this problem and believes that it was not maintained.) The three failing mortise-and-tenon joints were replaced with metal shoes during the 1910 overhaul. These lacked the original system's resistance to "uplift" and only counteracted the lateral forces of the steeple's inevitable swaying in the wind. This was so great, under normal circumstances, that a multi-faced clock Byram designed had to be sent to East Hampton's Presbyterian church, where the pendulum could keep accurate time.

The hurricane struck from the southeast, precisely where the vertical bracing had been removed. With the air holes sealed, Croxton believes, the pressure differential inside the steeple and out was so extreme that, with insufficient vertical bracing, it lifted off, sucked into the vacuum above. Still upright, Lafever's ornate tower dropped on the downwind sidewalk to the northwest—collapsing like a telescope, just as it had been raised almost a century before—then toppled into the Old Burying Ground next door. The string of unlikely events made for a "perfect storm," striking at the point of greatest weakness.[67]

THIS AFFRONT TO LOCAL PRIDE was still fresh in mind when St. Andrew's Roman Catholic Church wanted its back parking lot cleared of the home of Sag Harbor's early customs collector, Henry Packer Dering, soon after the Old Sagg-Harbour Committee got underway. Appointed by George Washington, Dering served from 1791 to 1822. At first, his home on Union Street, opposite the Old Whalers' Church, served as the Custom House; later, that function moved across the street to the arsenal (page 35), which stood in front of the Old Burying Ground until 1885. Like many of Sag Harbor's larger houses in its factory years, Dering's home became a boarding house before it fell into the hands of the church. The Old Sagg-Harbour Committee arranged to have it moved and restored in 1948. Charles Edison, a former governor of New Jersey and Secretary of the Navy, had already restored the Hannibal French house; he made half of its double-wide lot available to the Committee, paying to have the Custom House moved onto his side yard (page 235; see, also, pages 73, 77 and 121).

The Committee ran tours of this and other houses in the village until it disbanded in the 1970s, having given the Custom House to the Society for the Preservation of Long Island Antiquities (SPLIA) in 1966. After some repairs and a more thorough restoration, SPLIA reopened the building to summer visitors in 1972. Whereas the Old Sagg-Harbour Committee considered

the Custom House "a typical old Sag Harbor home," furnishing it with assorted antiques its members donated, SPLIA created a museum devoted to Dering and the early American waterfront he administered.[68] (Josephine Bassett, the committee's longtime president, tells the story of moving the Custom House in a 1976 interview on page 74.)

THE 1950S AND SIXTIES were the decades of "urban renewal," when the historic fabric of many American cities and neighborhoods was sacrificed to the conveniences of modern living, often to make room for highways and housing developments. Frank Lloyd Wright's European counterpart, the architect Le Corbusier, advocated leveling a central section of Paris and replacing it with high rises. He didn't get his way that time, but his utopian view informed the International Style, which set out to scrap the past and build "the City of Tomorrow." But its planned communities seldom allowed for community, and gutted cities and slums

Moving the Custom House, 1948, photographer unknown. Courtesy of the Society for the Preservation of Long Island Antiquities, Cold Spring Harbor, NY.

were often the result.[69] Sag Harbor kept its historic downtown, though many longtime residents moved into ranch houses along the village's previously unbuilt southern edge, called Mount Misery, or to neighboring North Haven. Other new developments of seasonal housing near the water such as Bay Point and Noyac catered to the growing number of summer tourists, who in those days were mostly of modest means.

By the early 1970s, the completion of the Long Island Expressway (LIE) made weekend homes on the East End more accessible to city dwellers. The vast highway reached Riverhead, where the East End's two forks meet, in 1972, after creeping east from New York City for a quarter century. This was a key part of the plan that New York City's road and bridge builder Robert Moses pushed through to open Long Island to commuters and industrial development. Some of the nation's first tract housing had been built on former farmland in Levittown, farther west on Long Island, for returning servicemen and women and their families shortly after World War II.[70] Believing automobiles to be the vehicles of the future, Moses shortsightedly opposed running rapid transit lines down the center of the superhighway, which could have radically altered

commuting habits and today's traffic juggernaut.[71] New York City Mayor Edward Koch proposed adding rapid transit lines alongside the LIE in 1978, but it proved too expensive. To frustrated commuters, this remains "the world's longest parking lot."

After the completion of the LIE, with plans underway for a continuation of the new Sunrise Highway across much of the South Fork (firmly opposed, it barely crossed the Shinnecock Canal), the East End braced itself for a population explosion. In July 1971, the Suffolk County Planning Department presented Sag Harbor with its *Sag Harbor Study and Plan*, which projected a suburban future for the village. Illustrated with photographs of its historic buildings and blueprints for its preservation, the report noted that, under current zoning, the village's population could double to approach 5,000, and that, if all the vacant land around the village were built up, its population would effectively be closer to 25,000. This would force the development of a new shopping center outside the village limits, killing its historic downtown, the planners threatened. A modern shopping center of just the sort they envisioned was built along the Montauk Highway in Bridgehampton in the 1980s. But conservation of open land around the village and "up-zoning" of surrounding areas, from half-acre to one-acre lots, significantly lowered the area's maximum population.

The planners failed to predict the strength of the market for second homes. The village has experienced tremendous development pressure, yet its population has held constant. To protect it from unplanned development, the report proposed an urban renewal plan, with tourist centers along the waterfront, a shopping complex behind Main Street, and apartment buildings and hotels clustered along the cove. It also recommended the creation of a historic district. These solutions might haved killed the patient while administering the cure. The plan would have ringed the village with modern amenities and preserved it in the manner of a theme park, dwarfing its scale and its essential relationship to its maritime surroundings. However well-intentioned, it serves as a reminder that Sag Harbor survives as an accident of history that could easily be reversed.

FURTHER PROOF of the need for historic preservation had come in the late 1960s, when Sag Harbor's school board bought the recently shut-down Academy of the Sacred Heart of Mary and demolished its elaborate Victorian quarters and chapel (page 237) to make room for a new elementary school.[72] Several surrounding houses were moved to comply with a state law requiring open space around public schools, and only one modern building from the academy was left.

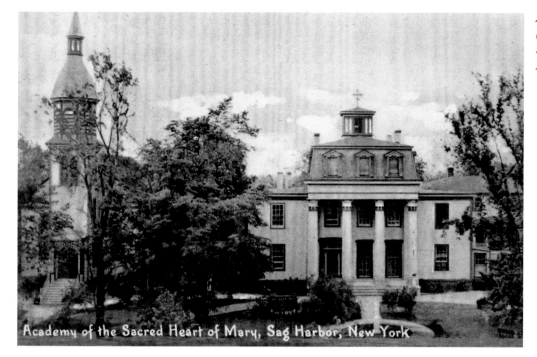

Academy of the Sacred Heart of Mary (demolished), Hampton Street, ca. 1920. Silver gelatin postcard. Courtesy of Joe Markowski, Jr.

Academy of the Sacred Heart of Mary, Sag Harbor, New York

"It felt like a murder," recalls Myrna Davis, a co-chair of the Sag Harbor Historic Preservation Commission, which lobbied for the village's initial historic district in the early seventies, then oversaw its management. In 1963, the grand home that once belonged to Captain Wickham Havens—George Sterling's grandfather—had been moved to wealthier East Hampton to make room for a new Catholic elementary school. "Some people worried they were going to take all our history away," recalls Dorothy Sherry, Davis's co-chair. (An interview with Sherry is on page 54.)

Instead of waiting for each building to be threatened with demolition, legislative protections were intended to focus attention on the entire village, a combination of grand and modest dwellings that together tell its story from colonial to modern times. "It is just this evidence of historic and architectural continuity from the mid-18th Century down to the present that makes Sag Harbor unique among communities in the United States," wrote Robert Pine, the consultant whom the commission engaged to make its case for a preservation program. "The buildings

remain in scale with nature and with each other as they always have," he added, warning that "It would not take much…to destroy this delicate balance."[73] Pine's illustrated report, published in June 1973, developed the recommendation of the county planning board in more palatable terms and formed the basis of the village's successful application to create a historic district, listed in the National Register of Historic Places that same year.

Although this took considerable volunteer effort and the cooperation of village government, it resulted in little actual change, since the commission only had advisory power. "You could still knock a house down," Sherry recalls.[74] And, contrary to the recommendations of the 1973 report, the initial district only covered the heart of the village. It wasn't until 1985, with the advent of a new zoning code, that the current Board of Historic Preservation and Architectural Review was created and empowered to determine the "appropriateness" of construction throughout the village. As a board of architectural review, not just historic preservation, it is authorized to approve designs for new construction, in the interest of the "harmonious" quality of the overall streetscape. Where historic buildings are concerned, its standard is the minimum change necessary to existing buildings, to the extent they are visible to neighbors or the public. The law requires that all meetings of the board be public and properly advertised. Its five volunteer members are appointed by the village trustees for three-year terms, with the chairman selected annually by the mayor. All members must be residents, but the village requires no further qualifications. After considerable effort by preservation professionals and volunteers working under the aegis of the local historical society to inventory Sag Harbor's historic structures, some 1,500 in all, the landmark district was expanded to place nearly all of the village on the National Register of Historic Places in 1994. (A summary of these legislative efforts is on page 280.) In theory, this places the village's appearance and scale—one might even say, its substainability—in the care of all its residents.

Sag Harbor is not alone in its efforts to maintain a semblance of architectural continuity. Nantucket, which faces many of the same development pressures, created its first historic district in 1955, enlarging it to cover the entire island just before Sag Harbor created its initial district in 1973. The island elects its five-member Historic District Commission, which is also composed of non-specialists, though in recent years they have had access to a small staff of planners with preservation training, something Sag Harbor's smaller Building Department lacks. Sag Harbor's architectural review board is empowered to hire expert consultants, but it has gotten out of the habit. By contrast, East Hampton and Southampton Villages, the centers of the two surrounding

towns, both have smaller landmark districts, and both hire preservation professionals to consult on all proposals with implications for their historic buildings. Meanwhile, the unincorporated hamlets of Bridgehampton and Wainscott nearby lack historic protections, and both have seen important early buildings torn down in recent years, since the land underneath the buildings is more valuable for development. As Anthony Tung, a former New York City landmarks commissioner who has surveyed urban preservations codes around the world, notes, "The pursuit of money creates the resources to make landmarks, and to save landmarks, but it is also the justification for destroying them."[75]

Sag Harbor had the first historic district on the East End, and now it has the largest, the only one that virtually covers a municipality. But it has preferred to manage it in its own way, even when it receives criticism for doing so. The notion of the minimum change necessary to historic structures has come to seem quite fluid. The national guidelines for rehabilitating historic structures established by the Secretary of the Interior propose a firmer line, but only local preservation laws are binding on private property owners.[76] And with each dramatic expansion of a house in the village, the standard to which others must conform softens.

Sag Harbor's mercantile heritage, coupled with its long bout of hard times, may explain its occasional compromises. But with property values rising and the resulting population turnover, the politics of preservation have been heated. Property owners don't like being told what they cannot do with their new homes—and realtors don't always tell them. The rules can seem less like a mandate to retain control of the community's historic proportions than a set of bureaucratic hurdles homeowners must leap, with varying degrees of finesse. With so many houses bought and built for speculative purposes, the plans proposed, and the decisions made, are not necessarily those of people who plan to stay in the community for long.

The village's preservation laws and its freethinking heritage empower its citizens, perhaps more than they realize. Like many historic communities, only more so, Sag Harbor defines the struggle between preserving a sense of place and profiting from one. These priorities are not set in stone; they are always open for debate. Historic preservation opens this debate, providing a necessary corrective to market economics, but there are also more personal ways of keeping time.

A DANGER OF PRESERVATION LAWS is the idea they can encourage of a past frozen in time: a foreign country we can visit but not inhabit. This can be a self-fulfilling prophecy if a community cannot manage its rate of change. Some of the homespun remodeling jobs of the mid-twentieth

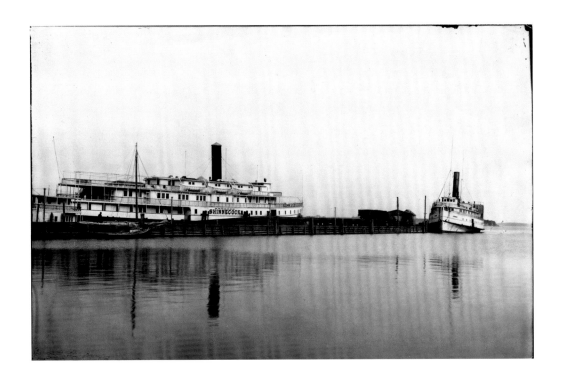

Steamers Shinnecock *and* Greenport *at Long Wharf, Sag Harbor, October 1903, photographed by Hal Fullerton. Courtesy of the Suffolk County Historical Society, Riverhead, NY.*

century may show more continuity with Sag Harbor's past than today's museum restorations and gutted interiors. At its best, architectural preservation is not about freezing time or cloning old buildings, but engaging in a conversation about what it means to treat a place as a renewable resource. This was natural in Sag Harbor's early days, when old buildings were recycled, moved, or reconstructed—acts that today's architectural review board would probably forbid—and when the population didn't pass through a revolving door. There was an incentive to reuse building materials in earlier times, as much of the lumber that went into Sag Harbor houses had to be imported. Now, it's often cheaper to replace old materials with modern look-alikes. The cost constraints are understandable, yet the replacements cannot surprise us with new discoveries about the community's past. Our copies are only as good as our understanding of the era we seek to emulate, based on a historic record that is inevitably incomplete. A house that has survived several centuries contains echoes of them all.

Just as the past changes with perspective, vital pieces of the local lore fall out of favor, then return. No one misses the long-vanished try-works, and some consider the watchcase factory an

ugly reminder of the industrial past. But preservation is not about picking and choosing the past; it is about engaging with a community's origins, in the belief they remain vital to its identity.

When does the past begin, as something disconnected from the present? When construction methods change and hand-made things have to be fixed by machines? When a critical mass of old-timers leaves? Or when, for all these reasons and more, we cease to remember (literally, put back together) where we are? The physical reminders of history are touchstones as we face these questions.[77] Buildings and photographs can help, as we puzzle out how places change and try to keep our bearings. Personally and collectively, we need to remember where we are to figure where we're going, even if we're staying home.

THE FRENCH PHILOSOPHER GASTON BACHELARD believed that we all carry within us the unconscious imprint of our childhood homes, where we learn our initial relationships to space. "In its countless alveoli space contains compressed time," he observes in *The Poetics of Space*.[78] "That is what space is for." Our first communities also shape lasting habits. This may apply culturally, as well as personally, judging from the many newcomers flocking to Sag Harbor, against considerable economic odds. The nation's first communities have unique lessons to offer and a continuity of purpose that is life-enhancing. We tamper with their designs at our peril, since their success is the result of many happy accidents over time.

Much of Sag Harbor's appeal is its scale, big enough for anonymity, small enough for intimacy, and of course its setting. The ability to live in a working village of manageable size in such beautiful surroundings is a luxury for most Americans today, but the community's rich and riotous heritage reminds us it was once a democratic ideal. Volatile housing markets and the forced migrations they engender, for workers at all levels—national concerns, of which Sag Harbor's predicament is a special case—disrupt long-term relationships to place, at the cost of personal and political losses so great they threaten to uproot our society. For all its challenges, perhaps this unique American place—built by whalers, maintained by watchmakers, and reinvented by weekenders—formulates a problem and suggests solutions that deserve broader attention, as Sag Harbor begins its fourth century, freshly remodeled.

Notes

Epigraph: Marcel Proust, *Swann's Way* ("Place-Names: The Name"), *Remembrance of Things Past*, Vol. I, translated from the French by C. K. Scott-Moncrieff and Terence Kilmartin (New York: Random House, 1981), 462.

1. For more on the tug-of-war between the British, Dutch, and Indians for control of eastern Long Island in the seventeenth century, see Faren R. Siminoff, *Crossing the Sound: The Rise of Atlantic American Communities in Seventeenth-Century Eastern Long Island* (New York: New York University Press, 2004).

2. Sag Harbor's first church (which, like other churches in the area, went from Congregational to Presbyterian in its early years) was not founded until 1766 and did not hire a full-time minister until 1797. Meanwhile, in each of the surrounding Hamptons, the church was a major landowner and the minister a key citizen.

3. See Dorothy Ingersoll Zaykowski, *Sag Harbor: The Story of an American Beauty* (Sag Harbor: Sag Harbor Historical Society, 1991), 4–11. By tracing these allotments, one can watch the village grow gradually outward from its historic core; Union Street was its southern boundary in its very early years.

4. William Wallace Tooker, "The Indian Village of Wegwagonock" in the *Souvenir of the Firemen's Fair* (Newark, NJ: John E. Rowe & Son, 1896). A copy of the original booklet is in the East Hampton Library's Pennypacker Long Island Collection; this essay was reprinted in the brochure for Tooker Day, celebrated August 1, 1998, at the Sag Harbor Whaling and Historical Museum. See, also, William Wallace Tooker, *The Indian Place-Names on Long Island and Islands Adjacent, with their probable significations* (New York: G. P. Putnam's Sons, 1911), 284.

5. See Luther Cook's "Historical Notes of Sag Harbor, L.I." A four-page typescript of these unpublished notes from 1858 is in the East Hampton Library's Pennypacker Long Island Collection. An excerpt published in the Sag Harbor newspaper, *The Corrector* (April 18, 1891), omits the passages on early settlers. These two are particularly pertinent: "There was no permanent settlement at Sag Harbor previous to 1730"; "In 1760 several reputable families established themselves here. Mrs. Ruth Sayre, long resident at Sag Harbor said to me (L. D. Cook, 1858) that she could remember when there were only three houses there, which were occupied severally by John Foster, Daniel Fordham and James Howell. Between 1760 and 1770, this little place had opened a trade with the West Indies, at which time the since [sic] City of New York had only a few small coasting craft. In 1790 Sag Harbor had more tons of square rigged vessels engaged in foreign commerce than the Port of New York." Some subsequent historians have concluded that there were three houses in Sag Harbor in 1730, but this does not follow from Cook's remarks. In his 1837 letter reprinted on page 257, Cook mentions he has been in Sag Harbor fourteen years, or since 1823. Mrs. Sayre would have to have been close to 100 when Cook arrived to remember 1730. As this seems unlikely, his two remarks are probably unrelated, placing the three houses—and Mrs. Sayre's long residence—somewhat later. Citing another early resident, Prudence Fordham, born in 1726, Henry Hedges traces the famous three houses to 1740. See H. P. Hedges, *Early Sag Harbor: an address delivered Before the Sag-Harbor Historical Society* (Sag Harbor: J. H. Hunt, 1902), 35; reprinted in *The Writings of Henry P. Hedges, 1817–1911, Relating to*

the History of the East End, edited by Tom Twomey (New York: Newmarket Press, 2000), 200–01. Dorothy Ingersoll Zaykowski cites Ephraim Fordham as the source of the oral tradition of the three early houses in *Sag Harbor: The Story of an American Beauty* (1991), 4. This would put the earliest possible date around 1740, since Fordham was born in 1837. He was captain of Sag Harbor's first whaling sloop in the 1760s, having been whaling aboard a Nantucket vessel in the previous decade.

6. Joshua Hempstead, *The Diary of Joshua Hempstead: A Daily Record of Life in Colonial New London, Connecticut 1711–1758, With an account of an overland journey the writer made to Maryland and back in 1749* (New London, CT: The New London County Historical Society, 1999), 35. Hempstead (1678–1758) regularly visited the English colonies on Long Island's North and South Forks. On Tuesday June 15, 1714, he writes, "I went to Sag & ye Harbour. I Sold 1 bb Rum for 3s 6d p gall gt 31½ to Mr. White." In other words, he sold one barrel of rum for three shillings and sixpence per gallon for a grand total of thirty-one and a half gallons to Mr. White of Sagaponack, after landing at Sag Harbor. This provides a useful price comparison, as three shillings and sixpence, the cost of a gallon of rum, is precisely the amount Southampton's town trustees paid someone seven years earlier to go to Sag Harbor on undisclosed business; see below.

7. H. P. Hedges, *Early Sag-Harbor* (Sag Harbor: J. H. Hunt, 1902), 43–44; (Newmarket Press, 2000), 206.

8. This thirteen-star flag was discovered in a Bridgehampton attic in 1927, alongside the muster roll of Hulbert's troop, who were released from service in early 1776. Legend has it that they carried a distinctive flag and that not long after their arrival in Philadelphia, the Continental Congress asked Betsy Ross to copy a flag. The "Hulbert flag" looks like an early version of her Stars and Stripes. Its stars have six points, not five, a change Ross is said to have suggested; instead of forming a circle, they mimic the overlapping St. George's and St. Andrew's Crosses of the early Union Jack. (Joy Lewis, whose first Sag Harbor house began its life as the elder Hulbert's ship's store on the waterfront (pages 156 and 157), suggests the rebels were ready to abandon their King, but not their patron saints.) Although the flag is one of the prize possessions of the Suffolk County Historical Society in Riverhead, it hangs under a cloud of uncertainty. It was donated by William Donaldson Halsey, an East End historian who lived next-door to the house where it was discovered (the home of another collector). Halsey's niece made some repairs. Since the 1970s, textile conservators have suggested the thread is mid-nineteenth century, though this is still hotly debated, and the repairs may have confused the issue somewhat. Also, questions have been raised as to whether Hulbert's men made it all the way to Philadelphia—it appears there may have been a changing of the guard in New Jersey. For the creation of the legend, see William Donaldson Halsey, *Sketches from Local History* (Bridgehampton, NY: Harry Lee Publishing Company, 1935, reprinted by The Yankee Peddler Book Company, Southampton, NY, 1966), 77–81; for its unraveling, see Henry W. Moeller, "The Discovery of a Tattered Thirteen Star Flag," *Suffolk County Historical Society Register* Vol. XXIII, No. 1 (Summer 1997), 2–10.

9. William R. Palmer, *The Whaling Port of Sag Harbor* (Columbia University Ph.D. dissertation, 1959), 29. Palmer's speculation is based on the fact that Southampton Town ordered a settler named Russell off Hog Neck in 1704, telling him "to go back where he came from." Nevertheless, he remained in the area.

10. Nancy Boyd Willey mentions a 1707 visit from a crown revenue officer to investigate undocumented shipping through Sag Harbor, but she gives no source for her information. See Nancy Boyd Willey, *Built by the Whalers: A Tour of Historic Sag Harbor and its Colonial Architecture* (Sag Harbor: Old Sagg-Harbour Committee), 9. Henry Weisburg and Lisa Donneson repeat the story on page 10 of their *Guide to Sag Harbor Landmarks, Homes & History* (Sag Harbor: The John Street Press, 1975; reprinted by the Sag Harbor Historical Society, 2003), also without a source, presumably relying on Willey's research.

11. Harry D. Sleight, *The Whale Fishery on Long Island* (Bridgehampton, NY: The Hampton Press, 1931), 7.

12. Although these and other Long Island Indians have long been described as independent tribes, their villages were linked by kinship systems prior to the area's colonization. Long Island's first historian, Silas Wood, is credited with the creation of its "thirteen tribes," each named for the place where the early colonists found them, in his *Sketch of the First Settlement of the Several Towns on Long Island, with their Political Condition to the End of the American Revolution* (1828). For a corrective, see John A. Strong, *The Algonquian Peoples of Long Island From Earliest Times to 1700* (Interlaken, NY: Empire State, 1997), 23. Tribal structures developed in response to white settlement. Both the East End's surviving tribes are now seeking federal recognition of their sovereignty. The Shinnecock have long been recognized by New York State; their hope for a casino has forced the issue of federal recognition. Two rival groups of Montaukett are both seeking federal recognition. Since their homeland was taken from them in the 1880s (after the developer Arthur Benson bought Montauk at auction and proceeded to ignore the early treaties which promised the Montaukett they could always live there), it has been hard to establish the continuity of tribal government.

13. See David Gardiner, *Chronicles of the town of East Hampton, county of Suffolk, New York* (New York: Bowne and Co., 1871), 5. Gardiner describes a Montaukett ceremony following the capture of a whale, but his account is sketchy, at best.

14. John Strong, "The Evolution of Shinnecock Culture" in *The Shinnecock Indians: A Culture History*, edited by Gaynell Stone (Stony Brook, NY: Suffolk County Archaeological Association, 1983), 32–34. For more detail, see Strong's "Shinnecock and Montauk Whalemen," *The Long Island Historical Journal*, Vol. 2, No. 1 (Fall 1989), 29–40; and his *The Montaukett Indians of Eastern Long Island* (Syracuse: Syracuse University Press, 2001; paperback, 2006), 50–55.

15. A glance at the modern map might make one wonder why Sag Harbor was not called Bridge Hampton Harbor, since downtown Bridgehampton is now slightly closer to the port than Sagaponack. On at least one occasion, in the Town of Southampton's records for 1711, the new port was called Bridge Hampton Harbor. See Harry D. Sleight, *Sag Harbor in Earlier Days: A Series of Historical Sketches of the Harbor and Hampton Port* (Bridgehampton, NY: The Hampton Press, 1930; reprinted on demand by Higginson Book Co., Salem, MA), 1. Although Bridgehampton traces its history to 1656 (and consequently celebrated its 350th birthday in 2006), the year Josiah Stanborough, one of Southampton's original settlers, built a house near Sagg Pond, Bridge Hampton was a new name in the early eighteenth century (and two words at the time). It included

several late-seventeenth-century offshoots of the Southampton colony, including Sagg and Mecox, which Ezekiel Sandford's 1686 bridge over Sagg Pond connected, lending the area its overarching name. Given period roads, Sagaponack was the closest to Sag Harbor of this group, hence the new port's name. Today's downtown Bridgehampton developed later in the eighteenth century, in the area once called Bull Head, after an early tavern located where the Sag Harbor Turnpke meets the Montauk Highway. The new port helped this area develop. In its "new" location, Bridgehampton benefited from Sag Harbor's rising fortunes far more than the oceanfront farming community of Sagaponack. The link was confirmed when the Long Island Rail Road came to Sag Harbor via Bridgehampton in 1870, its easternmost stops on the South Fork at the time.

16. A 2006 *Forbes* magazine survey of recent home sales found Sagaponack to be the most expensive ZIP code in the United States, its median house price just over $2.75 million. Of course, this only describes the houses changing hands. For a first-hand account of farming against these economic odds, see Marilee Foster, *Dirt Under My Nails: An American Farmer and Her Changing Land* (Bridgehampton, NY: Bridge Works, 2002). "These days, a bomb dropped in summer on a Sagaponack cocktail party might destroy nearly half of the U.S. literary establishment," jokes Peter Matthiessen, a resident since 1960, in his essay on the Peconic Bay, "Great River," in The Nature Conservancy's collection, *Heart of the Land: Essays on Last Great Places* (New York: Pantheon, 1994), 276.

17. Nathaniel S. Prime, *A history of Long Island, from its first settlement by Europeans, to the year 1845, with special reference to its ecclesiastical concerns* (New York and Pittsburg[h]: R. Carter, 1845), 208.

18. Tooker titled his photograph of the building "Old Parker House (built before the Revolution) 1770" in his photo album in the John Jermain Memorial Library. Harry D. Sleight begs to differ, several times, in *Sag Harbor in Earlier Days* (1930), finding no reference to the building before 1790. The hat factory was run by the Denison brothers.

19. The watercolor is in the local history collection of the John Jermain Memorial Library; it is reproduced in color in Helen A. Harrison and Constance Ayers Denne, *Hamptons Bohemia: Two Centuries of Artists and Writers on the Beach* (San Francisco: Chronicle Books, 2002), 22. A black-and-white reproduction that presumably shows the lost original is in a 1950s album of clippings about Sag Harbor's Custom House in the library. No artist or source is given, and the date is a century off, but the caption reads: "Sag Harbor of 1710, Showing Little Hoggenoch and First Shipping Section Oil House and Cooper Shops."

20. The opening to Northwest Creek was moved substantially west of its natural inlet when a new channel was dug in the mid-twentieth century, making it difficult to imagine the early harbor. Today, the bottom is evenly shallow in the surrounding water, suggesting one reason why this harbor was soon outgrown. But the hurricane of 1938 added nearby Cedar Island to Cedar Point, shifting the tidal flow; Northwest Harbor's shoals may have been exaggerated as a result.

21. Shelter Island, Sag Harbor's neighbor to the north, established trade relations with the West Indies in the seventeenth century, thanks to a plantation its chief landowners, the Sylvester family, owned in Barbados. Sylvester Manor, a colonial land grant, has been the site of extensive archaeological research in recent years; for an account of the resulting discoveries and a "biography" of the property, see Mac Keith Griswold, *Slaves in the Attic: The Story of Sylvester Manor, a Long Island Plantation, 1651–1944* (Boston: Houghton Mifflin, forthcoming in 2008).

22. See T. H. Breen, *Imagining the Past: East Hampton Histories* (Boston: Addison-Wesley Longman, 1989; reprinted by University of Georgia Press, 1996), in which Samuel Mulford's warehouse at Northwest plays a starring role. The native people whom the settlers gradually displaced also relied on trade, in response to the colonial economy. Montaukett women drilled wampum from clam and whelk shells found on their beaches. Dutch colonists turned the beads into a currency, which the English adopted in their competition for the seventeenth-century fur trade. So money has been made on East End beaches for some time.

23. Mulford's 1714 address to the New York Assembly is available on the Library of Congress Website (www.loc.gov), in the collection "An American Time Capsule: Three Centuries of Broadsides and other Printed Ephemera."

24. See Peter Matthiessen, *Men's Lives: The Surfmen and Baymen of the South Fork* (New York: Random House, 1986), on the loss of the local striped bass fishery in the 1980s after New York State restricted the practice of haulseining on the ocean beaches, pitting a longstanding commercial fishing culture against the tourist sport fishing lobby.

25. Everett J. Edwards and Jeanette Edwards Rattray, *"Whale Off!" The Story of American Shore Whaling* (New York: Frederick Stokes, 1932; reprinted by Coward-McCann, 1956), 274–75.

26. See the elder John Hulbert's "Ledger Commenced June 1760" in the Hampton Library, Bridgehampton, NY; quoted by William R. Palmer, "The Whaling Port of Sag Harbor" (Columbia University Ph.D. dissertation, 1959), 35–36.

27. The racial make-up of Sag Harbor's whaling crews deserves further research. This would involve locating and interpreting the crew lists and seaman's protection papers for Sag Harbor's estimated 807 whaling voyages, which can be found in the New York City branch of the National Archives and in surviving ships' logs. The government-mandated protection papers, or passports, do not record race *per se*, but they list each man's hair, eye, and skin color. Men of color often went whaling to evade the law, if they were fugitives from slavery or a contractual apprenticeship or indenture. In regions such as New England that favored the abolition of slavery, there may have been incentives to conceal a sailor's race, still, a careful reading of these documents would provide the best information available. See Stuart C. Sherman, *Whaling Logbooks and Journals, 1613–1927* (New York: Garland Publishers, 1986) for the whereabouts of Sag Harbor whaling logs as of 1986. I am grateful to Stuart Frank, Senior Curator at the New Bedford Whaling Museum, for calling my attention to these resources.

28. A search of public collections from Salem, Massachusetts, to Newport News, Virginia turned up nothing comparable, so maybe this image truly is unique. The Nantucket Historical Association has just one scenic daguerreotype, showing the island's Main Street before its 1846 fire. There are many photographs of New Bedford whaling, made once photography was available to amateurs in the 1880s, but Sag Harbor was out of the business by that time.

29. James Abbe (1912–1999), a photographer turned antiques dealer who specialized in early Long Island art, bought this daguerreotype from the Sag Harbor antiques dealer Rocco Liccardi in the 1960s. Liccardi, in turn, recalls buying it from a "picker," who often brought him old things purchased in local houses. Abbe sold the daguerreotype to a photography dealer, from whom the curator Keith F. Davis bought it in 1997 for the Hallmark Photographic Collection, which has since become part of the Nelson-Atkins Museum of Art in Kansas City, Missouri. I am grateful to Davis and his colleagues at the Nelson-Atkins Museum of Art for making a reproduction of this important early Sag Harbor image available for this book. It is this provenance, of course, that suggests it shows Sag Harbor.

30. Jacqueline Overton, *Long Island's Story* (Garden City, NY: Doubleday, Doran & Co, 1929), 214.

31. If the "butcher shop" plate was not exposed by a visiting photographer, Van Scoy and/or Douglas might be responsible. E. H. Payne is the only other daguerreotypist known to have worked in Sag Harbor. (See the "business directory" for the 1840s, which Dorothy Ingersoll Zaykowski compiled from newspaper ads, in the appendix to her *Sag Harbor: The Story of an American Beauty*, 352.) In 1846, E. H. Payne advertised his services in the Exchange Building at New London, Connecticut, across Long Island Sound. (See *Craig's Daguerrian Registry*, available online at www.daguerreotype.com.) This is not surprising, given how much the itinerant portraitists traveled. What is surprising is that, when a pioneer woman photographer named Henrietta Horton Payne—Etta, to her family and friends—set up shop in Southold, on the North Fork, in the 1880s, her shingle also read E. H. Payne. Was she related to the earlier photographer whose name she adopted, or is this simply a coincidence? Photography may make the past look present, but its earliest years remain opaque.

32. For details on these and other early maps of Long Island, see David Yehling Allen, *Long Island Maps and Their Makers: Five Centuries of Cartographic History* (Mattituck, NY: Amereon House, 1997).

33. This round image is reproduced in Dorothy Ingersoll Zaykowski, *Sag Harbor: The Story of an American Beauty* (1991), n.p. The school's bell tower resembles the larger one atop East Hampton's Clinton Academy, one of the first college-preparatory schools in New York State, built two years earlier in 1784.

34. See my essays on this painting, establishing its richly symbolic subject and confirming its attribution to Fordham: "Keeping an Eye on Sag Harbor" in *The Long Island Historical Journal*, Vol. 19 (Fall 2006/ Spring 2007); and "Solving a Painting's Mystery: A Light Keeper's Eye on Sag Harbor" in *The Sag Harbor Express*, September 8, 2005 (available on the "Archives" section of the *Express*'s Website, www.sagharboronline.com).

35. Cedar Island only became part of Cedar Point after the great hurricane of 1938. It is now a Suffolk County Park. The lighthouse is slowly being restored by the Long Island Chapter of the U.S. Lighthouse Association, after being gutted by arson in the 1970s.

36. Prentice Mulford, *Prentice Mulford's Story: Life by Land and Sea* (New York: F. J. Needham, 1889), 6; reprinted by The Narrative Press, Crabtree, OR (2004) and Kessinger Publishing, Whitefish, MT (2003). After joining the migration of young men from Sag Harbor to California, Mulford wrote a spoof of Sag Harbor's first effort to run a factory; see Dorothy Ingersoll Zaykowski, *Sag Harbor: The Story of an American Beauty* (1991), 236–37.

37. Charles Hanson Towne, with drawings by Thomas Fogarty, *Loafing Down Long Island* (New York: The Century Co., 1921), 160.

38. Allan M. Schneider Associates was acquired by the Corcoran Group, which called it "the jewel in the crown" of East End realtors, in 2006. Corcoran Group, which is also active in New York City and Palm Beach, Florida, is owned by the same holding company as Century 21, which has several brokerages on the East End (though each is managed independently). Like much of American business today, the situation is increasingly monopolistic, with few locally owned firms. Schneider himself was an important player in this drama. For a discussion of his role in South Fork real estate in the 1980s and nineties, see Steven Gaines, *Philistines at the Hedgerow: Passion and Property in the Hamptons (Boston: Little, Brown and Co., 1998)*, 3–48.

39. Zachary N. Studenroth, Executive Director of the Sag Harbor Whaling and Historical Museum, Lafever's other Sag Harbor building, puzzled out this link. Dover, the Long Island publisher, reissued *The Modern Builder's Guide* in 1969, with an introduction by Jacob Landy, but the edition has gone out of print.

40. The *Lucy* had to clear customs in New London, since Sag Harbor's Custom House was not established for another three years.

41. For the broader context of Mrs. Sage's philanthropy, see Ruth Crocker, *Mrs. Russell Sage: Women's Activism and Philanthropy in Gilded Age and Progressive Era America* (Bloomington: Indiana University Press, 2006); for her Sag Harbor charities, see pages 271–74.

42. Captain Wade's descendant Cornelia French Round penciled a note to this effect in her copy of Harry Sleight's *The Whale Fishery on Long Island* (1931), to which she was one of the original subscribers, after a discussion of whaling wives on page 149. Some of the cutlery, marked "H. Wade," remains in the family. I am grateful to Nancy French Achenbach for sharing this volume with me.

43. See Anne MacKay, editor, *She Went A-Whaling: the Journal of Martha Smith Brewer Brown, from Orient, Long Island, New York, Around the World on the Whaling Ship Lucy Ann, 1847–1849* (Orient, NY: Oysterponds Historical Society, 1993). See, also, the several publications of Joan Druett (who writes a foreword to this volume) on seafaring women in the nineteenth century, particularly *She Was a Sister Sailor: The Whaling Journals of Mary Brewster, 1845–51* (Mystic, CT: Mystic Seaport Museum, 1992).

44. Fordham's portraits of Cooper and his wife can be seen on the museum's Website (ww.whalingmuseum.org), by searching the "object collections." An ambrotype of Cooper can be seen in the museum's online "photo archives." These treasures were acquired from the late Southampton Town Judge Mercator Cooper Kendrick, a twentieth-century descendant, amazingly enough, of both Mercator Cooper and John Kendrick, a Boston captain who was the first American to visit Japan, on a maverick expedition in 1791. I am grateful to Stuart Frank, Senior Curator at the New Bedford Whaling Museum, for pointing out this connection. Cooper's Southampton home is now part of the Rogers Memorial Library, where reproductions of the Fordham portraits are on display.

45. The print says "Pinxt O. H. Bears"—painted by Orlando Hand Bears—in the lower right-hand corner.

46. The exact chronology of the clock's manufacture is recorded in Byram's account book in the Sag Harbor Whaling and Historical Museum, where the wreckage of the clock also resides, another casualty of the 1938 hurricane, "the Long Island Express." It is quoted as follows in Russella Hazard, "Ephraim Byram, Famous Clockmaker" *Long Island Forum* Vol. XIX, No. 10 (October 1956), 184: "Sent pattern May 10, 1838; Received castings June 10, 1838; Cut teeth Dec. 20–27; Put up dials Jan. 18, 1839; Began to finish off May 3rd, 1839; Set running temporarily, July 6, 1839; Set striking Aug. 26, 1839; Completed Nov. 16, 1839. Received for clock $370. Cost of clock $150. Days work on clock 240; on tools 20. 260 days @ 84½ cents."

47. In addition to the portrait illustrated here, showing Byram with the globe he made himself, Bears painted a full-length portrait of him with his telescope, illustrated on the back jacket of Dorothy Ingersoll Zaykowski's *Sag Harbor: The Story of an American Beauty* (1991). Both paintings are dated 1834. The portrait of Byram with his globe was the subject of an article by James Monroe Perkins, its then owner, in *Antiques* magazine in May 1970; the globe is in the Sag Harbor Whaling and Historical Museum. According to Peter Davies, who restored Byram's "Oakland Cottage" in the 1980s, a place for the full-length portrait was built into the front parlor, where a window appears to be missing. (It was later owned by Andy Warhol.)

48. In fact, the window is even tighter: lithographs made by the Kellogg firm after July 1840 were typically signed by D. W. Kellogg's brothers, E. B. and E. C. Kellogg. I am grateful to Nancy Finlay, Curator of Graphics at the Connecticut Historical Society Museum, for this piece of information and for making this important early view of Sag Harbor available. For more information on the Kellogg firm's landscape prints, see Nancy Finlay, "Suitable for Framing: Landscape Prints and City Views by the Kellogg Brothers of Hartford, 1830–1886," *The Magazine Antiques*, December 2006, and her forthcoming catalogue raisonee.

49. William Wallace Tooker photographed many of the East End's windmills, including some now gone. His photograph of a vanished "smock mill" is reproduced in Robert J. Hefner, *Windmills of Long Island* (New York: Society for the Preservation of Long Island Antiquities/W. W. Norton & Co., 1983), 19. Jet Lowe's 1978 photograph of the Beebe windmill (page 207), built for Sag Harbor, then moved to Bridgehampton, was made for Hefner's book. Lowe's complete series, including interior views, can be seen on the Library of Congress Website (www.loc.gov), under the heading "American Memory."

50. *Picturesque America* was published twice monthly, starting in June 1872; the chapter on eastern Long Island was in section 11, published November 1872. Fenn's East Hampton images appeared in *Appletons' Journal* March 25, 1871, under the heading "East Hampton and Its Old Church." I am grateful to Sue Rainey, the author of *Creating Picturesque America: Monument to the Natural and Cultural Landscape* (Nashville: Vanderbilt University Press, 1994), for this timeline. See my article in the Spring 2007 issue of *Imprint*, the journal of the American Historical Print Collector's Society, on early Sag Harbor prints.

51. In 2006, Pastor Thomas MacLeod announced he is entertaining another relocation. With dwindling membership and rising maintenance costs, he wonders if it isn't time to get over the "edifice complex" and put the historic building up for sale to help finance the construction of a new church outside the village.

52. For more on Brainerd, see Julie C. Moffat, "George Bradford Brainerd (1845–1887): Photography of a Pioneer," an M.A. thesis from the City College of the City University of New York kept on file at the Brooklyn Collection of the Brooklyn Public Library, which owns a set of modern prints from Brainerd's plates.

53. The nearest one, Sylvester Manor, still stands across the harbor, on Shelter Island. Gardiner's Island, the largest private island in the nation, also located between the East End's two forks, had an early manor house, but it burned down and was replaced. There were also manors (colonial land grants to wealthy individuals) on Plum and Fisher's islands, off the tip of the North Fork, with another two on western Long Island.

54. Sag Harbor's Cormaria retreat house, run by the Religious of the Sacred Heart of Mary, was the estate of Frank Havens, the poet George Sterling's uncle. The Palatine Fathers once occupied the estate built for Bertha Barclay, a daughter of Joseph Fahys, on North Haven's West Banks (now a gated community).

55. Little is known of this English courtier, knighted by King George III in 1782, who authored the memorably titled play *Apollo Turn'd Stroller*. He died in Sag Harbor, aged fifty-six, on December 6, 1817, and is buried in its Old Burying Ground, though the marker is gone. See Dorothy Ingersoll Zaykowski, *The Old Burying Ground at Sag Harbor, Long Island, New York* (Westminster, MD: Heritage Books, 2003), 9. This convinced one notable East End historian to write Oldmixon off as a myth; see James Truslow Adams, *History of the Town of Southampton (East of Canoe Place)* (Bridgehampton, NY: The Hampton Press, 1918; reprinted on demand by Higginson Book Co., Salem, MA), 154–55. Sir John's grandfather, also John Oldmixon, was an early historian of British America.

56. The story of how the Edwards clan of Amagansett revived the practice of shore whaling in the late nineteenth century is told by Everett J. Edwards and Jeanette Edwards Rattray in *"Whale Off!" The Story of American Shore Whaling* (1932). The whale skeleton displayed in New York's Museum of Natural History came from the last animal caught in this period, in 1907.

57. This was Tooker's preferred spelling of the word Algonquian; he called himself an "Algonkinist."

58. William Wallace Tooker, *The Indian Place-Names on Long Island* (1911), 105.

59. "Indian place names are invariably descriptive of the place to which they are applied, and were therefore topographical, and not mere marks to distinguish one place from another like our names," Tooker writes in "The Indian Village of Wegwagonock," published in the *Souvenir of the Firemen's Fair* (Newark, NJ: John E. Rowe & Son, 1896); reprinted in the brochure for Tooker Day (August 1, 1998) at the Sag Harbor Whaling and Historical Museum.

60. Tooker's collection of archaeological finds, mostly stone tools—which the *Brooklyn Eagle* boasted, in March 1898, would "preserve for all time a permanent record of the history of the aboriginal tribes that inhabited Long Island"—has been moved around quite a bit in the century since, shrinking along the way. The collection was not formally accepted into the Brooklyn museum until 1901; in 1961, it was transferred to the Heye Foundation's Museum of the American Indian in New York City. Before it became a part of the Smithsonian Institution, this institution was scandalously mismanaged, and many objects were sold without a paper trail. See Edmund Carpenter, *Two Essays: Chief & Greed* (Andover, MA: Persimmon Press, 2005). A few items from Tooker's collection remain at the Brooklyn Museum and are now on display. Those that reached the Smithsonian's Maryland warehouse are available for viewing by appointment. An inventory of Tooker's entire collection is in the East Hampton Library's Pennypacker Long Island Collection.

61. This list, a "Vocabulary of Unquachog or Puspatuck collected by Thomas Jefferson at Brookhaven, Long Island on June 13, 1791" is published in Gaynell Stone, editor, *Languages and Lore of the Long Island Indians* (Stony Brook, NY: Suffolk County Archaeological Association, 1980), 17–18.

62. Many of the colonial records Tooker relied on—early land deeds, which record Indian place-names—burned in a fire at the New York State Capitol in Albany shortly before his book was published. For a contemporary anthropologist's assessment of his linguistic research, see John Strong, "William Wallace Tooker," *Long Island Historical Journal,* Vol. 16, Nos. 1 and 2 (Fall 2003/Spring 2004), 149–52. For more on Tooker's research, see Lois Beachy Underhill, "William Wallace Tooker: A New Look at Long Island's Pioneer Ethnographer," *Long Island Historical Journal,* Vol. 11, No. 2 (Spring 1999), 190–202, and John C. Huden, "William Wallace Tooker, Algonkinist" in the *Long Island Forum,* Vol. XVIII, No. 8 (August 1955), 143–58.

63. William Wallace Tooker, *The Indian Place-Names on Long Island* (1911), 72. Tooker may have put "Hogonock" in parentheses in the caption to his photograph to indicate a misspelling of this (misinformed) name. He favors the spelling given here in his book.

64. Sag Harbor has seldom recommended archaeological investigation as a proactive preservation tool (even when the foundations for a new police station were dug at the heart of the early settlement in 2005). By contrast, East Hampton Town, out of respect for the claims of Montaukett Indians, requires archaeological investigation of construction sites of potential significance on the Montauk peninsula, where much of the town's new construction is taking place.

65. Nancy Boyd Willey, *Built by the Whalers: A Tour of Historic Sag Harbor and its Colonial Architecture* (Sag Harbor: Old Sagg-Harbour Committee, 1945). In 1939, Willey self-published a shorter pamphlet, *The Story of Sag Harbor*, with illustrations by her mother, Annie Cooper Boyd, who died in 1941.

66. For several years, Sag Harbor has been debating whether to renovate or replace its public library, a gift from Mrs. Russell Sage in 1910. At a public meeting when plans for a new library were unveiled in 2004, the most frequent objection was that modern architecture is out of place in Sag Harbor. For this and many other reasons, a referendum for the new library failed. Few unbuilt lots remain in the village, so most new construction involves additions to existing buildings, but several "new old houses" have recently gone up on empty lots in the village. The proposal for Sag Harbor's initial historic district in 1973 had this to say on new construction: "Rather than attempting to foster 'period design' for new buildings, it is proposed that Sag Harbor give great freedom and latitude in both building and site design and encourage the most creative works of architecture possible in the village. Although it is recommended that all plans for new construction anywhere in the Village be subject to administrative review procedures, this review should be aimed at assisting the architect or developer in arriving at a final design that shows a thoughtful relationship to neighboring buildings and is as much in keeping as possible with the scale, materials and visual feeling of the Village as a whole." Robert H. Pine, *Sag Harbor, Past, Present and Future: A Proposed Historic Preservation Program for the Village of Sag Harbor Prepared for the Sag Harbor Historic Preservation Commission* with drawings by Joan Baren and photographs by Otto Fenn (Village of Sag Harbor, 1973; reprinted in a "Bi-centennial Edition" in 1975), 71. One can hear Willey's voice in these hopes, however difficult they might have been to enact. In a recent meeting, several members of Sag Harbor's architectural review board regretted that they could not approve visible solar panels on properties in the village, even as they approved several more well-screened swimming pools. This seems a parable of what happens as preservation becomes bureaucratic: it is the look of the past, not the logic of the community, that gets preserved.

67. This theory is based on unpublished research by Randolph Croxton. I am grateful to him for giving me the opportunity to share his findings in lay terms.

68. The quote is from the minutes of the Old Sagg-Harbour Committee's founding meeting, August 31, 1944, in the archives of the Sag Harbor Historical Society. The last item on the committee's list of plans was: "To take some old house, for example the old post office house, and turn the first floor into a typical old Sag Harbor home and to have meeting rooms on the second floor." (Henry Packer Dering was Sag Harbor's postmaster, in addition to being its customs collector.) I am grateful to Dorothy Zaykowski for locating this document.

69. The classic protest against the devastation of "urban renewal" is Jane Jacobs, *The Death and Life of Great American Cities* (New York: Random House, 1961). In one of her last books, a modern Socratic dialogue, Jacobs describes the shifting economic cycles that can sustain communities for very different reasons than those that brought them into being—another subject of great relevance to Sag Harbor. See Jane Jacobs, *The Nature of Economies* (New York: Random House/Modern Library, 2000), especially Chapter Four, "The Nature of Self-Refueling."

70. Frank Lloyd Wright, a conceptual father of the modern suburb, had proposed a similar, if more idiosyncratic, model, in his Broadacre City in 1932.

71. The hegemony of Robert Moses over New York City's urban and regional planning in the mid-twentieth century is amply documented in Robert Caro, *The Power Broker: Robert Moses and the Fall of New York* (New York: Alfred A. Knopf, 1974). Moses considered himself a populist, equally glad to grab land from estates and farming districts. In his defense, he created popular state parks at the tips of the East End's two forks, at Montauk and Orient Point, but the integrity or survival of historic communities clearly did not factor into his designs. This was exactly the style of bulldozer building that Jane Jacobs deplored.

72. The Academy, which largely served the daughters of South American diplomats, closed after the 1968 school year, having opened in 1877. The new Sag Harbor Elementary School opened in 1971.

73. Robert H. Pine, *Sag Harbor, Past, Present and Future: A Proposed Historic Preservation Program for the Village of Sag Harbor* (1973), 69–70.

74. A memorable example of the old style of "building by the seat of the pants" (as an early chairman of the architectural review board described it) was Sag Harbor's "zoning holiday" of 1970. Shortly before the initial historic district was created, a developer facing opposition to a condominium complex he wanted to erect near the waterfront challenged the legality of the village zoning code, claiming it had not been properly filed with New York State. He succeeded, and the zoning code was summarily revoked. The condominiums were built and several other alterations to existing buildings, which might not otherwise have been approved, were made while the code was revised. Many villagers remember this episode quite fondly as an expression of Sag Harbor's maverick spirit. The same people may be aghast at the latest affront to the local preservation ordinances, asking, "How did they get away with that?"

75. Anthony M. Tung, *Preserving the World's Great Cities: The Destruction and Renewal of the Historic Metropolis* (New York: Clarkson Potter, 2001), 5.

76. For the national standards for rehabilitating historic structures named on the National Register of Historic Places, see: www.cr.nps.gov/hps/TPS/tax/rhb/.

77. For further touchstones, see David Lowenthal and Marcus Binney, editors, *Our Past Before Us: Why Do We Save It?* (London: Gage Distribution Co./Maurice Temple Smith, 1981) and Arnold R. Alanen and Robert Z. Melnick, editors, *Preserving Cultural Landscapes in America* (Baltimore: The Johns Hopkins University Press, in association with Center for American Places, 2000).

78. Gaston Bachelard, *The Poetics of Space*, translated from the French by Maria Jolas, with a foreword by John R. Stilgoe (Boston: Beacon Press, 1994), 8.

Documents

Index to the Documents

Luther Cook to Thomas W. Williams (1837)

Luther Cook (1794-1867), a Connecticut native whose ancestor Francis Cooke came to New England on the Mayflower, *became a Sag Harbor ship owner and whaling agent after marrying Col. Benjamin Huntting's daughter, Mary. They lived in the former John Jermain house on Main Street (page 53). Cook was a historian of the local whaling industry in its prime, keeping track of the port's investments and returns. This letter contains his account of the origins of Sag Harbor whaling. Sadly, the information he included was no longer with it when it reached the Nantucket Historical Association Research Library (as part of the Edouard A. Stackpole Collection—MS 335, folder 1029.50). A lengthy excerpt from Cook's 1858 address to the Sag Harbor Lyceum, summarizing the port's whaling returns, does survive, reprinted as Chapter XLVI of Harry D. Sleight's* The Whale Fishery on Long Island *(1931). The letter, addressed to "Tho. W. Williams, Esq., New London (Con.)," is written in an elegant, spidery hand. Disco's Island is off the west coast of Greenland, in Davis Strait—a long way from Long Island. Ulto., or* ultimo, *means "last month."*

Sag Harbor 1, March 1837.
Thos. W. Williams Esq.

Dr. Sir

Yours of the 16. ulto. came to hand a few days afterwards, and I now with pleasure proceed to furnish you with the information you therein request of me, so far as I have been enabled to gather the same. I would here observe, that about nine years ago, I forwarded to S. H. Jenks Esq. Editor of the Nantucket Inquirer, by his request, a somewhat lengthy, and I believe, a tolerably correct account of the origin, rise and progress of the Whale Fishery from this district, which I took the more interest in furnishing him with, supposing he then had in view the compilation of

an accurate and authentic History of the Whale Fishery from this country from its earliest origin. I have however been disappointed in not having ever heard from him, and giving me the reasons why his first design in relation to this subject had been abandoned. He did however subsequently in substance, state, under his editorial head, that could he be similarly favored by persons residing at the different Ports where the Fishery was prosecuted, he should be enabled to furnish his Countrymen with a compilation, which might not prove altogether unacceptable to them.

The Whale Fishery was carried on at this place, long previous to the American revolution, though to an inconsiderable extent. A century ago the inhabitants of the South shore of Long Island, used to take more or less Whales, annually, proceeding in the usual manner of "Shore Whalemen." About the year 1760, we have accounts contained in the Records of this Town, which go to show, that a very few Vessels (and those of small size) used to go out from here, and proceed a few degrees to the Southward of us, and if so fortunate as to Capture a Whale or two, they were in the habit of bringing in "the blubber" here and trying it out on the Shore near where our principal Wharf is now located. I think it not unlikely that this mode of procuring Whale Oils had been practiced, long before that period, probably as far back as 1730. I have occasionally met with, now and then, during my residence here of fourteen years, of old veterans' who stated "that they used to go to Disco's Island" in Sloops, on Whaling voyages previous to the Revolution. But the Whaling as it is now carried on, or rather in prosecuting it at a distance from home, <u>even in South latitude</u>, was first commenced here by Stephen Howell and Benjamin Huntting about the year 1785. The first Vessel which made a Voyage to the Coast of Brazil, was the Brig Lucy. She was purchased about that period of Elijah Hubbard of Middleton (Con.) and was owned by the late Col. Benjamin Huntting of this place so late as the year 1797. She may be considered as having been the original Craft or School house, for our principal beginners here in learning the first rudiments of the Science of "throwing the dart and using the lance," and also of laying the foundations for the fortunes of the Howell's and the Huntting's of Sag Harbor. She might with propriety have been called a Sister of, and compared with the famous little Ship Lydia, of Nantucket (of olden time), and which by her unusual success opened the way for the acquisition of the princely Estate left by the late Zenas Coffin of that Island, who died in 1828.

Since about 1794, the Whaling business has on the whole, been gradually increasing here, though at some periods it has been reduced to an inconsiderable amount of tonnage.

I will now aim to give you some account of the arrivals and produce of the Whale Fishery from this district; commencing with 1804; Collected by me from good authorities, and that portion of the Enclosed Mem. commencing with 1821; to the present time, being data and are facts in most cases derived from the Owners Books, and compiled by myself. I also have the pleasure of enclosing for you and my other friends in New London my annual statement of arrivals, and produce of the Fishery of this District for the year 1836, made out on the 1. Jan. 1837. I should be gratified could you give me a similar Mem. and also, if convenient for you, a brief history of the origin and rise of the Whale Fishery of your district. Up to this time we have <u>no intelligence</u> from our absent Whalers.

With much respect,
Your Friend & Ob. Serv.t
Luther D. Cook

CONTRACT BETWEEN BENJAMIN GLOVER AND DAVID JEREMIAH YOUNGS (1842)

Very few building contracts for Sag Harbor houses survive. Architecture was just being formalized as a profession in the United States when Sag Harbor's master builder, Benjamin Glover, and the tinsmith David Jeremiah Youngs wrote this contract in 1842, resulting in the modest house Glover built that year at 15 Oakland Avenue (page 166), the first one on a new street. Glover's own house (page 120) was just around the corner, on Main Street. The contract is written in a practiced hand, presumably a lawyer's. The halting prose and cruder penmanship of Glover's receipts make the letter that follows, also from a carpenter, all the more remarkable. The builder's receipts tell us that he provided a "balloon" mortgage, paid off (with some difficulty) a year after Youngs moved in. Does this indicate a friendship between two craftsmen and neighbors, or the cost of doing business in a world without mortgage brokers? It's hard to believe skilled carpenters were short of work in the harbor's prime.

A family photograph that, like these documents, stayed with the house shows it in the late nineteenth century, without the large dormer on the front, but with an early addition on the right. Could this be the "repair" for which Youngs's brother-in-law, the painter Orlando Hand Bears, paid three years after the house was built? Was he moving in? The 1858 map of Sag Harbor (page 27) lists Moses Bears, the father of Orlando and Frances (David Jeremiah's wife), as the house's occupant, though it was passed down to David Jeremiah's descendants for two generations. A tureen the tinsmith made—using the humble material as if it were silver—can be seen on his great-granddaughter Mildred Dickinson's dining table on page 169, below an early self-portrait by Bears. Other portraits by Bears are on pages 65, 155, and 220; his view of Sag Harbor is on page 25. Several of his paintings were in the Oakland Avenue house when it was sold out of the family in the 1960s.

It is mutually agreed by and between Benjamin Glover and David J. Youngs, both of Sag Harbor, County of Suffolk and state of New York, as follows, Vis.

The said Benjamin Glover hereby agrees to build, erect and complete for the said David J. Youngs, a Dwelling house with Cellar, in form, dimensions and materials as follows, Vis.~

Said house is to be built agreeable to the plan herewith shown, of one story, of $7\frac{1}{2}$ feet in clear, and the posts running one foot up into the garret—

Is to stand upon a sufficient number of firm wooden posts, or stancheons, sixteen inches high & each placed upon a stone; and underpinned with boards matched together

Timber of size sufficient for good strength and durability

To be covered with good merchantable boards, not exceeding 10 inches in width, the laps rabeted, the Roof covered with best Quality pine shingles

The rooms finished with a good one coat wall and slip

A bedroom 9 by 11 feet in the Garret, one side being in the middle of the building, 6 ft 8 in high in clear

Three 4 Pannel doors inside. Front door common 6 pannels back, milkroom, press and garret bedroom doors good battened

Three 12 light 6 by 8 glass windows in the gable ends, and one window of sufficient dimensions in the cellar and a head light over the front door.

A triangular gutter at the rear eve, Plain steps at the rear and front doors, and a common passage to go into the cellar from out side—

The whole to be of good materials, and every part tight; and completely finished on or before the first day of May 1842.

For and in consideration of which the said David J. Youngs hereby agrees to pay to the said Benjamin Glover, Three Hundred and Fifty Dollars, two hundred dollars of which is to be paid when said house is completed, and the remainder, One hundred and Fifty on the first day of May 1843.

The contract is signed:

(*illegible word*) whereoff we hereunto set our hands and seal this 11 day of February 1842
Benjamin Glover
David J Youngs

June the 3 1843
I Recd in full from the act bearer
Benjamin Glover

These receipts are on separate slips of paper. The first two, like the final entry above, closing the account, is in Glover's hand, which is difficult to read:

Sag Harbor May the 3 1842
Received of David J Youngs Fifty Dollars in Part Pay for Build A House
 Benjamin Glover

Sag Harbor May the 21, 1842
 Received of David J. Youngs
One Hundred and fifty dollars
In Parte Pay for Building a House
 Benjamin Glover

Sag Harbor Dec 11th 1845
Received of David J Youngs by the hand of Orlando H. Bears, ninety dolls in full for repairing house Benjamin Glover

Edward R. Merrall to his mother, 1843

This letter, written by a twenty-one-year-old carpenter who came from New York City to help build Sag Harbor's First Presbyterian (Old Whalers') Church, is the only surviving document that connects the architect Minard Lafever to this unusual building (pages 43–45, 47–49, 214, and 234). Edward Merrall was evidently a finish carpenter; he may have been hired to install some of the elaborate moldings that are a hallmark of Lafever's eclectic designs. Taking his own advice, Merrall found a wife in Sag Harbor, Laura Howell Gardiner (a woman with two prominent local families to her name). They stayed in the village and had six children, only one of whom lived to adulthood. Merrall became active in local politics but died of typhoid fever at forty-seven in 1869. He is buried in Sag Harbor's Oakland Cemetery. His letter did not surface until 1971, when the local historian Louis Tooker Vail (a nephew of William Wallace Tooker) gave a handwritten copy to the village's John Jermain Memorial Library. Vail had received it from Merrall's grand-daughter, his cousin Laura Gardiner (Vail) Tiffany, who apparently recopied the original in her own hand.

Just a year earlier, Jacob Landy published The Architecture of Minard Lafever, *the standard reference on the architect. Lacking firm evidence of Lafever's involvement with Sag Harbor's most famous building, Landy wrote, "Until evidence to the contrary appears, the strong probability is that Lafever was asked to advise on a Presbyterian church for Sag Harbor."[1] Merrall's letter is the evidence he was waiting for. After Randolph Croxton, the architect of the church's ongoing restoration, shared the letter with Landy in 1991, the scholar was able to confirm that Lafever indeed designed the church and supervised its construction. Sag Harborites are still looking for a document to confirm that Lafever built the Benjamin Huntting house, now the Sag Harbor Whaling and Historical Museum. Perhaps an aspiring relative is penning it now!*

[1] Jacob Landy, *The Architecture of Minard Lafever* (New York: Columbia University Press, 1970), 234.

Sag Harbour Oct. 1st 1843

Dear Mother

I expect this will find you at home and hope that your visits have proved benefitial to your eyes. I sailed from New York on Monday at 2 o'clock and arrived here the next day at ? past twelve just 3 hours longer than it takes the steamboat. We had a beautiful voyage, fine weather and a fine breeze all of the way with the exception of a few hours calm, in the night. Contrary to my expectations, I was not sea sick. I took my supper and breakfast on board for which I paid a shilling a meal. You can see the land on both sides of the sound all the way up. The widest part being fifteen miles across. Sag Harbour is a pretty good sized place though very dull. Whaling being the principal business followed by the inhabitants. There is hardly a person here who has not been on at least one voyage. There are five Churches—Catholic, Methodist, Presbyterian, Baptist and Universalist. Colonel Perry of the Texan Army is the Methodist Minister. The Methodist Church is the handsomest in the harbour. It stands on a hill facing the bay and has a clock which can be seen some distance from the harbour. The church that we are building will be a much more handsome edifice and considerably larger. The steeple is to be 165 ft. high. The original contract to build it was ten thousand dollars, since this they have added work to the amount of over two thousand more. Instead of my finding it enclosed as Mr. Lafever had told me, some of the window frames were not in when I arrived. The steeple was not boarded up over fifty feet high and there is sixty five feet more of the form to go up yet. I do not expect the outside work will be done in much less than two months. There were seventeen men at work on it when I came, three have left not much liking the job. The Boss gives the old hands the preference for the inside work, all but two being from New York. An Englishman is getting out the stairs, they are a half circle going from the basement to the gallery. The pews are to be made in New York. The boss wants to lump some of his work to the men here but they will not lump any from him. Mr. Lafever appears to be a very nice man but has not been well for some time. We think he may not live long if he stops here—the sea air does not seem to agree with the New Yorkers. There has been but one day since I have been here that there has not been somebody sick in our boarding house. There are seven of us in our boarding house with a widow Lady. We pay two Dollars

per week for our board and very good board too. There was but one of the six that engaged to come who came and he only stayed four days as he got a better job in New York. If Thompson had come, he might have got a job on a church about seven miles from here at Southampton where they want carpenters. The boss said he did not care about any more men now. He did not authorize Mr. Lafever to send more than three men. I do not expect that the church will be finished before New Years. The plasterers say that it will be two months before they can get through. The Boss does not pay his men very regular and owes some of them 30 and 40 Dollars. Some of them are nearly paid up, he gave me five Dollars on Saturday night, not having small bills enough to pay the balance. The streets here are not paved—we have not any mud in wet weather as it is nothing but sand and gravel for miles around. I have not seen an acre of land under cultivation since I have been here, all of it about being covered with stunted trees, most of them being over six or eight inches in diameter. The produce comes from Connecticut and the lower part of the Island in sloops and is dearer than in New York. House rent is nearly as high as in New York. There are five houses building here now. About fifty whale ships are owned here. Three or four are lying at the dock now ready to go out. When they are gone, the stores will be mostly closed for the winter as there will be but a few men left in the place. It is raining all day today and I cannot get out. The men have to lose time in wet weather if the Boss cannot find inside work for them to do. There is one boat lying at the dock that has had her side stove in by a whale. There are two Cabinetmakers shops in the Village. They do not grant a license to sell liquor on this part of the Island though plenty of it can be got here by those acquainted. Some fisherman caught three smack loads of porgies the other day at one haul with a seine. We have church services here every night and three times on Sundays. The place is overstocked with girls so if Mr. Merser wants a wife, he can come here and get his pick out of a few hundred that stand ready for the first offer. The girls here wear Sou'Westers instead of bonnets. Please pack me a valise with my coat, cap and shirts and have father take them down to the slip at South Street. Give the valise to the Captain of the Sag Harbour sloop and I will call and get it.

Your affectionate Son

Edward R. Merrall

WILLIAM M. DAVIS ON CAPTAIN JAMES HUNTTING (1874)

The exploits of Capt. James Huntting (1825–1882), a grandson of Col. Benjamin Huntting, were larger than life, like the man himself. Once he was pulled underwater by a whale, his ankle caught in a coil of line, but he rose to tell the tale. William M. Davis immortalized the captain with the "proportions of Hercules, and the face of man" in his whaling narrative Nimrod of the Sea; or, The American Whaleman *(1874). Chapter XXXII opens with this tale of "Captain Jim" doing a fine imitation of Melville's Ahab, in pursuit of a sperm whale near the mouth of the Rio de la Plata, which divides Argentina and Uruguay. It was 1858, and Huntting was in charge of the Sag Harbor ship* Jefferson.*

From 1857–1873, the captain lived in a prominent Greek Revival house on Bridgehampton's Main Street, opposite the end of the Sag Harbor Turnpike. It was built for the painter Nathaniel Rogers in 1840. Soon after Huntting sold it, this became the Hampton House, one of the area's first boarding houses for tourists, who began arriving on Long Island Rail Road in 1870. The Bridge Hampton Historical Society is restoring the building for the Town of Southampton, which acquired the property in 2003 to prevent its development.

Before bidding adieu to the sperm-whale, and passing to an account of the southern right whale, I will recount the experience of Captain Huntting, off the Rio de la Plata.

Some sage has remarked, by-the-way, that hunting tigers may be fine sport, but that when the tigers take to hunting the hunters, the sport has a different aspect. The aspect of whaling is not improved, certainly, when a ninety-barrel bull whale hunts on his own account in deep water. Such a one was met by Captain Huntting. When the monster was struck, he did not attempt to escape, but turned at once on the boat with his jaw, cut her in two, and continued thrashing the wreck until it was completely broken up. One of the loose boats picked up the swimmers, and took them to the ship. The other two boats went on, and each planted two irons in the irate animal. This aroused him, and he turned his full fury on them, crushing in their bottoms with the jaw, and not leaving them while a promising mouthful held together. Twelve demoralized men were in the water, anxious observers of his majestic anger. Two men who could not swim had, in

their terror, climbed on his back and seated themselves astride forward of the hump, as perhaps the safest place from that terrible ivory-mounted war club which he had brandished with such awful effect. At one time another man was clinging to the hump with his hands. The boat which had gone to the ship with the crew of the first stove boat now returned, and took the swimmers on board.

The whale had now six harpoons in him, and to these were attached three tow-lines of three hundred fathoms each. He manifested no disposition to escape, but sought to reduce still further the wreck about him. Boats, masts, and sails were entangled in his teeth; and if an oar or any thing touched him, he madly struck at it with his jaw. This was entirely satisfactory to Captain Huntting, who was preparing other boats to renew the fight. At length two spare boats were rigged, and these, with the saved boat, put off again. The captain pulled on; but the whale saw the boat, and tried his old trick of sweeping his jaw through the bottom of it. She was thrown around out of his sweep, however, and the captain fired a bomb-lance, charged with six ounces of powder, which entered behind the fin and exploded in his vitals. Before the crew could get out of the way, "he tore right through my boat, like a hurricane, scattering all hands right and left." So said Captain Huntting. Now four boats were utterly lost, some twelve hundred fathoms of line, and all the gear. The remaining boats were hastily and poorly provided, the men were gallied, the sun was going down, and the captain, when he was fished out, consented to give up the day and cry beat.

All hands went to work to fit other boats. Through the night, under shortened sail, the ship lay near the scene of conflict; and while the weather was calm it was possible to keep track of the whale as he occasionally beat around. But the breaking day brought rough weather, and the captain proceeded to Buenos Ayres, as much to allow his men, who were mostly green, to run away, as for the purpose of refitting, as he knew they would be useless thereafter. In this design he was not thwarted. Most of them promptly deserted, having had enough of wrestling with the fighting whale of the La Plata.

Not all whaling stories were heroic, as Harry Sleight, Sag Harbor's historian in the early twentieth century (and, briefly, its newspaper editor), explains in this episode from Chapter XV of his book The Whale Fishery on Long Island *(1931):*

The old whalemen were wont to congregate in French's store, Vaughn's grocery, and more recently at Hedges' paint shop, to spin yarns and rehearse the thrilling experiences of the past. Some pretty tall stories were told....

Prentice Mulford used to spin a good yarn. He was chosen "cock of the forecastle," when he related how a whale boat, painted green, fastened to a big whale, which, instead of sounding, started off dead to windward at a speed that threatened to take the boat to the other side of the globe in short order. The line smoked as it ran around the loggerhead and through the chock from the coil tub; and water had to be poured on the gunwhale to keep the wood from catching afire. But the captain decided to hang on. The hair blew off three whalemen and another lost his eyelashes; the boat was being towed so fast, and the pitch of the boat's seams melted and ran out from friction, so the men had to bail with their hats to keep afloat. Finally the captain looked over his shoulder, and saw another green boat just behind. No boat had any business to be there, as by this time the whalemen were miles and miles away from their ship. He looked over the gunwhale and saw the wales bare of paint, and then sprang forward and cut the line attaching him to the whale. "Boys," he said, "it's time to cut clear when that a're critter tows us so fast he pulls the boat right out'en the paint.

"Just how fast the whale went," Prentice used to finish the yarn, "was never known; but it took the whalemen two days to pull back to where the ship was left behind."

NANCY BOYD WILLEY TO FRANK LLOYD WRIGHT (1945)

A member of one of the first families to settle Southampton and Sag Harbor, Nancy Boyd Willey (1902–1998) was an advocate for Sag Harbor's preservation throughout her long life. She was also a client and friend of the pioneering modern architect Frank Lloyd Wright. She and her husband, Malcolm, a professor and later a vice president at the University of Minnesota, commissioned Wright to design them "an affordable house" in 1932, the year he founded his Taliesin Fellowship of apprentices in Wisconsin. After rejecting his first design as too costly, Nancy oversaw construction of a second plan in Minneapolis two years later. Ten years after it was completed, in 1944, at her summer home in Sag Harbor, she helped found the Old Sagg-Harbour Committee to focus attention on the early structures of her ancestral village. Her guide book, Built by the Whalers: A Tour of Historic Sag Harbor, *was first published by the committee in 1945. This letter is her apology to the man who worked harder than any other American to render old houses ("boxes within boxes") irrelevant.*

Wright did not reproach his former client, at least not in writing. The current owner of the Willey House, Steven Sikora, hopes to publish the full correspondence between Willey and Wright about the house they built together. Her letter is in the archives of the Frank Lloyd Wright Foundation at Taliesin West in Scottsdale, Arizona. Considered a step on the way to the populist "Usonian" designs of Wright's later years, the Willey House was the subject of an exhibition at the Minneapolis Institute of Arts in 2007. Sikora maintains a Website on its ongoing restoration: www.thewilleyhouse.com.

After retiring to Sag Harbor in the late 1960s, Nancy Willey inspired the effort to create the village's first historic district in 1973. She did not serve on the Historic Preservation Commission, but most of its surviving members remember her asking them to do so. She also organized the Conservation and Planning Alliance (CAPA), which lobbied for land conservation in the surrounding area. Willey helped to prevent housing developers from building along Sag Harbor's eastern boundary, Little Northwest Creek, and the adjacent Barcelona Point. Both areas are now owned by New York State. Beyond Barcelona Point (which sailors named for its resemblance to a bluff near the Spanish port), there are substantial Suffolk County parks at Northwest Creek and nearby Cedar Point. Much of the land between them, bordering Northwest Harbor, has been set aside by the Town of East Hampton, with The Nature

Conservancy's flagship Mashomack Preserve opposite on Shelter Island. Given the intensity of develop-ment around Sag Harbor, it's hard to overstate the importance of these conservation achievements of the 1970s and eighties to the quality of life locally. Much of the land bordering the historic maritime entry-way to the port cannot be developed, giving the village room to breathe. Many deserve credit, but Willey deserves more than most.

A 1976 interview with the preservationist begins on page 61, opposite a photograph of the other small house she loved, the eighteenth-century cottage her mother, the painter Annie Cooper Boyd, con-verted into a summer home beside her family's larger house on Sag Harbor's Main Street. An active pro-ponent of local history in her own lifetime, Boyd believed her little house was the building from which David Frothingham published Long Island's first newspaper, The Long Island Herald, *in the 1790s, but early deeds have since proven otherwise. She ran a tea room there during the Depression. Willey left her house to the Sag Harbor Historical Society, which helped to expand the village's historic district in the early 1990s. It is now the society's office and gallery (page 60).*

Mrs. Malcolm M. Willey
255 Bedford street, S.E.
Minneapolis 14, Minnesota

Dear Frank,
"The holw damn two of us" are right here, and we've had you on our minds especially, ever since Hallow'een 1944 which was the tenth anniversary of "the house." It seemed as though you should be saluted in some way, but somehow, with the frailty of human nature, even the letter of salute has been procrastinated…if that is English.

When are you and Olgivanna coming this way again? It would be so wonderful to see you both and catch up on things.

I have not seen Bob Warn again, although he writes once in awhile. I hope he was an asset to Taliesin West. I'm sure it was a wonderful thing, for him, to be with you.

Did you know Malcolm was a vice-president now?

He is working on a talk to his dining club, this winter, on the educational philosophy of Frank Lloyd Wright. Ever hear of him?

Our vacation in Sag Harbor took a new turn last Summer. I don't know whether to try to explain or to just not try. It's a committee to promote the appreciation of the 1790–1850 old homes! ——!-! -xxxx! ????—!!.. well, I know, but…

Do you believe that sort of thing is vicious? Of course I have terrible qualms but…it's the only integrity the little old town has…the alternative is not honest new building, but horrible cheap modern things, and bad "remodeling" of the old. The Americana that was caught there when progress pulled out and passed by in 1850, has a dignity, value and glamor, better than anything the fly-by-night, here to-day and depression to-morrow industries can bring in. It seems like the town's only chance for dignity and welfare. In emphasizing the setting that the houses belonged to, the whaling days, I hope not to spread the idea that there is anything sensible in copying them for the life of to-day. But I know, right well, that that will be a result to some extent. I love the little old town, and believe there was much fine American tradition there, that it is well to honor.

What is your comment? that "the prostitute in the back of the room had better sit down?" or is there a better side? I am writing a sort of guide book, telling the tales of the old houses, and a bit of the human side of the architecture. Gosh I feel like Brutus! If you write me and begin "dear Brutus", then I'll know my soul is lost.

Thanks so much for your "receipt for 1945." It was awfully good to hear from you in your own special language.

With love to you all, from both of us,

Nancy

January 16, 1945

FILLMORE CALHOUN TO WILL YOUNGS (1947)

Although undated, this letter—simply addressed to Mr. Will Young, The Hotel, Sag Harbor, Long Island, New York (his name was Youngs, but the final "s" must have been lost in the mail)—was postmarked April 23, 1947. It records one of the first summer home purchases of the post-war era, and quite possibly the beginnings of Sag Harbor's middle-class summer colony. The price is a sign of the times. Fillmore Calhoun (1910–1967) was an international editor for Time-Life, having been a war correspondent in Italy during World War II. His widow Elizabeth (Lib) still lives in Sag Harbor. Youngs was the proprietor of the American Hotel. A receipt he kept with this letter, now in the care of his grandson Jack Youngs, notes that he sold the Calhouns the following furniture, along with the house on Rysam Street: a highboy ($35), a bureau ($10), and a table ($2). The couple bought several Sag Harbor houses and put them "in shape," encouraging friends, many of them fellow journalists and editors from Time-Life, to join them in Sag Harbor. Some bought summer homes of their own, and eventually moved out from the city full-time. After John Steinbeck's arrival in the 1950s, Sag Harbor developed a reputation as a writer's community. Many writers "discovered" Sag Harbor, thanks to its cheap housing and rich atmosphere. Where else could Nelson Algren and Betty Friedan have lived on the same block?

Together with the builder's contract on page 260, this letter allows for some crude math. Whereas in the 1840s, at the height of the whaling era, a basic house in Sag Harbor could be built for $350, a century later, a house of comparable size and vintage in need of basic maintenance changed hands for $2,800— eight times more. Today, both houses would fetch at least $1 million, roughly a 400-fold increase in just sixty years. This describes the village's transformation, an extreme case in a national trend.

LIFE
TIME & LIFE BUILDING
ROCKEFELLER CENTER
NEW YORK 20

EDITORIAL OFFICES

Dear Mr. Young:

Mrs. Calhoun and I have talked about your little house with our friends and also have discussed the possibility of buying it ourselves.

It <u>would</u> take quite a lot of work to get the house in shape and, in order to cut down the additional costs of furnishings, we'd like to buy it as is with all the old furnishings—except, of course, for the piano and the three or four other pieces that you mentioned you wanted to keep. We think we could handle a price of about $2800 but we'd like to check the situation again and would greatly appreciate it if you would hold off other offers until we see you this weekend.

Sincerely yours,
Fillmore Calhoun

JOHN STEINBECK ON THE OLD WHALERS' FESTIVAL (1964)

The popular novelist John Steinbeck was a frequent resident of Sag Harbor from 1955 until his death in 1968. His wife Elaine remained active in the village's cultural life until her death in 2003. Steinbeck's account of his drive around the country, Travels with Charley in Search of America *(1962), begins in Sag Harbor—after a stop to secure his boat. Such attentions, and his fondness for the village's working people, made him a local favorite. Sag Harbor provided the model for the New England port in Steinbeck's last novel,* The Winter of Our Discontent *(1961). From 1963–1968 he served as Honorary Chairman of the Old Whalers' Festival, one of the village's first efforts to promote itself as a tourist attraction. The author's handwritten copy of this "Manifesto," printed—with slight variations—in several of the annual festival programs during his lifetime, hangs among the harpoons on the wall of the Sag Harbor Whaling and Historical Museum. In 2004, a bronze bust of the writer by the sculptor Kimberly Monson was placed in the reading room of the John Jermain Memorial Library (pages 80 and 217) across the street. A plaque acknowledging Steinbeck's contributions to the festival is on the windmill beside Long Wharf.*

This is the second annual Sag Harbor Old Whalers' Festival, and it promises to be even more reverent and memorial and confused and historical and crazy than the one last year. It is Sag Harbor's answer to automation. For one thing, much research has gone into this festival, and we now know more about the original Old Whalers than some of them would want us to.

We made some mistakes last year which helps because now we can make the same ones quicker and easier and go on to new errors.

One of these will be a real whale boat race, participated in by Sag Harbor defending against the neighboring towns for the Cetacean cup. This is no clocked affair. The flower of our youth and strength will man the sweeps, each whale boat driving down the harbor. The winning boat gets the first harpoon in a genuine artificial whale. And if that isn't an invitation to mayhem, I don't know what is.

This resurrected sport is so new that it has no ground rules as yet. We may have to get some later to save life and limb, but not this year. However, this race may prove that there is as much blubber now as there was in the old days.

But this is only one of many fascinating, historical and improbable events. There will be parades and reenactments—a beard judging and a beauty contest for fish.

We aim to experiment with a beach buggy contest over a course like a lunar landscape. No one can foresee what will happen here but the prospects are dreadful and beautiful to contemplate. But after all the Old Whalers whom we celebrate lived dangerously, and we cannot let them down.

Not all attention will be on blood sports. Youth and beauty of the feminine persuasion will preside over the dancing and music together with many romantical inventions and conceits—all designed to create a Dionysiac spirit of quid pro quo, and the quoer the better.

North Sea will participate in the festival which is a guarantee of enthusiasm even if the insurance rates do go up.

Harborites have been working and planning and practicing for this celebration for many months. We want to make our guests welcome only promising to clobber them if they get out of hand. We hope we are not overtrained.

The fact that I have been made Honorary Chairman of the Old Whalers' Festival is a clear indication of the explosive but cautious thinking of the descendents of the Old Whalers. If all goes well, we share the happiness but if the Village blows up, I get the blame.

I don't know how I got here. I am only a sixth class citizen. It takes six generations for first class. But my neighbors are considerate and kind to me.

Any way, we hope you will enjoy our festival. Complaints may be made in Riverhead or will be individually taken care of behind Otter Pond and perhaps in it.

John Steinbeck
Honorary Chairman and running scared

DOMINICK CILLI, DAIRY FARMER, INTERVIEWED DURING MILK DELIVERIES (1976)

Buildings aren't the only things that Sag Harbor has preserved. A few years after Dominick Cilli died in 1979, his family's dairy farm was for sale. The drama that ensued is a familiar one on the East End: a developer went into contract to buy the property, one of the largest pieces of open land in the village, pending the approval necessary to develop it. Over the next two decades, proposals for a subdivision, a nursing home, and indoor tennis courts were put forward and shot down. In 2000, the village bought the nearly nine-acre property with help from Southampton Town and Suffolk County to ensure that it would never be developed. Neighbors halted an effort to create an organic community farm on the property; now, the land is reverting to woodland and wetland. The dairy was started by Dominick's father, Vitale Cilli, one of many Italian immigrants who settled in the village early in the twentieth century.

My father came to Sag Harbor from Italy in 1909. His brother came first, got a job with the Fahys watch company, and saved enough money to send for my father. That's how they did it in those days. They didn't all come at the same time. There was no work for them in Italy, and that brought them to New York. Some of them knew other Italians who had come out to Sag Harbor, and the word went around that there was a lot of work to be found here. My mother came from the island of Sicily. She was one of twelve children, and around seven of them came to America. She and my father rented rooms in the same boarding house in one of the back streets of Sag Harbor, and that's how they met. My mother worked in a sewing factory in the village.

My father worked on Gardiner's Island when he first came here. He helped clear the woods so they could make trails for their shoots. Then he got a job cleaning up around Pierson High School that had just been built. After that he bought a bicycle and went to Southampton to work every day. He was just a laborer, getting odd jobs. One of them was in the Fahys watch factory. What he remembered about that place was that, at the end of one of the weeks he worked there, all he found in his envelope was twenty-five cents. It must have been a mistake, but he was afraid to say anything in case he would be fired.

Around 1914, the year I was born, my father bought a two-family house on Rogers Street. We lived upstairs and the Lattanzios lived downstairs. There was a man next door who had seven cows, and one day my father asked him if there was any money in the milk business.

"There's a living," he said.

So my father went up the road to Wainscott and met a fellow called Charlie Schwenk, and he sold my father a cow named Tessie. After a while Tessie wasn't enough, so he bought a cow named Elsie. My brother and I used to take them out every day and pasture them. Then the business got bigger, delivering milk around the village, and he bought two more cows. There wasn't room for all of them at our little place on Rogers Street, so in 1922 he bought four or five acres on Glover Street for $400 and got someone to build him a house and a cow barn.

As the business got bigger, my father bought more cows and more land until, by the time my brother and I took over, there were about twenty acres in the Sag Harbor village limits, all the way from Glover Street to Railroad Avenue and up to Baron's Cove Marina. When my father started the dairy business, he had $2,000 and five children and four cows. When he died in 1964, he left about $250,000 in money and property, so he didn't do too bad. One time when I was working with him, around 1943, we bought eighteen acres for $1,800, and I paid for it all with one-dollar bills my father gave me.

The first time I had money to invest was when my father died. My share was $50,000, and I went out and bought a farm and used up all the money. I figured back to the Indians, how they started trading jewelry and stuff for their land, how the white man got the land, and the land got value, and it never did go down.

A lot of the people who came here around the time my parents did never bothered to become citizens. My father and mother got their first papers, but they never got their last ones. A fellow got it started for them, but he disappeared when they were about half way, and they never knew what happened to him. What is unbelievable to me is that my mother and father

never spoke Italian at home, always American. They loved this land and they loved the people, and they never wanted to go back because they couldn't make a living where they came from. Over here, they said, you can always get a piece of bread.

My father said he would only go back if he had a lot of money he could give to his relatives. That's why he always sent them some money, maybe only five dollars a month, whatever he could afford. My mother also took care of her family back home. I would never think about going over there. From what my parents told me, it's much too hard.

I didn't do so good at school because I was always tired. I had to get up at about two o'clock in the morning to milk cows, and then I had to help again at night. I've been milking since I was nine years old. I started by watching my father. One day he said, "you try," and I milked four cows straight off. When he found I could do the job, I helped him every day after that. Them days people had to be at work at eight o'clock and nobody had refrigerators, and very few could afford ice, so my father had to have the processing done and deliver all the milk before twenty to eight. He had to harness the horse, who was named Nellie, and load all the milk bottles on to the closed-in wagon. One winter the roads was all ice, and the horse was slipping all over, so he had to call the blacksmith at four in the morning to put spikes on the foreleg shoes. It could be pretty rough them days, trying to make deliveries.

After milking, I never did go back to bed. It always seemed there was some kind of work to be done—feed the animals, go out and chop wood, keep the stove going in the house. Then I had to go out and pump water, thaw out the pump in the winter, and by the time I got ready to go to school I was tired. We finished school about 3:15. Then I would run down to the farm and help my father with whatever he was doing, like making hay. When I went to bed, I didn't have any trouble sleeping. I didn't go through high school. I only went to seventh grade. It was a very rough life for me, trying to get an education. Years later I had to educate myself. These days when I deliver milk, I don't figure the bills. You do. And some I have to guess on.

I do not have to do all this work, you know. I got land all over the place. I don't have to work, but it was willed on me.

One day when I was fourteen, my parents took all the other kids to Southampton and left me to watch the dairy. I think we had around ten or twelve cows at that time. It was the Fourth of July, and all the other kids in town had firecrackers but me. So I took a twenty-quart milk can and put a gallon of gasoline in it and hammered it with a sledge-hammer and nailed it tight. I got my blow torch working and put it against the milk can, and I went in the house, and I waited. And I waited. All the cows were outside eating pasture, minding their own business. About a minute or two later there was an explosion, and everyone in the neighborhood came running out wanting to know what happened. All their windows had rattled, and in fact a couple of them broke. To this day I never said anything about it. But, two years later, I was pasturing cows and saw the milk cap down by the marina, about a thousand feet away. I didn't figure the explosion would be that bad.

I am the only one of my brothers who really enjoys farming. It's all I ever did, and I was not interested in anything else. It's a good healthy life. I've never had many sick days. Any medicine we give the animals, penicillin or anything like that, with my being there breathing their breath, it automatically works in me, too. Many days I would go to the barn sick, and after being around the cows, I was all right. One day last winter I was alone in the barn, working on the last three cows, when I lost my breath. So I picked one of the cows, one I liked, and I got near her nose and started breathing her oxygen, and after three or four minutes I got my breath back. I guess the cows thought I was crazy. The cow that saved my life, I always gave her a little extra grain.

It will be the end of the farm when I stop running it. It will not continue on. But I figure there is an end to everything, anyway.

The most I have ever been to New York is four times. I went to watch the World Series with Gabe Schiavoni and to another World Series when Joe DiMaggio was playing. I went to the World's Fair in 1939. And the last time I went was—let me think, maybe twenty years ago.

Sag Harbor is a pretty nice place, and I don't see no reason to leave it.

ANTHONY BRANDT TO NEW YORK STATE (1989)

This account of Sag Harbor's architectural preservation program was written in April 1989 by Anthony Brandt, a local author who was then Chairman of the village's Board of Historic Preservation and Architectural Review. It was sent to the New York State Department of Parks, Recreation and Historic Preservation as part of the village's application to become a Certified Local Government (CLG), which was approved a month later. This national program, administered state by state, was created in 1980 to encourage a standard approach to local preservation legislation and its enforcement. In New York, certified local governments must have a review board empowered to grant or deny a "certificate of appropriateness" before building permits can be issued for any alteration, demolition or new construction on properties in landmark districts. They must also have the power to designate new landmark districts. In other words, their powers must be statutory, not advisory. The state sets minimum qualifications for board members and periodically audits each CLG, offering in return training and grant funding for publication.

Sag Harbor expanded its historic district in 1994 to include the majority of the village; only a few modern and industrial areas at its periphery now lie outside the district. On behalf of the National Park Service, New York's Department of Parks, Recreation and Historic Preservation also reviews properties within the state nominated for the National Register of Historic Places. The village's applications to create and later extend its historic district in 1973 and 1994 are available through the state agency's Website: nysparks.state.ny.us (follow the links to "Historic Preservation," "Online Resources," then "Document Imaging"). The boundaries of the current district are described at the outset of the 1994 application. Sag Harbor's village code—including the precise mandate of its Board of Historic Preservation and Architectural Review—is available on the village's own Website: www.sagharborny.gov.

STATEMENT OF PLANS, VILLAGE OF SAG HARBOR,
BOARD OF HISTORIC PRESERVATION AND ARCHITECTURAL REVIEW

Sag Harbor's historic preservation efforts have made slow but steady progress since a large portion of the Village was designated a National Historic District in 1973. In 1972 the Village created a Historic Preservation Commission to oversee building permit applications within the historic district and advise applicants on the historic quality of their applications. This Commission also recommended buildings for designation as historic landmarks, and twelve or thirteen such buildings are now so listed.

In 1985 a new administration came into office in Sag Harbor and amended the historic preservation law to make it more stringent. The Historic Preservation Commission was abolished, to be replaced by the current five-member Board of Historic Preservation and Architectural Review. This Board was given the power to deny building permit applications absolutely for failure to conform to the Village's historic and architectural character, and its authority was broadened to include the entire Village of Sag Harbor, not just the historic district. In 1988 its power to deny applications was extended to demolition permits in order to qualify for designation as a Certified Local Government. The Board meets once a month in open public meetings to discuss building and demolition permits and vote on them; a rotating committee of the Board meets once a week to consider minor applications. An adjunct to the Board, the Municipal Building Study Commission, spent the fall of 1988 considering options for the preservation of Sag Harbor's Municipal Building, an historically important masonry structure built in 1846.

The Board's plans for the future include bringing Sag Harbor's historic survey up to date to meet State and Federal requirements, adding buildings (where appropriate) to the list of historic landmarks, and training Board members in the finer points of architectural history and historic preservation. The Board more or less of necessity consists of interested amateurs in these areas. Sag Harbor is a summer resort whose year-round population is small and consists primarily of non-professional business people, retired people, people who provide services and a few artists and writers. The Board also hopes to expand the historic district to include parts of a black community within its borders which is quite old and has its own historical society.

List of Plates

ALL BUT TWO OF THESE PHOTOGRAPHS were made in the three years leading up to Sag Harbor's 300th birthday in 2007. The color transparencies were made with a Deardorff 4x5/5x7 view camera, which seems to still time, a bit like historic preservation. They were scanned and prepared for printing in this book and a companion exhibition by Adamson Editions in Washington, DC.

Credits for the Extracts

p. 24 H. P. Hedges, *Early Sag-Harbor: An Address Delivered Before the Sag-Harbor Historical Society, February 4th, 1896* (Sag Harbor: J. H. Hunt, 1902), 30; reprinted in *The Writings of Henry P. Hedges, 1817–1911, Relating to the History of the East End*, edited by Tom Twomey (New York: Newmarket Press, 2000), 197. A word in this passage was altered in the reprint; the quotation is drawn from the original publication to avoid repeating this typographical error.

p. 26 Carol Williams, *Moving Stories* (2003, unpublished), courtesy of the author. A related essay by Carol Williams, "Mapping Sag Harbor," appears in *Sag Harbor Is: A Literary Celebration*, edited by Maryann Calendrille with photographs by Kathryn Szoka (Sag Harbor: Harbor Electronic Publishing, 2006), 127–29.

p. 28 Everett T. Rattray, *The Adventures of Jeremiah Dimon: A Novel of Old East Hampton* (Wainscott, NY: The Pushcart Press, 1985), 9. Used by permission of Helen S. Rattray.

p. 30 James Fenimore Cooper, *The Sea Lions; or, The Lost Sealers* (New York: W. A. Townsend and Co., 1860); reprinted with an introduction by Warren S. Walker (Lincoln: University of Nebraska Press, 1965), 14–15. (Originally published in 1849.)

p. 32 Herman Melville, *Moby-Dick; or, The Whale*, Chapter XII, "Biographical" (New York: Harper & Brothers, 1851); reprinted with a foreword by Nathaniel Philbrick in a "150th anniversary edition" (New York: Penguin Books, 2001), 62.

p. 34 Prentice Mulford, "The Arsenal's Last Days." A transcript of this article is in a scrapbook on Sag Harbor's Custom House in the local history collection of the John Jermain Memorial Library. It credits the *San Francisco Bulletin* of February 14, 1875 (as does Dorothy Ingersoll Zaykowski, who quotes this passage in *Sag Harbor: The Story of an American Beauty* (Sag Harbor: The Sag Harbor Historical Society, 1991), 68.) But the *Bulletin* did not yet exist, and neither of its predecessors, the *Daily Evening Bulletin* or the *Weekly Bulletin*, published on that day. Presumably, the essay appeared in one of these publications on a nearby date and the transcript was mislabeled. The arsenal, built in 1810–1811, was demolished in 1885.

p. 36 Harry D. Sleight, *The Whale Fishery on Long Island* (Bridgehampton, NY: The Hampton Press, 1931), 211.

p. 42 Everett T. Rattray, *The South Fork: The Land and the People of Eastern Long Island* (New York: Random House, 1979), 140. (Rattray's spelling of the architect Minard Lafever's name has been standardized in this version.) Used by permission of Helen S. Rattray.

Donald Crawford, quoted in Berton Roueche, "The Steeple," *The New Yorker*, March 5, 1949, 55.

p. 46 Herman Melville, *Moby-Dick; or, The Whale*, Chapter IX, "The Sermon" (New York: Harper & Brothers, 1851); reprinted with a foreword by Nathaniel Philbrick, in a "150th anniversary edition" (New York: Penguin Books, 2001), 47.

Harry D. Sleight, *The Whale Fishery on Long Island* (Bridgehampton, NY: The Hampton Press, 1931), 215.

p. 56 John Steinbeck, *The Winter of Our Discontent* (New York: Viking, 1961), 43–44. Copyright renewed 1989 by Elaine Steinbeck, John Steinbeck IV, and Thom Steinbeck. Used by permission of Viking Penguin, a division of Penguin Group (USA), Inc.

Sag Harbor: In the Land of the Sunrise Trail, 1707–1927 (Village of Sag Harbor, 1927), 50.

p. 64 John Steinbeck, *The Winter of Our Discontent* (New York: Viking, 1961), 261–62. Used by permission of Viking Penguin, a division of Penguin Group (USA), Inc.

p. 66 Jason Epstein, "Sag Harbor Tour," in Jason Epstein and Elizabeth Barlow, *East Hampton: A History and Guide* (Wainscott and Sag Harbor: Medway Press, 1975), 98. (Revised and reissued by Random House, 1985.) Used by permission of the author.

p. 78 *The Sag Harbor Survey* (New York: The Department of Church and Labor, the Board of Home Missions of the Presbyterian Church in the U.S.A., 1911), 4.

p. 90 Anita Anderson, interviewed by Priscilla Dunhill, *The Sag Harbor Express*, April 14, 2005. Used by permission of the author and Bryan Boyhan, editor and publisher of the *Express*. A longer interview with Anita Anderson appears in the John Jermain Memorial Library's forthcoming oral history of Sag Harbor.

p. 96 Val Schaffner, "The Whaler's Gift," in *The Astronomer's House* (Sagaponack: Canio's Editions, 2003), 162–63. Used by permission of the author. The title story in this book of Sag Harbor ghost stories concerns the Ephraim Byram house.

p. 98 Suffolk County Planning Department, *Sag Harbor Study and Plan* (Hauppauge, NY: Suffolk County General Services, 1971), 6.

pp. 101–02 John Steinbeck, *The Winter of Our Discontent* (New York: Viking, 1961), 49–50. Used by permission of Viking Penguin, a division of Penguin Group (USA), Inc.

p. 104 Erastus Bill, *Citizen: An American Boy's Early Manhood Aboard a Sag Harbor Whale-Ship Chasing Delirium and Death Around the World, 1843–1849, Being the Story of Erastus Bill who Lived to Tell It* (Anchorage, AK: O.W. Frost, 1978), 57.

p. 107 Richard Henry Dana, Jr., *Two Years Before the Mast* (New York: Harper and Brothers, 1840); reprinted in *Two Years Before the Mast and Other Voyages* (New York: Library of America, 2005), 29. (This diary entry was written on November 7, 1834.)

 Harry D. Sleight, *The Whale Fishery on Long Island* (Bridgehampton, NY: The Hampton Press, 1931), 5.

p. 112 Daniel M. Tredwell, *Personal Reminiscences of Men and Things on Long Island, part one* (Brooklyn: Charles Andrew Ditmas, 1912), 162.

p. 122 Daniel M. Tredwell, *Personal Reminiscences of Men and Things on Long Island, part one* (Brooklyn: Charles Andrew Ditmas, 1912), 157. (From Tredwell's diary of July 1843; the passage quoted on page 112 describes a return visit in 1880.)

p. 125 Benjamin F. Thompson, *History of Long Island from its Discovery and Settlement to the Present Time*, 3rd ed. (New York: Robert H. Dodd, 1918), Vol. II, 195.

p. 126 Samuel L. Gardiner, quoted in *Sag Harbor: In the Land of the Sunrise Trail, 1707–1927* (Village of Sag Harbor, 1927), 26.

p. 142 Lawrence LaRose, *Gutted: Down to the Studs in My House, My Marriage, My Life* (New York: Bloomsbury Press, 2004), 35. Used by permission of the author and Bloomsbury Press.

p. 154 Dylan Thomas, *Under Milk Wood, a Play for Voices* (New York: New Directions Publishing Corp., 1954), 3. Thomas probably never made it to Sag Harbor, but his radio play brings to life a village or, as he writes (in the "voice of a guide-book"), a "backwater of life" (pages 25–26).

p. 188 Gravestone of Favieco Maeceia, Oakland Cemetery, Sag Harbor. The only date on the fading stone is Maeceia's age at death: forty-four. Harry Sleight says this occurred in 1858, and he speculates that Maeceia, who washed up with six Portuguese companions and plenty of cash, then promptly died, may have been a slave trader; see *The Whale Fishery on Long Island* (1931), 63.

p. 191 George Sterling, "The City By the Sea—San Francisco," *The Bulletin*, November 30, 1922 (Vol. 135, No. 19), 14. Sterling, a Sag Harbor native, was called "the poet laureate of California" early in the twentieth century. Several of his California poems describe Sag Harbor; see John C. Huden, "George Sterling, Prankster-Poet," *Long Island Forum*, Vol. VI, No. 9 (Sept. 1943), 163ff.

Acknowledgments

*I*T TOOK A VILLAGE TO MAKE THIS BOOK.

When it occurred to me I didn't know enough about Sag Harbor's early pictorial record, late in 2002, Suzan Smyth showed me just what I was looking for: William Wallace Tooker's photo album from the early 1880s, which she had been looking after along with the rest of the local history collection in the village's John Jermain Memorial Library. In the years since, she has put many other research materials in my hands just when I needed them. The library's Director, Allison Gray, and its board, led at the time by Bob Reiser, made the Tooker photos in their collection available for this book and the exhibition it accompanies. The blue-print of the Umbrella House (page 148) came from the East Hampton Library's Pennypacker Long Island Collection, with the help of its librarian, Marci Vail. Richard Barons, Executive Director of the East Hampton Historical Society, helped me locate an early print of Tooker's photograph of the whale that beached between Sagaponack and Wainscott around 1910 (page 33). Nancy Carlson shared with me the album of Tooker's drawings that turned up in her Sag Harbor attic, through family connections to his business partner in the pharmacy he once ran. Joy Lewis took me into Tooker's home, which is now hers, and shared the remarkable collection of early Sag Harbor artifacts she and her husband, the late Robert Lewis, gathered together. John Krug let me comb through the eclectic collection of early Sag Harbor photographs his partner, the late Otto Fenn, assembled. And Joe Markowski, Jr., and Jack Youngs—two Pierson High School classmates—both shared with me their collections of early Sag Harbor postcards, which they had never shown each other.

Fellow photographers and historians of photography also helped me find early images of Sag Harbor to inform my own. Kathryn Abbe shared previously unprinted photographs from her first visit to the village in 1944 (pages 197 and 231), as well as research her husband, the late James Abbe, did on early Sag Harbor painters and photographers. She was the first to show me a copy of the extraordinary daguerreotype on page 31, the earliest Sag Harbor photograph I found. It is an image as compelling to historians of photography as it is to historians of Sag Harbor, as Keith F. Davis realized when he bought it for the Hallmark Photographic Collection, now part of the Nelson-Atkins Museum of Art in Kansas City, Missouri. How he and I found each other and learned we both planned to publish it at the same time is one of the tales of serendipity that made this project invigorating. I am grateful to the Nelson-Atkins Museum of Art for making this image available; it can also be seen in the museum's new book of highlights from its photography collection, authored by Davis, *The Origins of American Photography, From Daguerreotype to Dry-Plate, 1839–1885*.

Many East End historians—including David Cory, John Eilertsen, David Goddard, Mac Griswold, Jean Held, Robert Hefner, both the Richards Hendrickson, Pamela Lawson, Henry Moeller, John Strong, Lois Underhill, Ken Yardley, Dorothy Zaykowski, Joseph Zaykowski, Jr., and Ron Ziel—let me pick their brains as I tried to puzzle out the movements of Sag Harbor houses and the many factors that shaped them. Still others—including Paul Babcock, Anthony Brandt, Alison Cornish, Peter Davies, Myrna Davis, Chris Leonard, Dorothy Sherry, and Joan Tripp—helped me understand the political background of Sag Harbor's efforts to preserve its architectural heritage. Preservation professionals helped me put Sag Harbor's experience in a broader context: notably Charla Bolton, Preservation Advocate at the Society for the Preservation of Long Island Antiquities (SPLIA); Julian Adams, Senior Historic Sites Restoration Coordinator, and Virginia Bartos, Historic Preservation Program Analyst, at the New York State Department of Parks, Recreation and Historic Preservation; and Patricia Butler, formerly Executive Director of the Nantucket Preservation Trust.

I relied on research assistance from archivists and curators from Nantucket Island to Newport News, Virginia, in my hunt for early images of Sag Harbor. Nancy Finlay, Curator of Graphics at the Connecticut Historical Society Museum, was especially helpful, as were Jill Annitto, formerly Photo Archivist of the Brooklyn Historical Society; Lisa DeBoer, Archivist of the Brooklyn Collection at the Brooklyn Public Library; John Hyslop, Assistant Manager of the Queens Library's Long Island Division; and Wallace Broege, Director of the Suffolk County

Historical Society. Stuart Frank, Senior Curator at the New Bedford Whaling Museum, helped me understand the history of American whaling and called my attention to Sag Harbor materials in New Bedford. Andy Kraushaar, Visual Materials Curator at the Wisconsin Historical Society in Madison, located the negative for an early postcard view of the John Jermain Memorial Library (page 217) in his collection (it was there, thanks to the foresight of his predecessor Paul Vanderbilt), and Robert MacKay, Executive Director of SPLIA, called my attention to photographs of the Custom House being moved (page 235) in SPLIA's archive. Kathy Tucker first showed me the tintype on page 110, found on the property on the facing page. Like all the best documentary evidence, it raises more questions than it answers. Elizabeth Bowser, Kathy's co-founder at the Eastville Community Historical Society, has suggested this may be Mary Jane Hempstead (born 1850), the daughter of David Hempstead, a prominent member of Sag Harbor's early African-American community. The photograph suggests a story I wish I could tell.

Several Sag Harborites let me photograph inside their homes, letting me to show the village from a more intimate vantage. Miles Anderson let me spend several days inside his mother's house after she died at 100, before the contents were auctioned off, and Bob Weinstein and Eric Hensley let me return to watch their renovation of the property. Thanks to all their hospitality, the story of the Anderson house (pages 83–95) serves a miniature version of this book, describing the transformation of Sag Harbor. Peter and Peg D'Angelo let me watch as they had the Maycroft mansion they had recently purchased on North Haven moved (page 114). David Bray, who has sold many Sag Harbor houses, let me photograph his own as he was offering it for sale (pages 158 and 161). Maureen Cogan let me photograph the Hannibal French house as it, too, was being sold (pages 72 and 73). Adrian Devenyi did not bat an eye when I told him I wanted to photograph the house he was just settling into, built by the astronomer and clockmaker Ephraim Byram, under a full moon (page 124). Mildred Dickinson shared with me her family miniatures, painted by her relative Orlando Hand Bears, and let me photograph his early self-portrait in her dining room (page 169). Joy Lewis never questioned my desire to make more pictures of her house (pages 153 and 155), often countering with a superb lunch. It seems fitting that many of these photographs were first exhibited on her dining table at a gathering she hosted in June 2006. Lynn St. John made me welcome in the Samuel Huntting house (page 52), as William Egan did in the John Jermain house (page 53), and Martha Sutphen let me photograph the whaling prints on the wall of the house that has been in her husband's family for many generations (page 22).

Several realtors let me photograph houses they were listing, notably Robert Evjen at Maycroft (page 113) and Ronnie Manning at the Mulvihill house (pages 162–65). Randolph Croxton took time away from his busy New York City architectural practice, the Croxton Collaborative, to take me inside the process of his ongoing restoration of the Old Whalers' Church (pages 43–45 and 47–49). David Kronman, of Cape Advisors, took me inside the Fahys/Bulova watchcase factory as he was planning its restoration (pages 128–29). Friends and strangers shared their knowledge of the village, or sometimes just the time of day, in my perennial hunt for timepieces to count off long exposures. Steven Sikora, who owns the house that Malcolm and Nancy Willey commissioned from Frank Lloyd Wright in Minneapolis, helped me understand the details of its creation. He also led me to Nancy's correspondence with her famous friend, including her letter of apology for speaking up on behalf of Sag Harbor's early structures (page 269).

Zachary N. Studenroth, Executive Director of the Sag Harbor Whaling and Historical Museum and a noted architectural preservationist on Long Island, was a collaborator from the outset. Without his support and the support of the Whaling Museum's Exhibition Committee, headed by Bettina Stelle with the able assistance of Barbara Pintauro-Lobosco and Linley Pennebaker Whelan, this book and its companion exhibition would have remained a collection of ideas and 4x5-inch transparencies in a box. I thank them and all the museum's supporters who made this publication possible. Bryan Boyhan and his staff at *The Sag Harbor Express* helped me keep the photographs in the box when I needed to by letting me load and unload my large-format film holders in the paper's darkroom. Bryan also provided a venue for several articles on historic images I found along the way, including several on Tooker photographs that I did not use in the book, and let me reprint a portion of Priscilla Dunhill's interviews with Anita Anderson, which the paper excerpted a week after her death in April 2005. I am grateful to Priscilla for doing these interviews and for sharing them.

Friends kept me going with their interest and conversation at critical junctures, especially Joan Baren, Jennifer Brown, Sarah Heming, Joy Lewis, and Carol Williams. Joan let me reproduce one of her drawings of Sag Harbor as she found it in the early 1970s (page 201), and dug out the contract for her house (page 260), which she had never fully deciphered. Carol let me borrow a passage from her forthcoming book about moving (page 26), which is the secret subject of this one, too. My mother, Joyce Egginton, transcribed unpublished interviews she did thirty years ago with three long-gone Sag Harborites (pages 61, 74, and 276) and gamely threw herself

into the time-consuming project of doing many more to bring the record up to date, letting a cross-section of today's villagers speak for themselves and for their buildings. The contemporary voices heard on these pages would not be there without her ear for spoken language and her inimitable shorthand. Our thanks go to all the Sag Harbor residents who freely gave us their time and answered our many questions. Joyce also helped with copyediting, as did Judy Long, taking a busman's holiday from her day job copyediting *The Nation*; Carol also served as an essential early reader. My wife, Kelley Tucker, accepted my long absences from the home we took in Wisconsin for precisely the three years I spent working on this book—one of the stranger East End real estate stories I've heard—and served as a second set of eyes and ears as ideas took shape. Her belief in the project made it possible.

Friends outside Sag Harbor were also indispensable. David Goldfarb provided many of the 500-odd sheets of film on which my pictures were made and lent me his camera when mine was being repaired. George F. Thompson, founder and president of the Center for American Places, understood the project right away, in all its curious complexity. I cannot imagine another publisher who would have. George's commitment to the local, artfully described, is a national story; I thank him for helping me tell mine. John Hughs, Assistant Director at Adamson Editions in Washington, DC, took great care to be sure my pictures looked their best, as did David Skolkin, the book's designer. Philip Kennicott made it easy to come and go from Washington, where the digital files and layout were prepared—though they benefited from Jill Metcoff's keen eye in Wisconsin. Ben Gest prepared digital files of the historic images at Columbia College Chicago, where I once taught. Columbia also underwrote the cost of designing the book, thanks to its ongoing collaboration with the Center for American Places. A Furthermore grant from the J. M. Kaplan Fund helped to cover the cost of scanning and proofing my own photographs. My brother, John, helped me acquire an early history of Sag Harbor and copies of several early images essential to telling this story.

Deirdre Brennan let me use her portrait of me working in the Old Whalers' Church, made when *The New York Times* ran a story on this project in 2005. Several authors—Jason Epstein, Lawrence LaRose, and Val Schaffner—let me quote from their publications, and Anthony Brandt let me print a letter he probably never expected to see the light of day (page 280). Helen S. Rattray let me quote two passages from her late husband Everett's books on the South Fork. And my father's old friend Lib Calhoun let me print the letter with which her husband, Fillmore, bought their first Sag Harbor house (page 272), which in a roundabout way led to my arrival.

All of this never would have happened if my parents hadn't brought me to Sag Harbor the year I was born and made it easy to keep coming back. It's the best birthday present I can recall. I would not have been able to return to the East End full-time if it hadn't been for the generosity of the William Steeple Davis Trust, which invited me to live in Orient for a year in 2001. That led me back to Sag Harbor (though a related project, pairing my photographs of Orient with those Davis made a century before, was exhibited at Greenport's Floyd Memorial Library in 2003, with help from the New York State Council on the Arts). David Rattray gave me a lesson in East End politics by asking me to write about local land-use issues for *The East Hampton Star* in 2003. This taught me some things I didn't want to know about the place I love, but needed to all the same.

Many other friends, old and new, have helped along the way; to all, my thanks and best wishes.

About the Author

STEPHEN LONGMIRE'S PHOTOGRAPHIC EXPLORATIONS of place have been exhibited in galleries and museums across the United States, including Chicago's Museum of Contemporary Photography and the Guild Hall in East Hampton, New York. In 2005, he was among ten contemporary artists working on eastern Long Island featured in Guild Hall's exhibition and catalogue, "East End Ten." Several of his recent photographs of the area are in the permanent collection of the Corcoran Gallery of Art in Washington, DC. Over the last decade, he has experimented extensively with photographic multiple exposure, creating moving pictures in still form. What began as an effort to visualize first-person experiences of place provided a tool for depicting a place that is changing fast. This book continues the project in a new way, combining contemporary and historic photographs in an effort to photograph historic time.

Longmire has written extensively on photographic art for a wide range of publications, including *Afterimage: The Journal of Media Arts and Cultural Criticism*, *The Chicago Reader*, and *DoubleTake* magazine, which also published his photographs of "Fairy Houses," miniature structures children build of found materials, in 1997. In 2003, he was a staff writer for *The East Hampton Star*, covering land-use issues on eastern Long Island, among other topics. He has taught the history and practice of photography at Georgetown University and Columbia College Chicago, and he has been a fellow at the Ragdale Foundation outside Chicago and the Smithsonian's National Museum of American Art.

Longmire holds graduate and undergraduate degrees in humanities from the University of Chicago. A native New Yorker, he has spent much of his life in and around Sag Harbor. He and his wife, Kelley Tucker, an environmental conservationist, live just outside the village, on neighboring North Haven.

The Center for American Places is a tax-exempt 501(c)(3) nonprofit organization, founded in 1990, whose educational mission is to enhance the public's understanding of, appreciation for, and affection for the places of America and the world—whether urban, suburban, rural, or wild. Underpinning this mission is the belief that books provide an indispensable foundation for comprehending and caring for the places where we live, work, and explore. Books live. Books endure. Books make a difference. Books are gifts to civilization.

With offices in Santa Fe, New Mexico, and Staunton, Virginia, Center editors have brought to publication more than 300 books under the Center's own imprint or in association with numerous publishing partners. Center books have won or shared more than 100 editorial awards and citations, including multiple best-book honors in more than thirty academic fields.

The Center is also engaged in other outreach programs that emphasize the interpretation of place through exhibitions, lectures, seminars, workshops, and field research. The Center's Cotton Mather Library in Arthur, Nebraska, its Martha A. Strawn Photographic Library in Davidson, North Carolina, and a ten-acre reserve along the Santa Fe River in Florida are available as retreats upon request.

The Center strives every day to make a difference through books, research, and education. For more information, please send inquiries to P.O. Box 23225, Santa Fe, NM 87502, U.S.A., or visit the Center's Website (www.americanplaces.org).

About the Book
The text for *Keeping Time in Sag Harbor* was set in Caslon. The paper is Leykam Matt, 150 gsm weight. *Keeping Time in Sag Harbor* was brought to publication in an edition of 2,500 paperback and 500 cloth-bound copies. The book was printed and bound by CS Graphics in Singapore.

For the Center for American Places
George F. Thompson, President and Publisher
A. Lenore Lautigar, Publishing Liaison and Associate Editor
Catherine R. Babbie, Editorial and Production Assistant
Judith Long, of *The Nation*, and Purna Makaram, Manuscript Editors
John Hughs, Assistant Director at Adamson Editions, and Benjamin Gest,
 Director of Digital Scans at Columbia College Chicago, Fine Art Scans and Digital Files
David Skolkin, Book Designer and Art Director